DRAWING &
SKETCHING

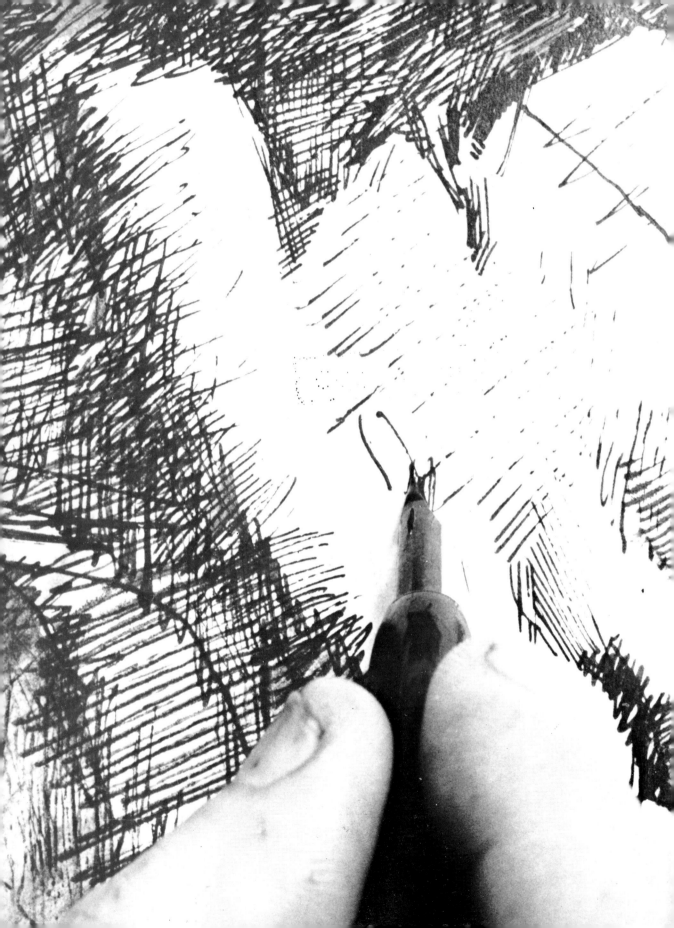

DRAWING & SKETCHING

Stan Smith

**Eagle
Editions**

A QUANTUM BOOK

Published by Eagle Editions Ltd
11 Heathfield
Royston
Hertfordshire SG8 5BW

ISBN 1-86160-881-0

QUMHDS

This book is produced by
Quantum Publishing
6 Blundell Street
London N7 9BH

Printed in China by
SNP Leefung Printers Ltd.

CONTENTS

1. INTRODUCTION
History and Development

page 7

2. MATERIALS AND EQUIPMENT
Pencils and Other Drawing Media ·
Paper · Where you Work · Sketchbook

page 17

3. BASIC TENETS
Composition · Proportions of the Human
Figure · Human Anatomy · Perspective ·
Light and Tone

page 53

4. FIGURE DRAWING
Figure Analysis · Female Figure ·
Male Figure · Children · Groups

page 73

5. PORTRAIT
Portrait Analysis · Female Portrait ·
Male Portrait · Children · Group
Portraits · Caricatures

page 103

6. LANDSCAPE AND ARCHITECTURE
Landscape Analysis · Landscape ·
Urban Architecture

page 121

7. STILL LIFE AND NATURAL HISTORY
Still Life Analysis · Still Life and
Natural History · Flowers

page 143

8. THE FINISHED DRAWING
Mounting · Framing · Exhibiting

page 161

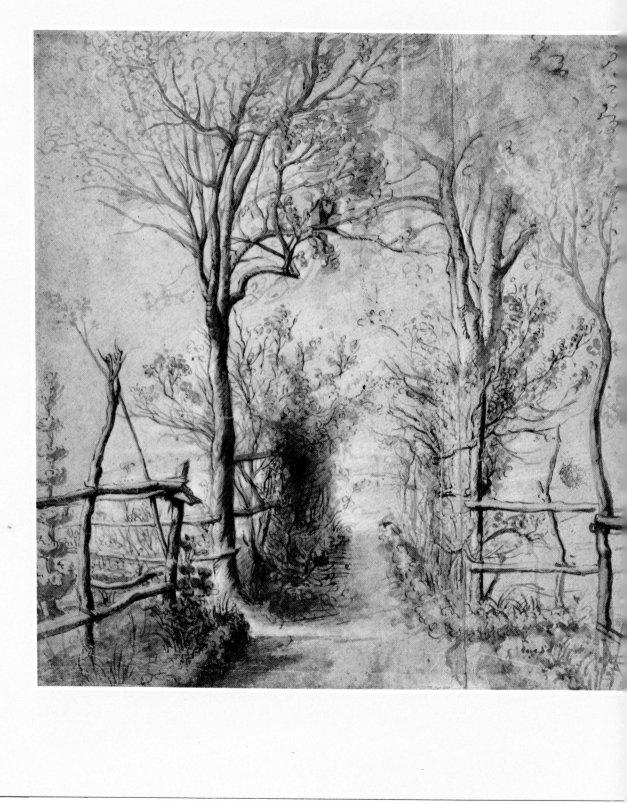

INTRODUCTION

DRAWING can be many different things; it is possible to stretch the definitions to cover anything from a finely-worked objective study of the world-as-seen to an idea with a line around it! Throughout history, the master draftsmen have provided us with copious examples of the variety and scope that can be achieved by this method of making pictures.

One way of attempting to define this many-sided subject is of recording what it cannot be. It cannot be listless, for instance; a sense of investigative urgency is the basis of good drawing and listlessness is its antithesis. While it can be bold, free, generous and full, it cannot be undisciplined, for this means that the medium controls the image beyond the acceptable bounds of experimentation and new discovery. It can be colored, but it cannot be painted in the sense that a finished watercolor can be. The definitions, then, do find their frontiers, but between these poles feel free to discover, as did so many of the great innovative draftsmen of the past, your own language – and make sure that it contains many dialects.

Above: Just one of the ways of making a drawing. Rubens, in *A Path Bordered by Trees*, has used fine, detailed line and stipple together with background washes to achieve a quality that is almost ethereal.

HISTORY AND DEVELOPMENT

Drawing is an activity that can be carried on almost anywhere. No specialist equipment is required; a few simple tools are all that are needed. Size, too, is a consideration that makes the medium particularly appealing. A drawing can be as large or as small as the artist desires; some of the most striking results are achieved on a small scale. The classic example is the pocket sketch book; this is easy to carry around and, as an important extra, usually contains sufficient variety of surfaces to allow for the rendering of different visual notes.

As well as such practical considerations, however, there is no doubt that drawing has a deep psychological appeal. Children, for instance, draw before they can even walk or talk, while artists throughout history have delighted in the medium. Its essence lies in the actual physical action – the mark of the chosen tool on the paper or other support. This is the case whether the results are, say, fluid and calligraphic, or dramatic and even violent.

There are, of course, other factors to be taken into consideration. In particular, what might be called the artistic intention of the line and the character of the medium being used combine to give the drawing character, force and authority. Traditionally, this has been an integral part of Oriental art; in more recent times, many Western artists have demonstrated it as well. The energy and succinctness demonstrated in the drawings of Hokusia (1760-1849) and Matisse (1869-1954) are not only the result of individual genius; they share the significant common factor of discipline. Not a single one of the speedy, fluent, flowing lines is made without a purpose.

An alternative approach is demonstrated in the drawings of Ghirlandio (1449-94). Here, the artist used silverpoint, a medium demanding a careful and slowly developed method of working. Although at first sight, this might seem to produce a result far removed from the breeziness and freedom of the other cited examples, they still have one basic in common – the moving hand. The careful tonal build-up is the result of hundreds of finely touched-in lines, gently caressing the paper's surface. The angle of the lines, the incisive outline etched around the sense of mass, the use of different pressures on the silverpoint to suggest volume and weight – all these express the art of drawing and its distinctively muscular action.

Drawing tradition

Each generation of artists has had a slightly different function for drawing; the preliminary sketches of the Old Masters, for instance, are far-distanced from the work of the *Punch* artists of 19th-century London. By studying the drawings of the former, we can recognise the wonderful impulsive handwriting that marks the individual. Such individuality was often smothered by the demands of the

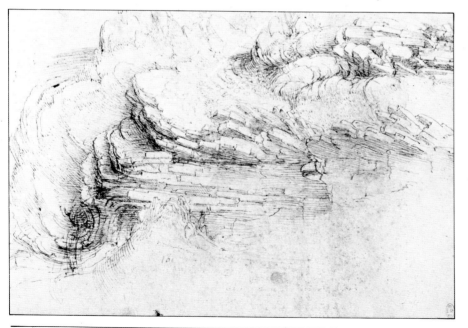

The notebooks and many drawings of Leonardo da Vinci are evidence of his restless interest in a vast range of subjects. He was extremely inventive in developing descriptive drawing techniques for recording his observation of people, objects and natural effects. A sketch of a rock formation (**left**) details the layered structure and the shift from a series of horizontal wedges into curving and angled forms thrusting upwards from the main rock bed. The delicate linear style of the drawing produces an atmospheric effect.

In the study *Antique Warrior* (**right**) the artist is again concerned with linear rhythms in the ornate patterning of the armor, but the image has considerable solidity and force. The drawing was made by the silverpoint technique.

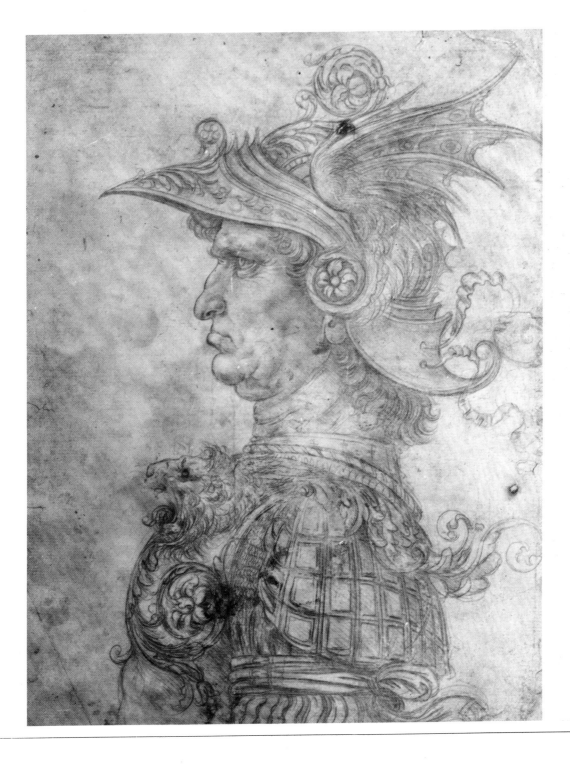

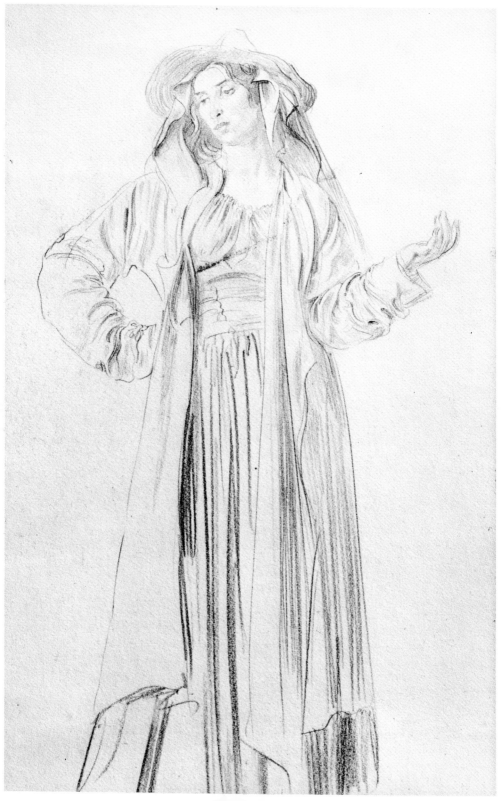

A pencil drawing by Augustus John, *Dorelia in a Straw Hat* (**left**), is typical of this artist's approach to the female figure. The multiple folds of drapery enhance the elegance of the classical pose and although it is a full length view, the facial features are noted sufficiently to give a portrait of the expression and style of the model. By contrast, details of this kind are missing from James McNeill Whistler's charcoal study *Maude reading* (**right**). However, a lively impression of the pose, with highlights picked out in white chalk on the tinted paper, conveys a great deal of information about the subject and retains a pleasing spontaneity.

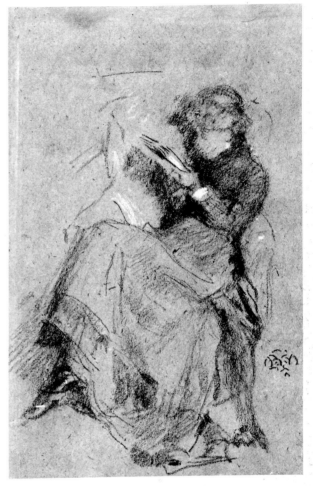

later translation into paint, clay or stone. In contrast, the *Punch* artists drew onto woodblocks for engravers to produce their brilliant cartoons – indeed, since the High Renaissance in Italy and northern Europe, drawing has come to be regarded as a unique artistic offering in its own right, rather than simply the preliminary structural or informative sketch intended to be translated and developed into other media. This is not to say that such a use does not have its place; as a preliminary to painting or modelling, or as a sketched scheme for alternative compositions (the arrangement of the different parts within a picture), drawing comes into its own. Whatever a drawing's character or intention, however, two factors remain paramount - the need to keep up the practice in order to perfect both concept and technique and the need to make each drawing stand on its own as something proud and unique.

Charcoal

Traditionally, charcoal drawings were rendered as highly finished and polished works, making frequent use of the stump to soften and melt one area of tone into another and to reduce the tone of edges and lines. In recent times, however, artists have developed interesting new possibilities. Charcoal is now most frequently associated with expressionist artists, who use the strong, dark mark on a large scale to encompass large-scale themes and ideas. The drawings of Auerbach (born 1931) demonstrate these qualities extremely well; the descriptive parts of the drawing are of no more, or less, concern than the exploitation of the characteristics of the charcoal itself.

A wide range of marks is possible, from an impression of tone, broadly suggested, through indications of texture, up to strongly defined facial features. The larger, broad gestural mark is effective at depicting movement, as demonstrated by many drawings full of incident. Such works could not have been created in any other medium.

As far as paper is concerned, the coarse-textured variety is often associated with charcoal drawing, but the medium preserves its character when used on cartridge or similar, smoother surfaces. Make full use of the stump, not necessarily, as mentioned, just for smoothing and polishing, but rather as an occasional blender for melting one tone into another, or for such tasks as softening a line.

Pen and ink

Pen and ink has a long tradition as a drawing medium. Leonardo da Vinci (1452-1519) and Michelangelo (1475-1564) both used pen and bistre – a dark brown ink – to make studies. Many of the preparatory drawings for the Battles of Cascina and Angiare, as well as the Sistine Chapel frescoes, are in this medium, with very precise

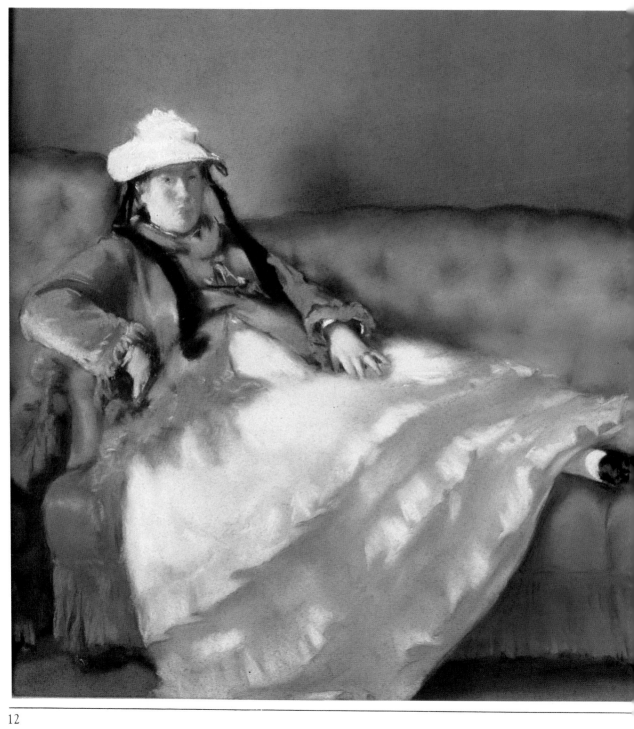

The fresh color and subtlety of fused tones which can be achieved by skill in pastel drawing are the essence of this remarkable portrait *Madame Manet,* by the French artist Edouard Manet. There are no harsh lines to disturb the overall harmony but the form emerges clearly from the masses of color and light. Areas of gray are enlivened by drawing in small touches of the vibrant blue which forms the background to the figure and the striking contrast of black and white, introduced at head and feet, gives the image points of focus. The delicate tones of the face are framed against the muted pink wall. The drawing is a telling example of the virtues of a limited range of color.

detailed features etched out and strong tonal passages indicated by hatching. This and cross-hatching are the terms used to describe the technique in which a series of lines are coagulated to make a solid tone. In the case of cross-hatching, the lines tend to cross each other at approximate right angles.

Pen and ink has been a favorite vehicle for cartoonists over the centuries. Here, the results were often affected by the limitations of the processes available for reproduction. The cartoons and illustrations worked up by such artists as Charles Keane (1823-91), who used pen and diluted ink to hatch and define lively caricatures, were drawn onto woodblocks, later to be engraved by superlative craftsmen. The results, however, had a cold stilted feeling, because of the nature of their method of manufacture. This meant that the original drawing was at some distance removed from the end product. With the advent of photo-mechanical reproduction in the 1820s, a very different picture emerged. Calligraphy, that distinctively 'pen-like' quality was at a premium.

Charles Dana Gibson (1867-1944) with his 'Gibson Girls', and Phil May (1864-1903), the great *Punch* illustrator, are prime examples of artists who were well fitted to exploit the new invention. The results are fresh, energetic and intensely personal line drawings, pen and ink tracing a thin, strong decisive line in a multitude of ways – now elegant and precise, now apparently wild and bold, now quiet and descriptive. Sometimes color is indicated by strokes and ticks, as are various textures – feathers, silks, leather, hair – but never at the expense of the medium.

Further examples abound. Thomas Eakins (1844-1916) used the pen to illustrate and to make notes for his paintings, as did Daumier (1808-1879). Picasso (1881-1973), the 20th-century giant of the visual arts, used a pen for a great variety of purposes. Nor did artists confine themselves to traditional approaches. One interesting variant is the use of a brush or stick with the ink, rather than a pen. Rembrandt (1606-69) and Goya (1746-1828) both used this technique, and the results, – quick notation, compositional suggestions, descriptions of fleeting light effects – still amaze today. For their part, Oriental artists can make the fluent brush line bend in a thousand fascinating ways.

Color

Color in drawing is now not restricted to mere suggestions in what is essentially a monochrome or single color drawing. Today, there is nothing to stop a drawing being made

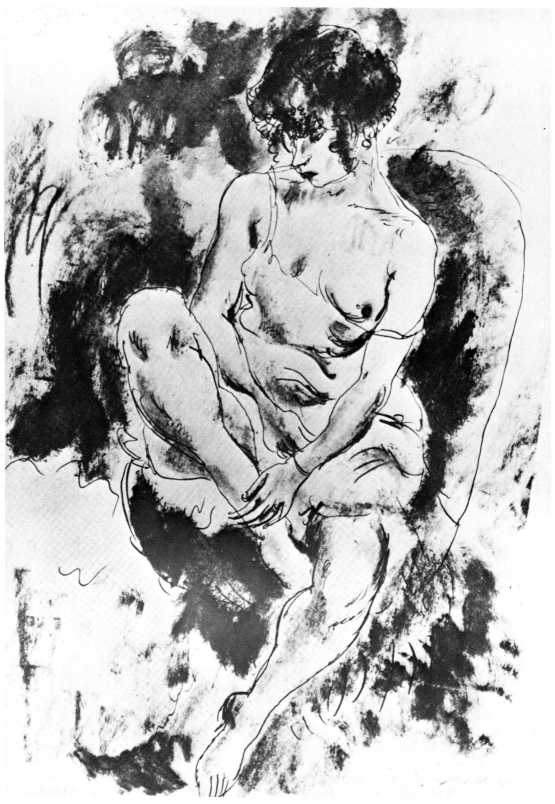

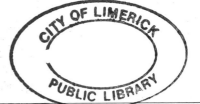

These two studies show, in different styles of drawing, the confidence of artists who are practised in working with pen and ink. There is little room for revision in an ink drawing and it is necessary to understand which aspects of the subject are to be conveyed and to observe the form carefully before any marks are made. The bold, fluid style of Jules Pascin produces a vigorous image in *Redhead in a Blue Slip* (**opposite**), with heavily smudged marks providing tonal emphasis to the energetic line drawing. The model's pose is accurately described but the drawing also indicates a mood and has a spiky, vital quality. The economical use of line by David Hockney evokes a more passive atmosphere in *Nick and Henry on board, Nice to Calvi* (**right**) Although the information is sparingly described, the difference in scale between the figures and a brief outline of the receding line of seats neatly establishes the artist's viewpoint. The image is more definitely accented in the sketchy lines describing the hair and dark tones in hat and glasses.

in limited or full color; a wide range of suitable colored pencils, pastels, inks and indelible markers are readily available, each with its own limitations and potential. David Hockney (b. 1937) uses a range of colored pencils particularly well, mixing colors by juxtaposing separate tints to achieve the same kind of optical mix that the impressionists achieved with their *pointillisme*. This often proves to be necessary, both because the limited range of colors needs amplifying and because such a technique brings life to the work.

Drawing with colored inks can take many forms, from lines in black with the colors laid in washes to the use of colored inks to draw the lines themselves. Many colored drawings are the result of mixed media, watercolors being mixed with pen and ink, pencil, colored chalks, crayons and even some areas of collage. Acrylic paints used in

conjunction with other drawing materials introduce an additional element of flexibility; textures may be created on the support over which chalk, pen and pencil marks can be worked.

The pen tends to be the instrument for rapid notes and the pencil for detailed investigations, while the breadth of black chalk and charcoal encompass ideas and summarize details. All are used for drawing, this thrilling muscular act that delights us with the various forms it has taken over the centuries, takes us inside the scientific mind of Leonardo, lets us share the endless inventions of Picasso and enables us to see afresh the sombre Amsterdam of Rembrandt's time. The definitions offered are loose, and deliberately so. They await further stretching, arising from new combinations of materials and implements and the discovery of fresh philosophies through vision and experiment.

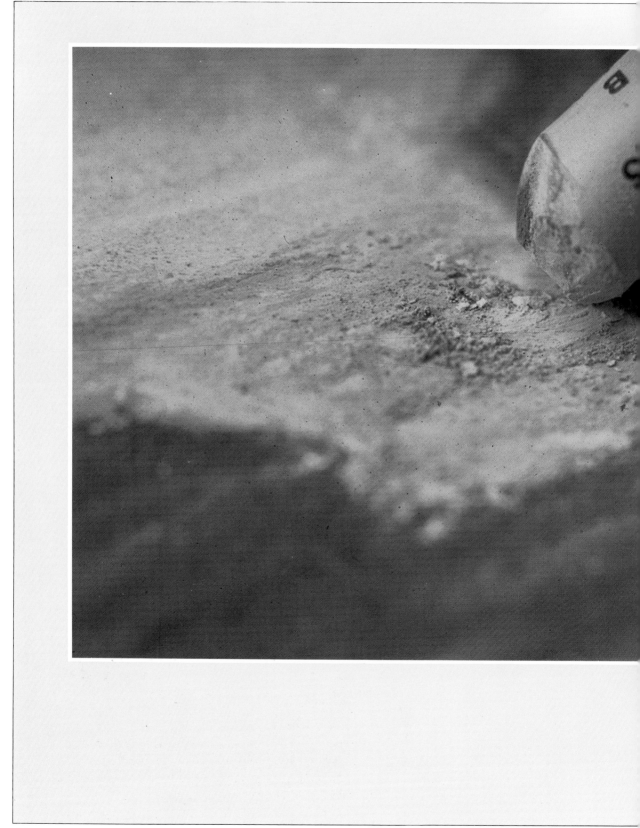

MATERIALS
AND
EQUIPMENT

THE MATERIALS CHOSEN for making drawings will vary according to the intentions of the artist and the nature of the subject. They will also vary because each artist will develop his own style and prejudices, preferring one method of applying tone, line or color to any other. Only by experience will you learn which method or material suits you best; by trial and error you are likely to discover the ideal medium, and unexpected combinations can often provide new possibilities.

The surfaces itself, as well as the tool used to make marks, is a factor to be considered. A completely different effect can be achieved when using the same instrument on a smooth or a rough paper. On one drawing, part of the surface can be made rough by rendering, or a variety of pencils, pens or chalks may be combined.

Develop a system for organizing your materials, both in your studio and when working in the field, so that nothing is lost or left behind when you most need it. As well as the support and the instrument to be used, you will have to remember erasers, perhaps a flat blade for removing unwanted passages by careful scraping, and some method of fixing the finished drawing. Several proprietary brands of fixative are available, but if you do not want to have to carry this with you, perhaps when travelling or drawing out of doors, sheets of thin paper such as bond can be inserted between the leaves of a sketchbook

Above: Pastel is just one of the means by which it is possible to add color to a drawing; it is available both in its traditional form and as oil pastel, which has an even wider potential. Other media used for drawing in color include chalks, colored pencils, felt tips and inks and they can be used either on their own or in combination with each other.

17

PENCILS AND OTHER DRAWING MEDIA

The word 'drawing' suggests to many a work executed in pencil, but a variety of tools has always been available and this selection is increasing so that the draftsmen of today can choose from a very wide range of materials. Within the field of pencil drawing itself, several grades of pencil can be used in one piece of work, letting the qualities merge on the surface in order to achieve a rich interplay of line. Many other materials can be used to extend the visual range.

One factor to be taken into consideration, as well as the type of effect you want to achieve, is where you plan to work. For instance, if you want to make detailed studies in a small country church, miles away from roads, practical problems of weight and ease of carriage will be uppermost in your mind. In this case a clutch pencil, the modern equivalent of the propelling pencil, would be a particularly suitable tool. Leads can be changed easily according to the degree of softness required so all that need be carried is one pencil, several leads and a pocket sketch book.

Pencil

The most common instrument used for drawing is the pencil (from the Latin work *pencillus* meaning little tail). Made originally from graphite, first discovered in Borrowdale, England in the 16th century, it was not until the 18th century that pencils developed into approximately the form we know today. These used a core made of a compound of graphite, clays and other fillers. The cores were inserted into groved wooden cylinders and thus the modern pencil was born. Nowadays synthetic graphite is used, enabling the manufacturer to more closely control the pencil's relative hardness or softness. When graphite was first discovered it was mistaken for lead, giving rise to the name 'lead' pencil that has persisted to the present day.

Pencils are graded by the 'H' and 'B' systems. H through to 8H indicate increasing hardness of lead, whereas B through to 8B denote increasingly soft cores. It is important to experiment with a wide range of pencils. Their characteristics may vary according to the paper used, a hard pencil, for instance, making a fainter mark on a smooth, coated paper than on a coarsely textured one. Similarly, a very soft pencil, say a 5B, will make an intensely dark, coarse and rich line on textured paper, so much so that marks may prove difficult to control. Often the best way to exploit the pencil fully is to combine several different grades. Paul Hogarth (b.1917), for instance, is an example of a leading contemporary artist who demonstrates the use of various grades within the same work.

Care must be taken when sharpening the pencil, particularly with the softer leads. Rotate the pencil and slowly shave off the wooden casing with a sharp craft knife or single-edged razor blade. Use a sandpaper block to finish

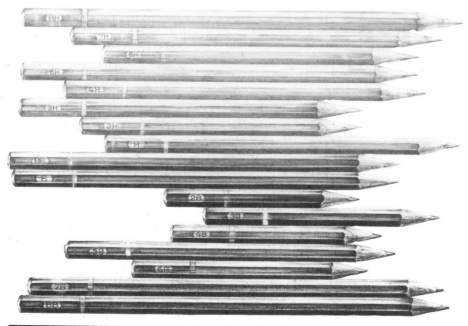

Left: Graphite pencils are available in a wide variety of degrees of hardness or softness, ranging from 8H, which is very hard, to 8B, which is the softest lead. In order to illustrate the differing effects, the appropriate pencil has been used to draw each of the selection shown below, so that the hardest, 8H, appears much fainter than the dark, smudgy effect of the softest, 8B.

Pencil effects 1. Different combinations of pencil and paper produce a wide range of effects. Here a 2B pencil has been used.

2. A fairly soft pencil (4B) creates a gradated tone on a moderately smooth paper.

3. Used on a rough paper, this same 4B pencil gives a much less even result.

4. Achieve the above effect by drawing with the reverse end of the pencil to create indentations, then shading.

5. An eraser is a useful adjunct to pencil drawing when specific effects are required. Here 2B lines have been partially erased.

6. A series of lines drawn with pencils ranging from 6H to 6B shows the differences in the weight that can be achieved.

7. For a very strong, dramatic effect use carbon paper on top of your drawing surface.

8. Pencil can be used to produce tone as well as line effects. Here, tone has been blocked in using a 2B pencil.

smoothing down harder pencils. Some uses will not necessitate very fine points and a blunt end will be better.

Masters of pencil

Fine pencil drawing has been a feature of art for may years and much can be learnt by studying the work of leading artists both past and present. The early forerunner of the pencil was silverpoint, a sharpened stick made from an alloy of lead and tin. The study of a man in a helmet by Leonardo da Vinci (1452-1519) shows a refined technique comprising many fine shaded lines, netting across the paper surface to record the image. Various pressures are employed to give due emphasis and stress; sometimes the surface seems to be almost caressed. Contrast this with the vibrant figure studies of the great French sculptor, Rodin (1840-1917). Here the line seems to be a continuous tracing on the paper, full of energy and conveying somehow a prediction of the next intended movement.

Ingres (1780-1867) combines long clear lines travelling with apparent inevitability alongside careful, shaded tonal details of character in the faces and heads. The line has here lost that instantaneous quality associated with the work of Rodin and seems to have moved a long way from a mere study; the drawings exist as fully qualified works in their own right. Other pencil drawings show a sense of searching towards a greater comprehension of the subject. The nudes of Matisse (1869-1954) show the line being pared down until the most simple, economical contour line will bring the sheet of paper to vibrant life, an approach that is virile and risky.

Charcoal

Charcoal is made of sticks of wood, often willow, burnt to carbon. Various grades are available, ranging from hard to very soft, and the latter particularly need to be fixed to the surface of the paper on completion of the drawing. This is normally done by the use of a proprietary brand of fixative.

Recent times have seen developments and changes in charcoal, as in so many other materials. Charcoal pencils, containing compressed powdered charcoal and a binding agent, offer more control and a cleaner instrument with which to work. The density of mark will vary according to

PENCIL EXPONENTS

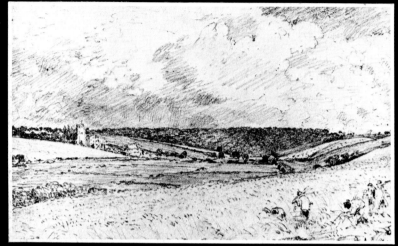

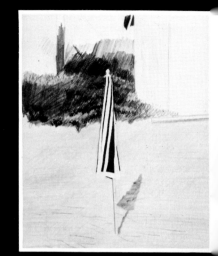

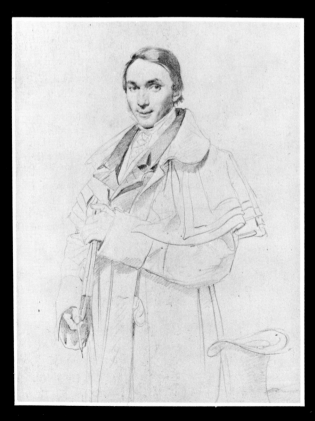

The versatility of a simple medium is clearly visible in these examples of different approaches to pencil drawing. Clarity and precision are the hallmark of work by the French artist Jean August Dominique Ingres, and the study of a young man (**right**) shows the same attention to form as his more complex oil portraits. An economical use of line drawing establishes the overall shape of the clothed figure. The head is more fully developed in areas of delicate shading which show the subtle changes in the contours of the face. Loose hatching and patches of grainy tone briefly define folds in the coat and the color of the man's jacket. By contrast, the landscape study by John Constable, *View of Wivenhoe Park* (**above left**), is more heavily worked over the whole picture plane, with a variety of marks which express the textures and colors of the subject. Constable's abiding interest in landscape was well served by his expertise in handling the pencil to convey charac ter of land and sky.

The studies of ballet dancers by Edgar Degas invariably capture an immediacy which is crucial to the subject. This pencil study, *Dancer adjusting her slipper* (**right**), vividly recalls his vibrant pastel drawings, but has its own formal qualities which show his understanding of this delicate medium. Nervous lines trace the outline of the form and the various visible alterations express the rapid observation of the whole form necessary when an artist must extract the essence of a fleeting pose. As the eye moves over the subject, the pencil swiftly records the impressions. Added emphasis in certain lines and the judicious use of tone fix the angle of the body. The traditional drawing media have been effectively revitalized in the work of David Hockney. *Beach umbrella* (**above**) is typical of his ability to fix upon an element of the subject which focuses the mood of the whole scene. A clever combination of line and tone indicates an effect of light

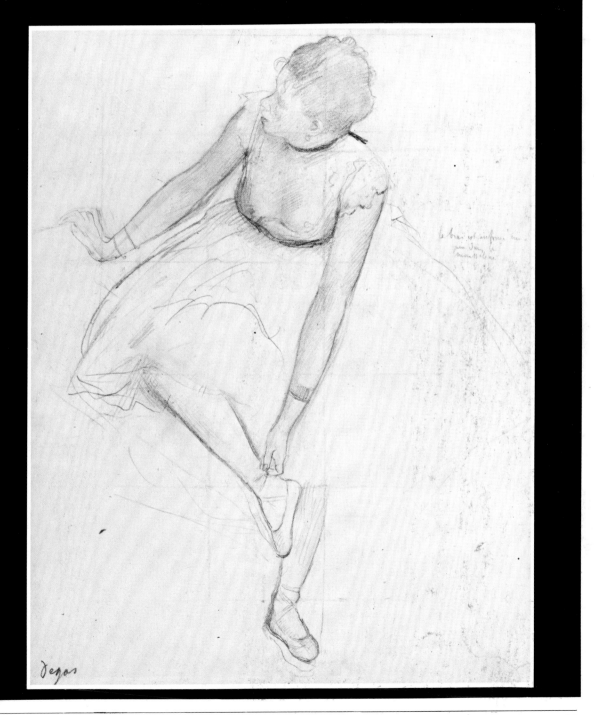

the proportions of pulverized charcoal to oil (or wax); a softer pencil contains more binder, a harder one less. In general a toothed paper or board is most suitable for use both with sticks and pencils.

Charcoal techniques

Charcoal can be used to good effect for strong and vigorous linear works and it is especially suitable for making tonal drawings working from the darks, a technique in which the surface of the support is covered with a consistent layer of powdered charcoal forming a flat, mid-gray tone. From this surface, by the use of a kneaded or putty rubber, the lighter parts of the design are provisionally picked out, leaving the gray sheet punctuated with patches of white. Into this beginning can be introduced the positive marks, using lines and smudges of charcoal. Development through the consolidation both of the negatives (the

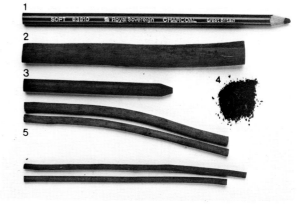

Above:
Compressed charcoal pencils (1) can be either soft, hard or medium; sticks come in varying widths – thick (2), medium (5) and thin (6); compressed charcoal also comes in stick form (3); powdered charcoal (4) is available for use with a stump.

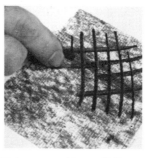

Charcoal techniques
1. Use fine, hatched line to build up an area of graded tone, working in one direction and varying the pressure.

2. Loose cross-hatching is an alternative method of applying texture and building up tonal areas.

3. Lay areas of tone with the side of the charcoal stick and cross-hatch over the top for a richer texture.

4. Use a finger to spread charcoal dust evenly over the paper or to vary the tone.

5. Work lights by using a soft putty rubber. A clean piece will erase charcoal completely.

6. Create areas of pattern and texture by rubbing lines lightly with a putty eraser without erasing them completely.

7. Use a charcoal wash technique to soften and spread the tonal areas. Work gently with a soft brush and clean water.

8. Highlights can be added by using a white chalk or pastel. This is particularly effective on tinted paper.

CHARCOAL EXPONENTS

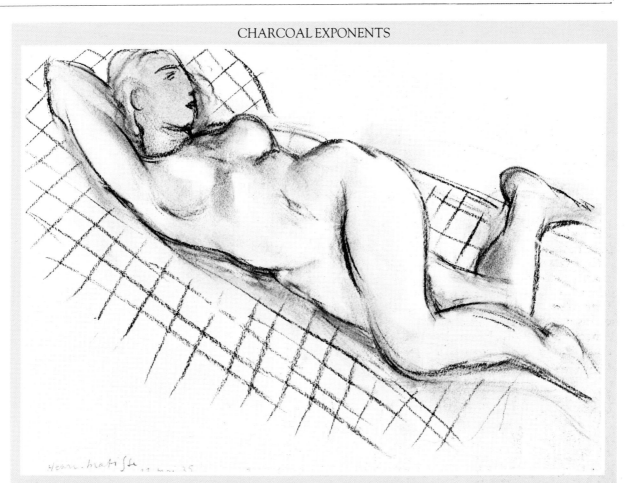

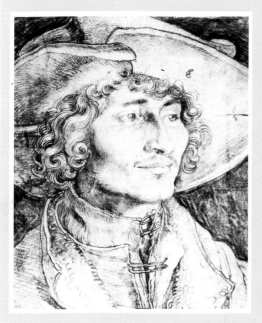

Portrait of a Young Man (**left**) by Albrecht Dürer illustrates the precision that can be achieved if charcoal is handled confidently. It is sometimes regarded as a clumsy medium, but here crisp lines in the hair and subtle modeling of the face are achieved with great skill and delicacy. *Study for pink nude* (**above**) by Henri Matisse has the bold, vibrant line characteristic of charcoal and the rounded forms are emphasized with rubbed tone and highlights created by erasing parts of the drawing. The relaxed pose is given implied movement by the activity of the charcoal marks. Van Gogh's handling of the medium is even more vigorous in *The Gleaner* (**right**). The treatment of tonal areas is similar to that of Matisse, but heavily scored with raw, scratchy lines.

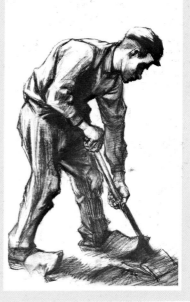

PASTEL

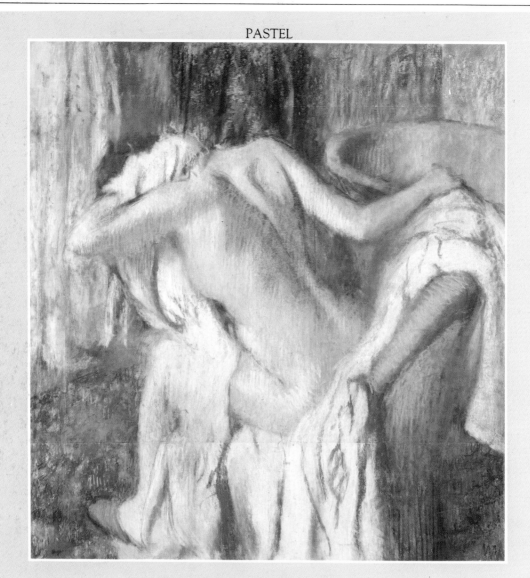

Degas broke with the tradition of pastel drawing, which had favored highly finished portraits in carefully blended colors and tones. The complex weaving of different colored strokes and the heightened contrasts of warm and cool colors are typical of his unique style. *Après le bain, femme s'essuyant* is one of his many studies of female form. The strong diagonal line of the design is reinforced by the arrangement of tone and color and the energetic marks made by the pastel sticks. The powerful combination of linear rhythms and colored masses is one of the great strengths in the work of Degas. He experimented with the medium to exploit the link between painting and drawing which it provides, using water or turpentine to dilute the pigment so he could spread it as a wash or paste of color. He also introduced other media into the drawings and in the example above used charcoal to establish the lines of figure and chair, and to lay in areas of heavy shadow, working the colored pastels over the top.

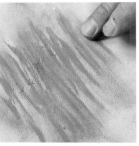

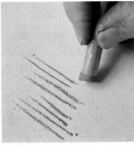

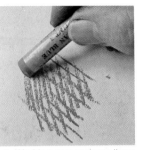

Pastel techniques
1. Diagonal hatching can be laid in by using the side of the stick of pastel. The thickness of the lines depends on how firmly you press.

2. By rubbing the hatched lines with a fingertip the color can be spread and a hazy effect achieved.

3. Use the side of the pastel and press lightly in order to obtain crisp, fine lines.

4. Working across these lines in the opposite direction results in a cross hatched texture, one of the best ways of achieving tonal and shading effects.

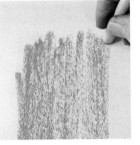

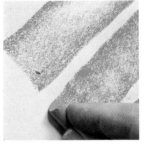

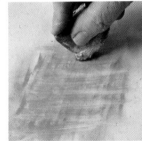

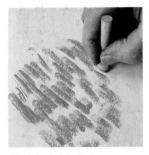

5. Lay an area of color with the blunt end of the pastel by working along the grain of the paper in one direction only, being certain to use firm, even pressure to achieve an even tone.

6. Peel back the protective paper and hold the pastel flat against the support to obtain a broad area of grainy color.

7. Use a kneaded rubber to create highlights and to lift off color and achieve paler tones.

8. Make brisk strokes across the grain of the paper with the blunt end of the pastel in order to create a stippled effect.

wiped off areas) and the positives allows great scope for adjustment and even major correction.

One of charcoal's prime advantages over other drawing media is this capability of being changed. The drawing can remain in a state of flux, with many obvious advantages. Degas tended to use charcoal in a similar way to chalk or pencil, enclosing the figure forms by firm, positive strokes, but exploiting the material's versatility by rapid indication of varying areas of tone. Matisse made figure drawings in charcoal combining line with the soft smudges, left as ghostly traces, of corrections having been made. Picasso, during the Cubist period, found charcoal a sympathetic medium.

Pastel

Color is used in drawing both to arrest a memory and to enliven the picture surface, but it can also be used to describe the world-as-seen or to propose schemes for works in other media. Pastel drawing was at its height as a popular medium for portraits in the 18th century, but since that time it has been used by a number of artists, either as a unique technique or in conjunction with other materials. Traditionally pastels are made from powdered pigments mixed only with sufficient gum or resin to bind them into stick form. Pastels tend to be softer than pencils or chalks; they are still, however, defined according to grade, depending on the amount of gum used in their manufacture.

The primary advantage of the medium is its immediacy of effect, it being necessary only to rub the stick over the surface for it to release the characteristic fresh pure color. This distinguishes pastel from oil or other paints. The support used is often pastel paper – a surface made with

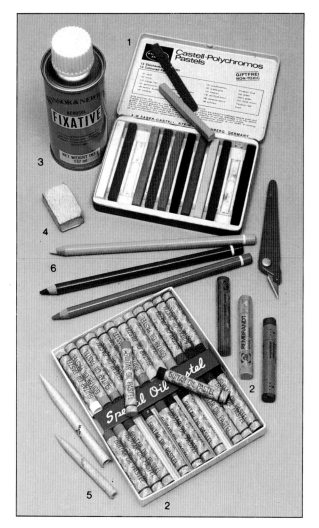

Above: Pastels **(1)** come in two types, hard and soft. The soft type tend to crumble easily. Oil pastels **(2)** are made from a coarser pigment and have an oil binder added; they are particularly useful in mixed media drawing. Fixative **(3)** is essential in order to prevent smudging. A putty rubber **(4)** and selection of torchons **(5)** are useful for spreading color or obtaining highlights and pastel pencils **(6)** can be used for detailed work. Use a knife for sharpening oil pastels but work carefully in order to avoid breaking them. Ordinary pastels should be sharpened by rubbing them gently on fine sandpaper; in general they are more suitable for delicate work than oil pastels.

pastel drawing specifically in mind and usually colored. If the available ground colors and surfaces prove unsuitable for the portrayal or design intended it might well be preferable to prepare the surface yourself. This can be done by applying watercolor, perhaps with the addition of a little gum or egg white. Acrylic paints can also be used, giving an agreeable and controllable texture; making selected areas of the surface textured assists in the quest for variety and richness.

Oil pastel

Oil pastel is a relatively recent development and has an entirely different range of possibilities from traditional pastel. Limited by its relative clumsiness in use, this medium nonetheless contributes its unique qualities to the repertoire of the draftsman. Used in association with, for example, pens or watercolor, it lends the richness of oil-bound pigment, but it is also an important medium in its own right. Although not really suitable for use in the small pocket sketch book (some people achieve even this) it is very suitable for quickly worked interpretations of figure or landscape. Control can be aided by the use of a little masking paper to lay beneath the working hand, thus preventing unwanted smudging and smearing. In common with traditional pastel, this new material shows well on a colored support but is perhaps at its best on white. This allows the rich and transparent oily colors to gleam as though lit from behind, and they can form the basis of a design over which watercolor or colored inks can be used, resulting in a type of work that is both elaborate and refined.

It is as part of a mixed media drawings that the oil pastel is unique, not only when overlaid by watercolor, gouache and inks but in association with pen drawing, traditional pastel, black chalk and pencil. Experiment with spirits of turpentine or turpentine subsitute, using them to dilute the marks on the paper and so create a wash effect; this quality of color proves most sympathetic as a basis for pencil and chalk work.

Chalk

Chalk is a harder medium than pastel, pigments being mixed with wax or oil to make them usable in stick form. As well as silverpoint and, later, pencils, chalk has long been used for drawing. Many of the drawings best known to us, through reproductions, by Michelangelo, Andrea del Sarto, Toulouse-Lautrec and Watteau, all made brilliant use of the medium. Some used black chalk, some red, and

PASTEL EFFECTS

**Laying an area of tone
1.** Use the blunted end of the pastel to draw in a fairly small area of thick color.

2. Work the color over the approximate area it is required to cover, using a fingertip and spreading the color lightly from the centre.

3. A torchon is more accurate than the fingers for putting the color exactly where you want it to go.

4. Rub the toned area with a piece of newspaper to push the pastel into the support and set the color.

Highlighting with a kneaded rubber By manipulating a rubber to a point, small areas of color can be lifted.

Adding detail with a pastel pencil Pastels in pencil form are easily sharpened and therefore suitable for detailed work.

Lifting pastel with a brush Excess color can easily be removed by brushing gently with a soft paintbrush.

Laying an oil pastel wash Use turpentine rather than water to spread the applied color, working on canvas or a grainy paper.

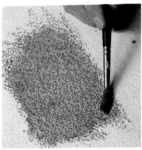

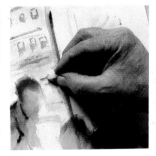

Adding detail with charcoal Sharpen charcoal by rubbing lightly on sandpaper and use the point to make strong, crisp shapes.

Oil pastel with watercolor On a coarse paper, rub a layer of oil pastel then lay a watercolor wash. The oil repels the watercolor, which settles into the pastel-free grooves of the paper.

Pastel with watercolor Wheras oil pastel repels a watercolor wash, ordinary pastel will be spread by it and mixed with the watercolor.

Spraying fixative A finished pastel may be fixed by spraying either the front or the back. From behind, the fixative permeates without dulling the color.

CHALK EXPONENTS

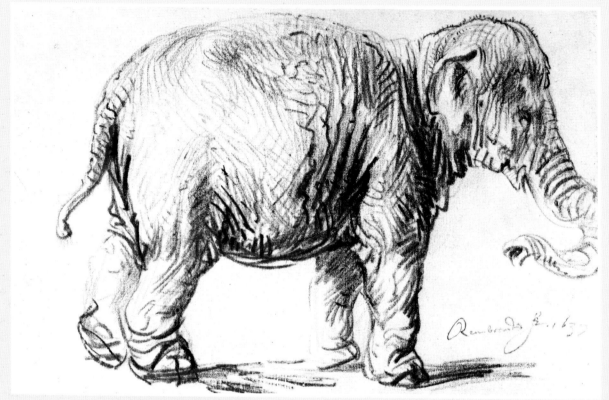

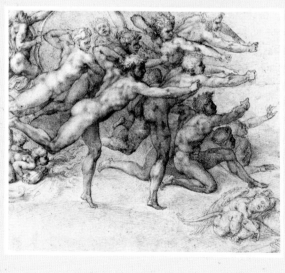

A sculptor's eye for dynamic form is combined with great skill in draughtsmanship in *Archers shooting at a mark*, a chalk drawing by Michelangelo (**left**). He has used the full range of linear and tonal qualities of the medium to elucidate this complex composition. Realism is treated with scant respect in the design as a whole, but each individual figure is minutely observed and described to show every muscle and curve within the form. Rembrandt's depiction of an elephant (**above**) by comparison employs a style which expresses the rough power of the creature. A network of calligraphic lines and loosely hatched tones arrests the movement and suggests the strange, furrowed texture of the skin. By working on coarse-grained paper, Georges Seurat arrived at a technique of drawing (**right above**) which closely mirrored his Pointillist painting method. A natural grading of tones occurs as the chalk is worked more or less thickly into the grain. This striking image has as much to do with formal and technical considerations as with subject matter. The character of the drawing is wholly identified with the emotive subject in the work of Kathe Kollwitz. *Death holding a girl in his lap* (**right below**) is formed with expressive lines and masses of heavy tone.

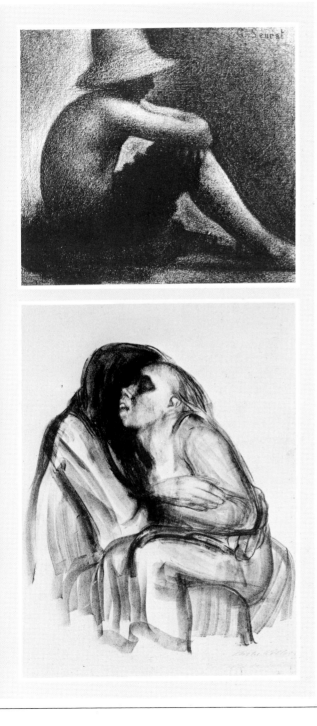

others mixed the two and even used white to bring out highlights.

Masters of chalk

A fine example of the traditional techniques developed in the High Renaissance is the self portrait by Andrea del Sarto (1486-1531), shades of tone being suggested through a great number of lines, laid side by side at an angle of 45°. Toulouse-Lautrec (1864-1901) uses the chalk quite differently, the results showing a mixture of strong linear description and areas filled with flat gray or black suggesting color patches. Watteau (1684-1721) had the rare fluency that allowed him to take on all manner of problems in his drawings, usually mixing black with red chalk and manipulating the visual world to create his own romantic visions. Käthe Kollwitz (1867-1945) brought a disturbing power to her studies of peasants.

Georges Seurat (1859-1891) was another inventive artist whose use of chalk perfectly matched the philosophy of his art. The sense of quiet monumentality, achieved through the organization of large areas of tone, discarding the more traditional language of line, is developed further in the artist's few large paintings. Giacometti (1901-66) worked to rediscover form, even to invent his own from the evidence before him. The fatter, fuller feel of chalk in Michelangelo's Sistine Chapel studies carries no less intensity but exploits fully that other quality of the medium, the broad sweep of the line. From the drawings of ballet dancers by Degas (1834-1917), through bullfight scenes of Goya (1746-1828) to landscape studies by Claude (1600-82) and the portrait of Tudor times presented by Holbein (1497/8-1543), the stick of chalk offers a wide range of possibilities.

Pen and ink

Despite the popularity of newly invented pens intended for use primarily by graphic designers, traditions die hard, and the ink-dipped nib in the traditional penholder remains the most popular instrument among professional artists. This is probably because the range of possible marks is very wide, and such flexibility is highly valued by the artist. The fact that the reservoir in the nib holds so little ink, making frequent dipping into the ink pot necessary, seems to be a major handicap at first but can prove to be a very real advantage. These fluctuations enforce the regular reconsiderations very suitable for studies and work of a particularly exacting nature.

Other styles of pen and ink drawing are better served by a

PEN AND INK EXPONENTS

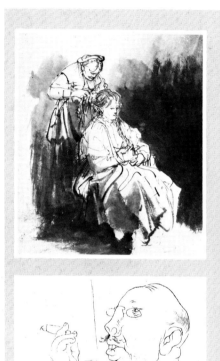

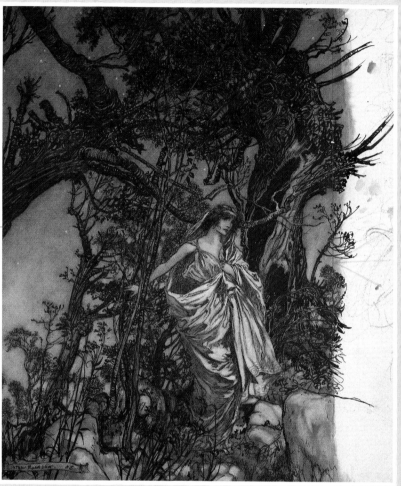

A Caricature by George Grosz, *Face of a Man* (**left above**) seems at first a rather simple drawing, but each fluid line is formed from a series of short, broken strokes of the pen. This gives the line considerable energy which invigorates the neatly observed portrait. Rembrandt's small, intimate study of his wife Saskia (**top left**), sitting patiently while her hair is braided, is swiftly sketched in with a pen and elaborated with washes of tone. A wealth of detail emerges from an illustration by Arthur Rackham (**right above**) although the style is flowing and free. Washes of diluted ink provide color and exra depth to the forms. To the right of the drawing, the original pencil guidelines can be seen on the white paper. Botticelli used wash areas and white chalk highlights to describe the figures in *Abundance of Autumn* (**opposite**). Masses of delicate lines trace the detail in hair and drapery.

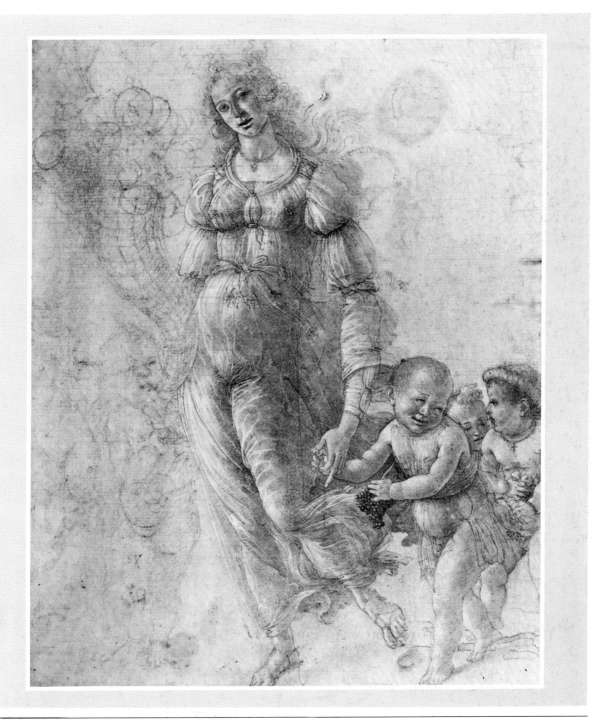

Right: A wide selection of inks is available. Artists' drawing inks are waterproof, drying to a glossy film which can be overlaid. They come in many colors, though black Indian ink is most commonly used for drawing. Non-waterproof inks dry matt and have the same effect as diluted watercolors; they can be further diluted and blended when water is washed over them with a brush. **Top row, left to right** Rotring special drawing ink, ink cartridges, Rotring, Pelikan and Quink fountain pen ink, smaller bottles of Rotring special drawing ink; **second row** Rotring and Grumbacher Indian ink, jars of Rotring special drawing ink, FW waterproof drawing ink; **third row** FW waterproof drawing ink and Pen-Opake; **bottom row** Rotring drawing inks.

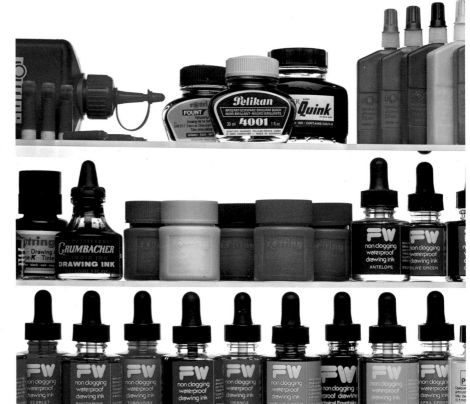

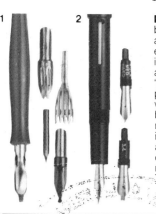

Left: Dip pens **(1)** have long been the traditional tool of pen and ink illustrators and are still extremely popular. The nib itself is known as the 'pen' and the main shaft is the 'penholder'. Many nibs are produced; they can be used with any type of ink but should be cleaned regularly under running water to prevent the ink caking. Fountain pens **(2)** are sometimes more convenient but the range of nibs available is much smaller. They are often filled by suction.

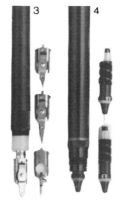

Left: Reservoir pens, as their name suggests, have an ink holder which is filled by pouring in the ink rather than by suction. Suitable inks are waterproof and available in a wide range of colors. The graphos pen **(3)** can be fitted with nibs in a variety of sizes and styles, while the stylo tip pen **(4)** has tubular nibs, in varying widths, giving a constant line width.

regular flow of ink and it is here that cartridge pens come into their own. It is extremely difficult to vary the width of line obtainable, and if care is not taken the resultant drawing can seem wiry and insensitive. With the addition of the brush line, however, this can easily be overcome. The combination of fluid, thicker and variable lines with the thin, regular lines of the cartridge pen creates an agreeable textural contrast, and is a ready means of suggesting color in black and white drawings. Black ink is not the only color; diluted black, brown or blue-black inks all have their own charms. Several densities of ink, made by making up varied suspensions of Indian ink in water, may be employed in one drawing, just as can a range of nibs or stylus pens and brushes. The mapping pen has an extremely thin nib suitable for fine and detailed work; this tends to impose the size of the drawings made .

Colored ink

Drawing in colored inks, both with a limited and a comprehensive range of colors, can stretch the possibilities of pen and ink drawing further. These inks add dimension, not only as washes of color but also when used to describe objects in their identifiable local colors. Pens and nibs can be varied and a wide range of colored inks used, perhaps consolidating the tones by the addition of a stronger, neutral ink. Tones can present a problem, it being imperative that all colors conform to an overall tonal scheme within the piece. A well resolved monochromatic drawing might prove the best foundation for color, used either as the juxtaposition of lines in various colors to effect an optical color mix or as single colors to describe objects.

Choosing a pen

There is a great variety of pens and other instruments suitable for making ink drawings. From the 16th century onward, many different tools have been used. The reed pen, made by selecting a length of reed, cutting a suitable shape and splitting it carefully to hold drawing ink , was

Pen and ink effects

Pen and ink is an extremely versatile medium and the small number of effects illustrated is offered only as a starting point from which to experiment. It is important to try different pens and techniques in order to find those which best suit your style of drawing. Stylo tip pens are particularly useful for drawing straight lines of uniform thickness and for producing a dotted effect **(top row)**. Indian ink, full strength or diluted, and dip pens can be exploited to create a huge range of results **(bottom row)**.

Using a stylo tip, lines of varying widths are drawn freehand with different nibs. Cross hatching creates a tartan effect.

Simple stylo tip scribbles can be profuse and dense or spare and delicate.

This dotted, or pointillist, pattern has been created by using a fine stylo nib.

Candle wax repels ink and can be rubbed over the paper to leave highlights or areas untouched by an ink wash.

Use an old toothbrush to splatter ink over a surface, blotting it off if a softer effect is required.

A combination of line and wash requires both brush and pen. Leave the wash to dry before adding the pen lines.

A blob of wet ink can be blown across the support to create random splodges and streaks.

Colored pencils are available in an enormous range of subtly varying hues, from intense primary colors to neutral and earth tones. Some are soluble in water (**1**) so that a basically linear style of drawing can be softened by spreading color with a damp brush. The ordinary colored pencils (**2**) are usually soft enough to allow delicate shading, while sharpening easily to a point, and the quality varies from one brand to another. Fibre tip pens (**3**) have relatively fine points made of tough material. The color is usually water soluble and can be blended with a brush. Felt tips and markers (**4, 5**) are often spirit based as they are used by designers needing stable color overlays. They are available with broad or fine tips and in many beautiful colors. Prices vary and a good set of markers can be quite expensive. For more delicate work. Fine ball tip pens (**6**) have largely replaced ballpoints and fountain pens as they are convenient and reliable writing implements, and for the same reasons they are useful drawing tools also. The color range is restricted, as is the range in ballpoint pens (**7**) but this type of pen is more easily carried and used for sketchbook work, for example, than other drawing media.

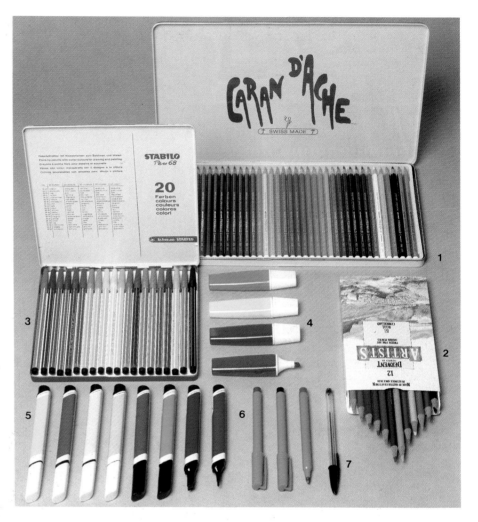

used in earlier times. The character of the line achieved is distinctive once recognized, exemplified by the trailing of the drying nib and the fullness of the main strong lines. Bamboo will produce a similar but less flexible implement and very good bamboo pens are now made by the manufacturers of artists' materials. Although these methods of applying ink to the support are associated with the past they are nonetheless extremely interesting for contemporary use and it is well worth experimenting with them.

The most common tool is a steel nib, which until the advent of ballpoint pens was universal not only for drawing but also for writing in ink. These are available in a range of sizes and on a scale of flexibility ranging from stiff to bendy. Each makes its own type of mark, those with greater spring tending to extend the range of effect achieved from fine lines to broad, thick ticks, whereas less flexible steel makes fewer variations in thickness of line.

Robust supports

A well sized paper surface is appropriate for use with pen and ink because it holds the mark well and does not bruise or break as is the tendency with softer surfaces. A support prepared with a gesso or acrylic base, say on cardboard or millboard, will make a suitable surface and can be polished

MIXED MEDIA

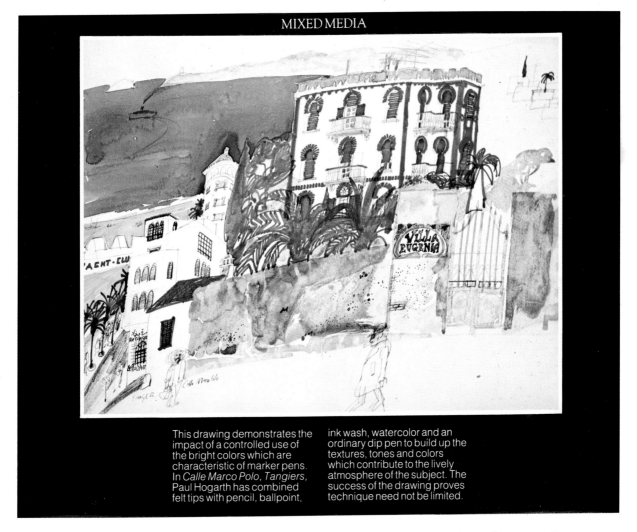

This drawing demonstrates the impact of a controlled use of the bright colors which are characteristic of marker pens. In *Calle Marco Polo, Tangiers*, Paul Hogarth has combined felt tips with pencil, ballpoint, ink wash, watercolor and an ordinary dip pen to build up the textures, tones and colors which contribute to the lively atmosphere of the subject. The success of the drawing proves technique need not be limited.

to a hard glossy finish to allow richly worked and over-worked drawings. It enables corrections to be undertaken by overpainting errors with fresh acrylic paint and reworking the offending parts. Even on a softer paper such as cartridge, mistakes are often remedied by painting out and overdrawing. Various opaque white correctives are available, quick drying and very hard, and all are useful to have to hand. If work is being made on a card or illustration board then a common technique employed to make adjustments and even major corrections is to scrape the top surface off, using a sharp craft knife or a single-edged razor blade. It is essential that the cutting edge, in this case the scraping surface, is kept almost flat against the support so that mistakes can be erased without tears or scratches. If they do appear, the area affected should be burnished flat.

Colored pencils and felt tips

The increase in the range of colored pencils available has been a recent exciting development in the repertoire of the serious draftsman. Not only is the variety of colors most impressive, but the differing compounds used to make up the lead filling have many different characteristics. In general, colored pencils are used to touch in color to an otherwise monochromatic drawing or to describe an object

within a work in its local color. Many contemporary artists have found this to be a good way of working, both in its own right and as a means of making preliminary studies for paintings.

Colored pencils can be exploited in other ways. Several brands have leads which are soluble in water, allowing an extension of effect within any one drawing. A marriage of linear drawing, perhaps with areas of solid color applied with a pencil, will contrast well with areas where the color has been 'melted' by the simple process of spreading it with clean water. It is possible to make complete drawings by this method, washing colors into each other or dissolving colors into white. Colored pencils are easily controlled and for this reason may be particularly useful for the artist who tends to draw in line but occasionally wishes to introduce a little color.

Felt tip pens have water or spirit-based colors saturated into strips of felt. They have become increasingly popular in recent times, particularly among graphic designers and illustrators, mainly because they tend to be brash and strong in color and make a highly contrasted tonal result suitable for reproduction in books and magazines.

This very advantage to the commercial artist is the reason for some reticence on the part of painters and fine artists. Using these pens, it is difficult to make subtle variations in color or to achieve the finely modulated tonal suggestions that are possible with other media. However, these characteristics have their own potential – strength, high contrast and directness are often the ingredients of high drama in a drawing. Some uses of these pens are particularly worth investigating, for example in association with other media or for staining paper to cut areas into a collage.

Erasers
Traditional burnishers comprised a handle, not unlike a brush or pen handle, with a piece of agate or other semi-precious stone attached to one end. This nodule of

Colored pencils 1. Small dashes of different colors are overlaid and blended together to make a graded tone.

2. A soft, water soluble pencil can be used to make an even layer of grainy tone which melts into a second color.

3. Heavily cross-hatched lines made with watercolor pencil are softened by washing over the top with a clean, wet brush.

4. On toned paper, a good effect of solidity can be achieved; work a shape in black and highlight with white pencil.

Felt tips 1. An intriguing pointillist technique is composed simply of random dots of color.

2. A blurred effect can be achieved by drawing through a piece of tissue paper onto your chosen support.

3. A transparent wash laid over water-based ink from a felt tip causes color to spread in a cloudy pool.

4. On thin paper, spirit based pens saturate the surface with color. Broad felt tips were used to draw heavy stripes.

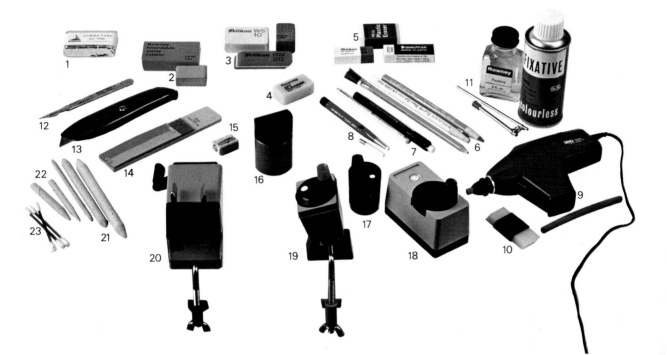

stone was rounded and smooth and was used across the surface in a caressing, gentle rubbing, followed by firmer, stronger strokes to polish the surface. If such an implement is not available then many other things make excellent substitutes. A softly rounded plastic object, for instance, or the grease-free back of the fingernail will burnish satisfactorily.

Erasers can be exploited in unconventional roles. Before the rubber as we know it today was in common use, a piece of bread worked between the fingers, or even a feather, was often used to remove pencil and chalk marks. Rubber itself proved to be more effective than the bread. Nowadays, by-products of the oilfields are used to make synthetic erasers and they come in a number of sizes and textures.

Hard gum-like sticks can be used to pick out faults among otherwise acceptable work, while softer rubbers can erase a larger area without damaging the paper surface. The putty, or kneaded, rubber is used in the positive/ negative technique recommended for charcoal. Although the rubber becomes dirty with this technique, experience shows that a little manipulation in the fingers cleans it quite effectively and it can be used again and again before finally becoming impregnated with charcoal dust.

Equipment Erasers are now made in a variety of forms to suit the demands of different drawing media. A bread rubber **(1)** was the earliest type, largely superceded now by kneadable putty rubbers **(2)**, which can be used in a solid mass or drawn into a pointed shape for greater precision. Soft rubbers **(3)** come in a number of shapes and sizes and the art eraser **(4)** is specially composed to have non-smudging properties. Plastic rubbers **(5)** give a clean, sharp edge and are suitable for erasing pencil, ink and graphite. Eraser pencils **(6)** and cores **(7)** can be used with accuracy and fibrasor **(8)** will rub out drawing ink, which is often difficult to correct. An electric eraser **(9)** is also marketed and the core in this can be changed to suit work in ink or pencil. An ink eraser made particularly for designers **(10)** may be found to have a use in a drawing studio. Fixative **(11)** is vital for

protecting work in pencil, pastel, charcoal or chalk. Aerosol cans are quite expensive but may be more convenient than a mouthspray. A scalpel **(12)** or general purpose knife **(13)** may be useful for sharpening pencils and crayons and will also come in handy in work incorporating collage. A glasspaper block **(14)** refines the point of a pencil and also sharpens charcoal sticks. There are many different types of pencil sharpeners from the most simple **(15,16)** to clutch models **(17,18)** which hold the pencil steady and for studio work a table sharpener **(19, 20)** fixed to the worktop can be a convenient device. Stumps **(21)** are resistant sticks which are used to spread chalk, charcoal or pastel when shading a broad area and torchons, or tortillons, **(22)** made of heavy rolled paper, serve the same function. Cotton buds **(23)** can also be used but are less precise.

PAPER

Paper is often the critical factor in a drawing and this is true no matter what the chosen medium. Although not the only support available, paper is by far and away the most common, for the good reasons of cheapness and portability. Variations in color, texture, weight and surface make it appealing for most uses.

Hand- or machine-made

The manufacture of paper has been a highly refined skill for centuries and although most is factory-made today, there remains a core of hand-made papers for the use of artists. The raw material for such papers is linen rag which is pulped with some other substances, great care being taken to remove impurities, and is laid out on drying racks. The correct side for drawing use is sized and is easily recognized from the manufacturer's watermark or the texture, the reverse side retaining evidence of the fine mesh upon which it dried.

Drawing papers are made by machine in three types, hot-pressed, not and rough, the texture coarsening in that order. Hot-pressed (or H P) is much used for pencil and for pen, ink and wash: its surface is relatively smooth but not completely so. Not, really 'not hot-pressed', has a more textured surface and a medium tooth very suitable for coarser media such as chalk or soft-leaded pencils. It is excellent for such uses in association with gouache, ink or watercolor washes. Rough is paper with a positively-textured face, especially favoured by watercolorists but also suitable for certain drawing purposes, or for mixed media works. In general the weight or thickness of the paper will increase with the roughness of its surface. This has to be taken into account when stretching paper; heavier papers need more water and take longer to dry out.

Specialist papers

Charcoal paper is a heavy, rough-textured paper usually with a colored finish. With a surface that is not strongly sized, it is good for its advertised purpose, and the crumbly, roughened feel under a charcoal stick is very satisfactory. It does not take kindly to the use of a hard eraser, its surface being easily damaged; the putty (kneaded) rubber comes into its own here.

Pastel papers are available in a wide range of colors, unlike the majority of drawing supports which are usually white, light or at least neutral. The effect created by these colored surfaces can be seen, for example, in the work of Eric Kennington (1888-1960). In these drawings, and others made during World War One, the pastel is used

quickly to model the basic figure or facial forms, contrasting light with dark out of the middle tone of the support. Beginning in this way, the artist gradually fills in other details until evidence of the underlying color is apparently obliterated. In fact it never is, for the whole work will be influenced in its mood by the color of the support; learning how to harness this factor will prove invaluable.

Rice papers are very fragile but are sometimet suitable for work in brush or pencil, often of an exquisite nature. All varieties are highly absorbent if watercolor or ink washes are to be used, but in common with all so-called limitations this can be turned to advantage. The manufacture of these papers differs from that of others; vegetable fibres are chiefly used, resulting in beautiful, refined surfaces.

Some recommended papers, suitable for all drawing media, are Kent turkey mill, Ingres papers (in several colors),

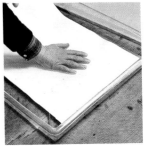

Stretching paper 1. In order to check which is the right side of the paper, hold your paper up to the light; the watermark should read correctly.

2. Soak your piece of paper in a photographic developing tray, basin or bath of clean water. The soaking time depends on the weight and type of paper used.

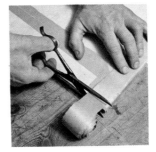

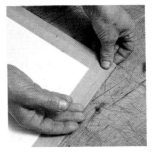

3. Cut lengths of gummed paper tape to the size of each side of the drawing board onto which you are about to stretch your paper.

4. Drain the paper, lay on board and stick tape along one side, then along the opposite side. Tape the other two edges and allow to dry naturally.

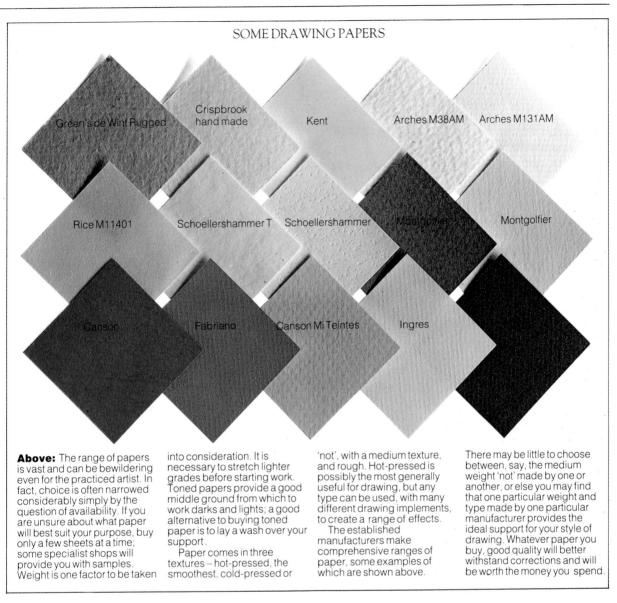

SOME DRAWING PAPERS

Green's de Wint Rugged
Crispbrook hand made
Kent
Arches M38AM
Arches M131AM
Rice M11401
Schoellershammer T
Schoellershammer
Montgolfier
Montgolfier
Canson
Fabriano
Canson Mi Teintes
Ingres

Above: The range of papers is vast and can be bewildering even for the practiced artist. In fact, choice is often narrowed considerably simply by the question of availability. If you are unsure about what paper will best suit your purpose, buy only a few sheets at a time; some specialist shops will provide you with samples. Weight is one factor to be taken into consideration. It is necessary to stretch lighter grades before starting work. Toned papers provide a good middle ground from which to work darks and lights; a good alternative to buying toned paper is to lay a wash over your support.

Paper comes in three textures – hot-pressed, the smoothest, cold-pressed or 'not', with a medium texture, and rough. Hot-pressed is possibly the most generally useful for drawing, but any type can be used, with many different drawing implements, to create a range of effects.

The established manufacturers make comprehensive ranges of paper, some examples of which are shown above.

There may be little to choose between, say, the medium weight 'not' made by one or another, or else you may find that one particular weight and type made by one particular manufacturer provides the ideal support for your style of drawing. Whatever paper you buy, good quality will better withstand corrections and will be worth the money you spend.

Saunders, Fabriano, David Cox and De Wint. Others are available both under manufacturers names and anonymously made as cartridge papers of various qualities.

Boards are on sale in many art stores, their surfaces prepared to make ideal supports for drawings. Many different types are available, usually comprising a sheet of high quality paper firmly attached to a backing board. These are especially convenient for working out of doors and can be put together by the artist himself. Thin paste boards, with surfaces ranging from an ivory smoothness to softer textures, are less stable but both cheaper and very pleasant to use. Experiment until you discover the best combination of paper, board or other support and instrument chosen to trace, score or hatch out the drawing.

Paper stretching

The technique for stretching paper is shown opposite. A thinner sheet of supporting board may be selected, say for reasons of easy transport, and in this case two strips of gummed paper tape should be laid diagonally across the back from corner to corner, crossing in the middle, as a precaution against warping as the paper dries. Special stretching frames are available but these produce a surface similar to stretched canvas, possibly better suited for paint or pastel works. It is possible to stretch paper by using thumb tacks instead of gummed paper; for small pieces this is quite satisfactory, but it is easy to tear the paper. Constant care is needed to guarantee the desired result in all these paper preparations.

WHERE YOU WORK

Drawing requires little cumbersome equipment and is not dependent on an elaborate studio set up. Do not be put off by photographs of major artists posing in spacious, purpose-built studios; an intelligent analysis of real requirements and the best way of utilizing available space will reveal many possibilities.

Indoors

Few drawings are larger than 20 x 30 in (60 x 76 cm) – most much smaller – and even when using acrylic or oil paint the average size of work is likely to be much smaller than might be imagined. By gearing the space available to the likely size of the work to be made in it, sensible solutions can be found.

This does not mean that it is impossible to produce larger pieces. Some artists have worked in an area no more than 10 x 10 ft (3.5 x 3.5 m), managing by using a system of rolling larger works – painting or drawing only one section at a time as they roll up the completed end. The danger with this method is that the essential overall view will be lost, resulting in the picture falling apart visually when seen as a whole. In general, the average requirements should be assessed and space and equipment employed accordingly.

In addition to a bench or easel you will need a small, conveniently situated surface containing your materials. This should be accessible to the working hand so as to avoid the danger of making blots on your work or knocking things over. Simplicity and common sense should be your guidelines, with as little clutter as possible, not only to minimize risks of accidents but also to reduce peripheral 'visual noise'. To this end it is best to have white or neutral walls, with unpatterned curtain material, thus avoiding the distraction of competing colors intruding on the retina.

Light is a vital factor in making images – preferably constant and even and traditionally north light. This last requirement is not essential, and it is sufficient if the window is large and clean enough to admit plenty of whatever light is available. What is more important is the location of the easel in relation to the light source, and making the best use of artificial light when this is necessary. For a right-handed artist, the light should come over his left shoulder, and vice versa, to ensure that no shadow falls across the drawing from the working hand. Artificial light should be similarly positioned. Overhead lighting can be adequate, but it is preferable if the bulb used is color corrected. These bulbs, usually blue in color, are readily

available and are useful in that they allow work to continue after natural light has faded.

Outdoors

When working out of doors the main requirements are compactness and portability. The weight of materials to be carried and the speed with which the working situation can be set up are very important. For these reasons, the sketch book and sketch pad are extremely popular and useful items, often superseding the drawing board and stretched paper which were previously in common use. A wide range of these books and pads is available from good artists' materials stores, in a variety of sizes and surfaces.

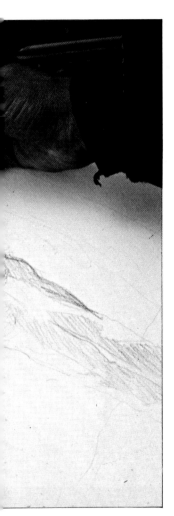

CHECK LIST
Indoor materials
Easel, desk or table
Chosen medium
Erasers
Fixative
Prepared support

Outdoor materials
Portable easel (if required)
Pencils or other drawing
implement
Sketchbook, sketchblock or
paper stretched on drawing
board
Erasers
Fixative

Clothes
Hat (in sunny weather)
Golfing or fishing umbrella
Folding chair or shooting
stick
Waterproof sheet to sit on

Above: There are no hard
and fast rules about the way in
which you should organize
your materials for drawing; so
much depends on the style of
your work and the media you
use. It is, however, essential to
adopt some sort of sensible
system so that you are not held
up by being unable to find a
particular piece of equipment
at a critical moment. Ensure
that you position yourself so
that your working hand neither
smudges completed areas nor
blocks the light from your
support.

Above: Many draftsmen
find that a desk or
table is a perfectly adequate
surface on which to work. It
may, however, be worthwhile
investing in the type of easel
that can be adjusted to several
heights and positions so that
you can work either standing or
sitting; a portable easel is
sometimes useful when
working in the field.

SKETCHBOOK

One of the most interesting aspects of the work of any artist is to be found not perhaps as would be expected in the finished drawings or paintings but in the preliminary attempts and exploratory drawings, in the sketchbooks. Sometimes large, used to record in detail the world as seen and sometimes small, the right size to carry in the pocket and have with you in all situations, a sketchbook of some sort will provide the artist with the opportunity to record, reflect and reminisce.

If you prefer a small, pocket-sized sketchbook, the quality and type of paper should match your intentions. Color notes require a well sized, lightly textured paper while a smoother surface is more suitable if most of your notes are to be made in ballpoint pen. A good quality paper, however, should take any medium adequately and allow you a certain amount of choice.

Some materials are less well adapted to small scale work. Bamboo, pens and oil pastel, for instance, are fairly clumsy tools, ideal for certain tasks but not generally for making rapid notes. It is, as always, up to the individual artist to decide what best suits his purpose; whatever combination of materials is eventually chosen, starting with a ballpoint pen, an HB pencil and a small sketchbook will allow for a surprisingly wide range of possibilities.

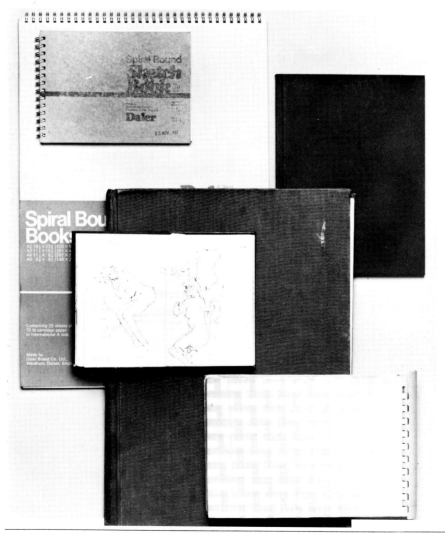

Left: Sketchbooks are available in all types and sizes. Those with a spiral binding are particularly useful, as is the type with tear-off perforated sheets; some come in book form so that it is possible to work right across the spread, or with a little ingenuity you can make a sketch book yourself, to your own specifications. Although a pocket size can be carried easily, not all sketching is done on a small scale.

The medium you choose to make your visual notes depends on personal preference. Color notes can be made with words and often an HB pencil and small notebook provide a practical solution. Ballpoint pens and pentels are permanent, requiring no fixing, whereas charcoal smudges easily; oil pastels and watercolor can be used to block in large areas at great speed. Only experience and practice will enable you to arrive at the ideal solution.

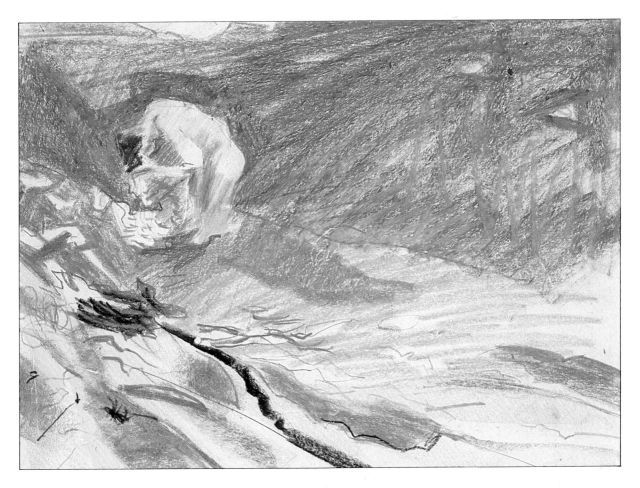

Above: This is a sketch made with a view to a specific finished painting rather than simply a record or a brief note. It attempts to solve some of the problems that will be encountered at a later stage. An artist will often use his sketchbook to try out alternatives, changing the figure size in relation to other features, for instance, or expanding or contracting the foreground areas. Color added to a sketch is a way of enlivening it, and of extending the information if provides and adding to its interest.

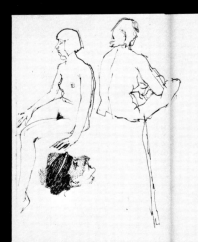

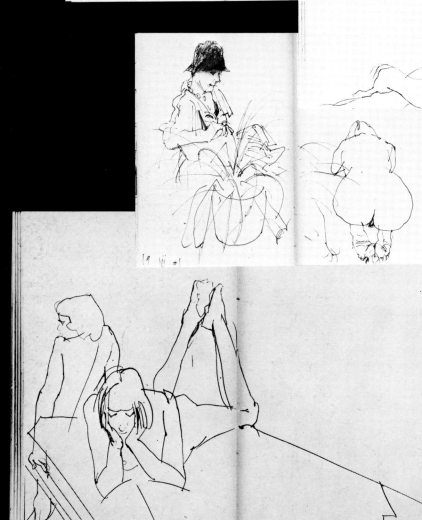

Left: Four open sketchbooks document a course in figure drawing organized for art students. The sketch at the bottom of the page relates to the one on page 49, showing the same poses but from a completely different angle, with dramatically different results. The figures have been drawn with the greatest care and concentration, but much attention has also been given to their position on the page and the relationships between themselves and the furniture, making useful drawings for development into larger works.

Right: This sketchbook drawing contains more information than those opposite, partly because of its larger size. Pencil is used to make tone as well as line and the effect is carefully wrought and assessed. Despite this care, the drawing has been carried out with urgency, to make the most of the fleeting ray of light. An alternative to working fast would be to make a basic overall sketch, with a detailed description of the effect of the light, and to invite the model to sit again at a later date. This would enable the artist to add relevant detail, correct faults and improve technique at a more leisurely pace.

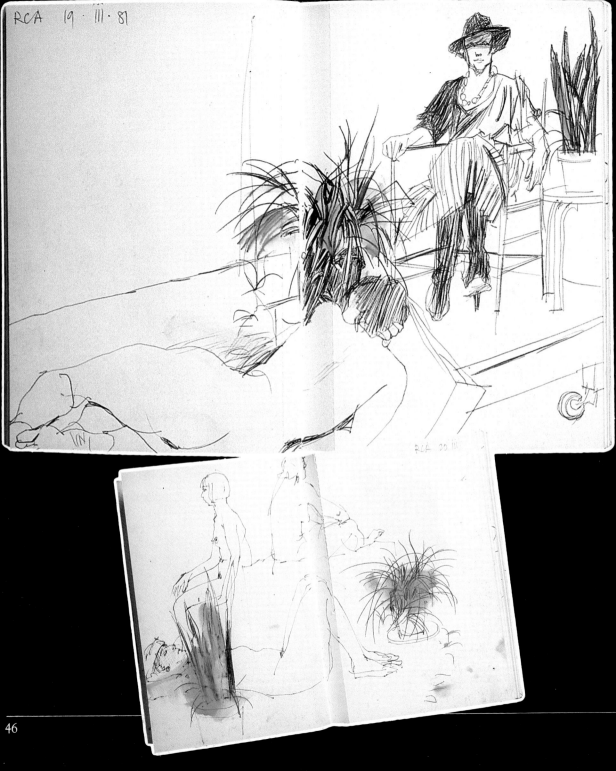

RCA 20 III

Opposite: The addition of local color provides another dimension in these two sketches, used to describe the exotic plants and contrasting with the fine linear drawing of the figure forms. Black can also be used in several ways to add 'color'. In conjunction with the green, it takes on a different quality than when used for the figure forms, and it can be treated as a gray when applied as stippling or hatching. The artist has been concerned with the positions of the figures on the page, placing them so that there is maximum contrast between the horizontal and vertical poses. **Right:** These drawings of a model undressing have been made in a full range of colored pencils. No simple outlines are used; solid areas of local and reflected color are blocked in by means of short, well-controlled strokes. The poses were drawn as they came, the artist seeing himself as a recorder, anchored to one spot and describing the events as they took place, with little choice of angle or viewpoint.

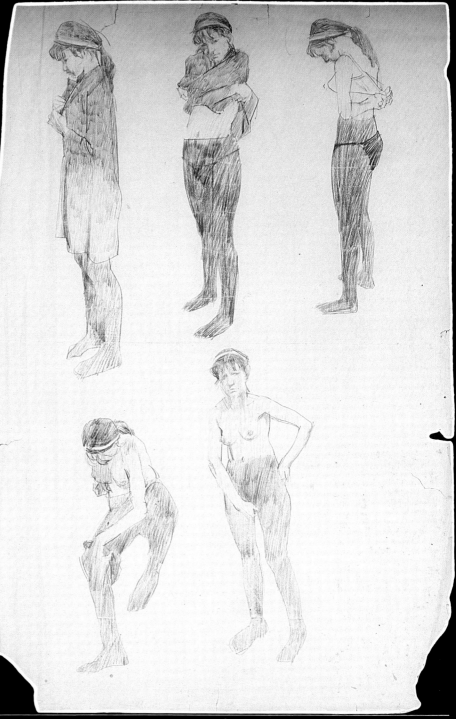

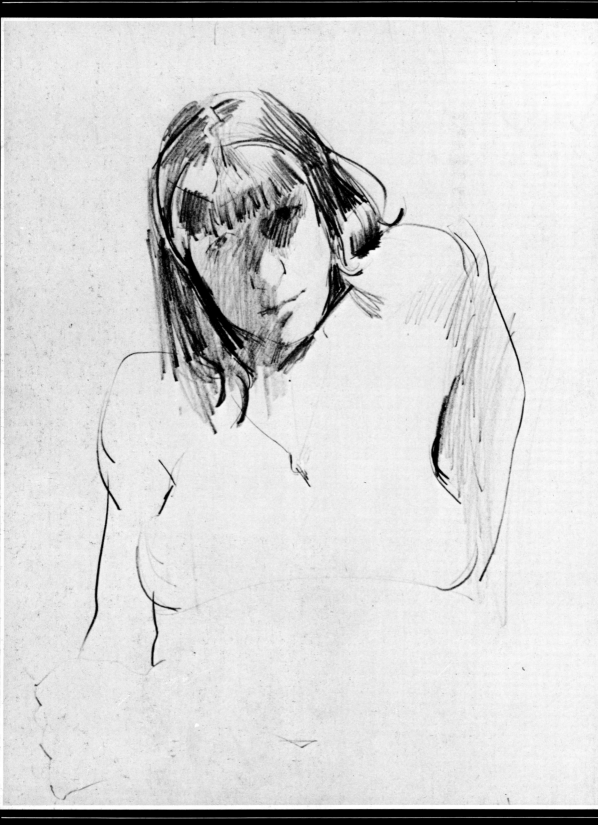

Opposite: When making sketches you plan to use later as the basis of a portrait it is as well to concentrate on the facial features, if necessary at the expense of other details. In this simple pencil sketch the color of the girl's hair has been suggested and the intricacies of the mask given some tonal rendering. As well as these details, the artist has managed to capture the interesting tilt of the shoulders and the contrasting angles of torso and head.

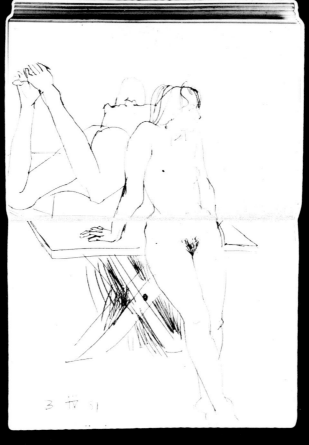

Left: One of the most important aspects of this arrangement of two figures is the difference between the levels of the floor and table top. The artist has made rapid but not perfunctory notes from several angles; when asking models to adopt poses such as that of the girl lying on the table it is necessary to work quickly or else allow your sitter plenty of rests.

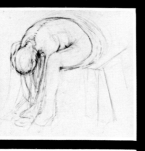

The great value of a sketchbook is indicated here by a number of examples which show different approaches to various subjects. The detailed botanical study (**above**) has been given the care usually saved for full scale works and thus presents an extremely useful record of the form and color of the plant. Obviously, materials for sketchbook work must be easily portable and an adequate range of colored pencils greatly increases the scope of drawings, if carried in addition to a pencil, fibre tip or ballpoint pen. By contrast, the calligraphic representation of an elegant nude model (**right below**) is sparing in technique but captures the main elements of the form. A small pencil sketch of a bent figure (**right above**) examines the outline again and again, producing a delicate network of lines from which the form emerges. The memory of a briefly seen episode is rapidly delineated (**far right**) in a visual note made with a ballpoint pen. To transpose such a view within the small area of paper requires careful attention to scale and the figures are convincingly held between the tall trees in the foreground and the swelling

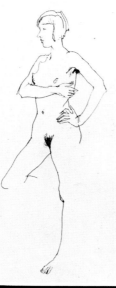

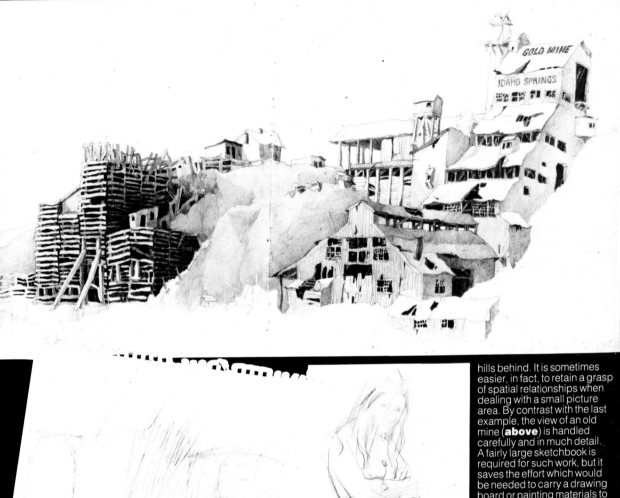

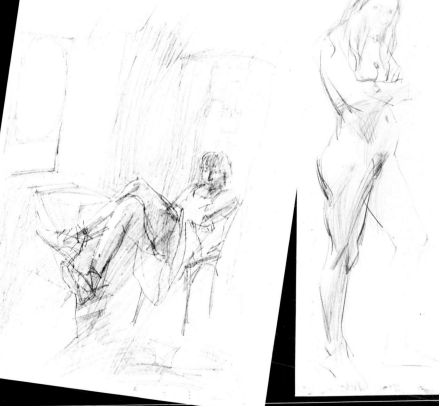

hills behind. It is sometimes easier, in fact, to retain a grasp of spatial relationships when dealing with a small picture area. By contrast with the last example, the view of an old mine (**above**) is handled carefully and in much detail. A fairly large sketchbook is required for such work, but it saves the effort which would be needed to carry a drawing board or painting materials to the spot and set up to work on a finished drawing or painting. All the information is here and can be used as reference for studio work. Two figure studies (**left**) offer alternative approaches to the subject. One is a swift, straightforward record of a pose, which catches the stance and the way the body weight is distributed. The second (**far left**) sets a mood and a brief impression of the environment, with tones applied in vigorously scribbled hatching. Detail is added to the figure with emphatic linear definition.

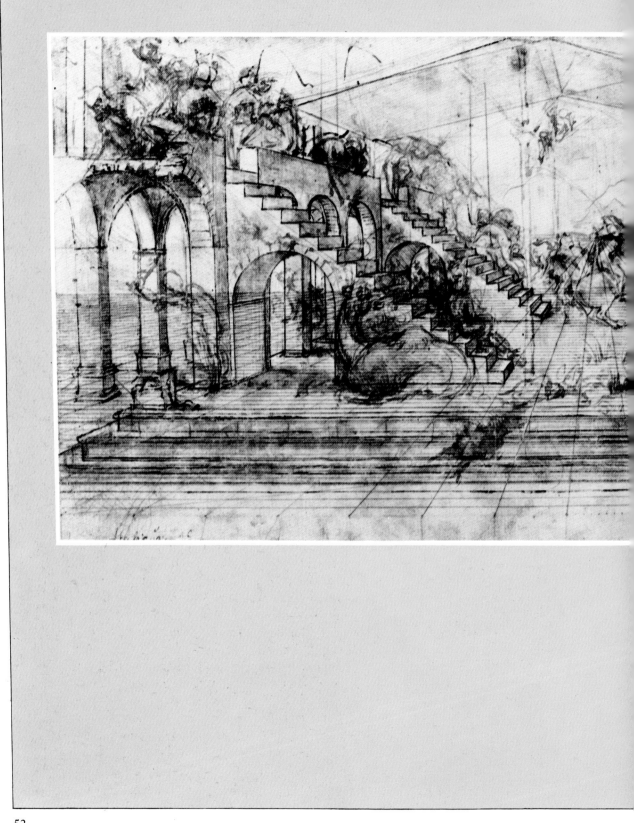

CHAPTER THREE

BASIC TENETS

THIS CHAPTER COVERS complex subjects in a way which will seem either daunting or insufficiently detailed, depending on how much practical work you have carried out already and how much, if any, further reading you have done. The theories of composition and perspective and the study of human anatomy have been a lifetime's work for some artists, while others have been unaware of their existence yet have produced excellent drawings. It is probably true to say, however, that many of the great works of art that appear to ignore the theories are the result of a deliberate turning away from rather than ignorance of these complex topics.

Any aspiring artist is well advised to try to come to terms with as much theory as possible. By looking at reproductions in books and visiting galleries you will be able to compare the ways in which various artists have dealt with problems of composition and perspective. Perhaps the most useful method, however, of learning about these subjects is through your own work. By setting yourself exercises and trying to complete them in the light of what you have read and observed you will gradually acquire greater understanding and be able to put this to practical use.

Above: Perspective is one of the main aspects of the theory of drawing to have preoccupied artists over the centuries. Leonardo da Vinci's *Perspective Study* provides an example of the way in which a strong and basically simple perspective space can be used as a three-dimensional stage in which to introduce living and moving beings.

COMPOSITION

Before starting your painting you must consider how to devise a visually interesting picture and to arrange color, shape and lines on your support in a way that will best suit your purpose. This is the essence of composition. Different objects and parts of your picture must be related to each other; if your composition is poor you will fail to convey the meaning and thought behind your work. Theories have been evolved over the centuries, but the reading and understanding of these theories is no substitute for practice.

Many paintings are based on the arrangement of geometric shapes such as triangles, circles and squares. Some have strong linear compositions, both vertically and horizontally; vertical lines give a feeling of stability and

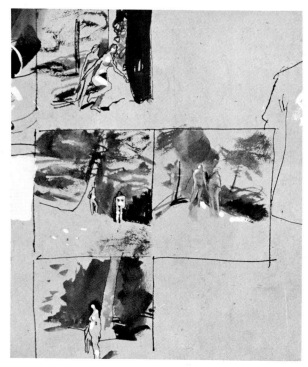

peace while horizontal lines tend to convey dignity. This is necessarily an oversimplified analysis and it is essential to try to analyze more complicated structures by looking at as many paintings as possible and understanding their design.

The mathematical approach
Mathematics has made a major contribution to the compositional theories of art. The Egyptians used it first and later the medieval master builders of cathedrals based their work on intricate mathematical theories. The Greeks devised several ideal standards, the most well known of which is the Golden Section. Evolved by Euclid, it was thought to divide the picture plane into a perfect proportion of natural balance and symmetry. Although it can be worked out mathematically, most people have an intuitive feeling for it and its harmony is a recurring concept.

Turner's *Norham Castle* is a fine example of the use of the Golden Section. Piero della Francesca (1410/20-92) is another artist who was deeply interested in mathematical structure, although his paintings have a quiet beauty and inner harmony which bely their complexity. More recently, Modigliani (1884-1920) was also concerned with the arrangement of geometrical forms.

Before you start
When about to embark on a painting, be certain that you have looked at it from every angle. The rearrangement of a still life, for instance, may make an enormous difference, and small thumbnail sketches will help you to remember any previous arrangements which you may have though more suitable. When considering a landscape, the placing of the horizon line is important. Consider the difference between a bird's eye view and that of a worm, and all the variations in between; thumbnail sketches are again very useful in helping you decide

Scale is another important factor, not only in giving clues about perspective and depth but also in determining the compositional impact of your painting. Difference in scale can heighten dramatic interest, a small, single figure conveying loneliness and isolation and a close-up view of a face giving a feeling either of intrusion or intimacy.

Some artists cut a hole in a thick piece of card of the same proportions as their support and use it as a viewfinder, as in a camera. It is possible to view a still life or landscape through this hole, considering a variety of proportions and viewpoints. Generally speaking, it is better not to place your main object of interest right in the center of your picture plane.

Above: To a certain extent, arriving at a successful composition is a matter of trial and error, it being necessary to try out a number of different groupings of objects and figures before you arrive at the best solution. Small thumbnail sketches are a useful aid, whether you are considering a still life, landscape or group of figures. The examples above show sketches of female nudes in various poses and against slightly differing backgrounds; they form the basis on which the artist will decide on the best composition for his finished painting.

LONG-STANDING THEORIES

Right: Piero della Francesca was a 15th century Italian artist as interested in mathematics as he was in painting pictures; the complicated compositional structures he used, however, do not detract from the beauty of the paintings. The triangle was the geometric base from which he worked (**center right**); following this principle, many other triangles can be discovered (**far right**).

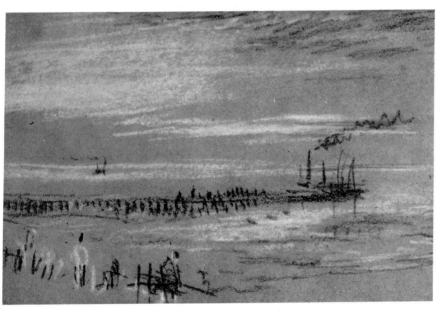

Left: The requirements of the Golden Section are fulfilled by this pastel sketch from the notebooks of J.M.W. Turner. It was on this theory of the Golden Section that the Greeks based their definition of perfect proportion. By this mathematical formula a line is divided so that the smaller part is to the larger as the larger is to the whole (**see below**). The Golden Section was held to have a natural balance and symmetry; ever since its inception geometry has played an important part in painting and drawing. In Turner's sketch the horizontal line of the jetty and the verticals at its far end conform to the ideal positions described below.

The Golden Section
Ascribed to Euclid, this rule was held by the Greeks to be the ideal division of a surface. To find the section, divide the line AB in half at C;

draw a radius from the top right hand corner of the cube to create D. In the drawing second right, lines have been drawn to create a rectangle, point BG forming

the vertical section. To find the horizontal section (**far right**) draw a line from the top of the vertical G to the bottom right hand corner and a radius from the top right

hand corner downward; the line and arc intersect at the level of the horizontal section.

PROPORTIONS OF THE HUMAN FIGURE

The average human figure is six-and-a-half-to-seven head-lengths tall. There are of course variations on this, but in general, this is the rule. In art, however, the extremes are much wider and are always dependent upon the artist's prowess and the piece of work in progress.

Distortion

In child art, as in much primitive work, the facial features are most important and therefore the head tends to dominate the figure; often it occupies a quarter of the overall size, which allows plenty of space to delineate features. In Egyptian art there was little apparent variation in proportion over three thousand years, whereas in European painting and sculpture from the pre-Renaissance to modern times the true proportion has been bent and adjusted to create, in turn, a sense of nobility, dignity, humor and movement. In extreme cases, such as in the paintings of El Greco (1541-1614), the figures are attenuated to twelve head-lengths tall. The sculptures of Giacometti (1901-66) are similarly long and thin, containing a kind of condensed power that seems to enliven the air around them.

Michelangelo's famous saying, 'The highest aim for art is man', reflects the exciting changes that took place during the 15th and 16th centuries, in the Age of Humanism. No longer was the human body merely a shell containing the immortal soul; now it became a beautiful machine of infinite subtlety and potential for artists' interpretations. The scientist-artists Leonardo da Vinci (1452-1519) and Michelangelo (1475-1564) blazed the trail alongside others in 15th- and 16th-century Florence,

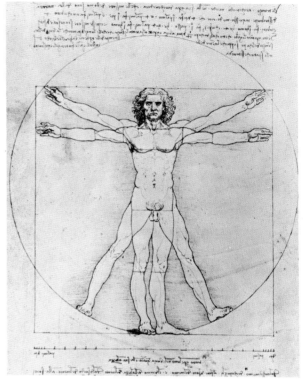

Above: Leonardo's *Study of Human Proportions* describes the navel as the center of the body; from this center a circle touches the outstretched fingers and toes of a man lying on his back. The distance between a man's outstretched fingers is about the same as that between the crown of his head and soles of his feet.

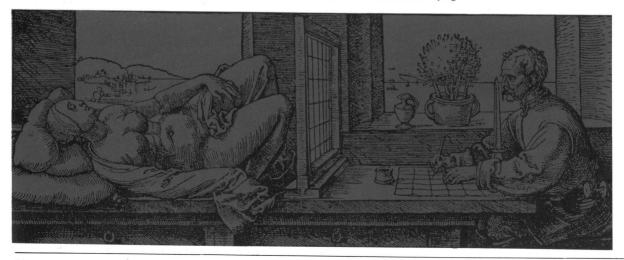

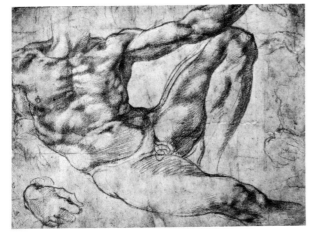

Albrecht Dürer went to the length of setting up a grid (**opposite below**), placing a vertical frame between the subject and artist and drawing the grid to scale on the support. He also studied the proportions of the human figure and the relationships between the different parts of the body (**below**), examining how these change if, for example, the figure is bending to one side. Michelangelo's study for the creation of Adam on the roof of the Sistine Chapel (**above**) is a prime example of the use to which he put his accurate knowledge of human anatomy; the stress on the musculature creates an almost super-human effect.

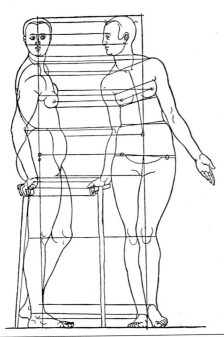

gaining accurate knowledge of human anatomy by means of dissection and analysis. This information they then used in their various ways to create godlike men in paintings and sculpture. The proportions of the figures on the Sistine Chapel ceiling, however, bear little relation to the prosaic truth; rather they are poetic interpretations.

By distorting the relative scale of features Michelangelo puts stress on the musculature, creating figures of gigantic proportions. When making monumental sculpture, such adjustments to normal proportions are common, indeed in some cases they are essential to create the required sense of grandeur. One modern equivalent of this is the way in which a fashion illustration will distort the figure in order to emphasize the elegance of the clothes. But in spite of the major obligations laid upon artists to meet the demands of their day, there are certain fundamentals of proportion that remain constant.

Basic measuring

Taking as a basic proposition that six-and-a-half-to-seven head-lengths is the average, this distance can be divided into separate parts. From the top of the head to the pubis, just above the crotch, will be half the length of the total figure. When beginning a drawing of the standing figure this formula is very useful; ticking off the distance between these points and then doubling it will make it obvious whether the full figure will fit on the sheet of paper.

In such an operation, however, the rule of thumb should operate. Avoid using a measuring device such as a ruler or other precision instrument. Never be a slave to the rules; the essence of good drawings is spontaneity and invention. Each artist decides and develops his own character and this includes selection and adjustment of human proportion.

Text books, whether by old masters or modern artists, should be used as a means by which knowledge can be acquired rather than slavishly copied. Theories are intriguing but can become a straitjacket if not absorbed into the blood-stream and reconstituted intuitively merely as a part of the language used.

Historical systems

The historically accepted tenets of human proportion are exemplified in the works of Leonardo, Richter and Dürer. Each made firm rules with carefully calculated mathematical divisions, often going to great lengths to divide every single feature, almost down to the fingernails!

Leonardo makes his man eight head-lengths tall and employs four concentric circles, each one head height

Right: In terms of proportion, no two bodies are exactly the same, but in general the human body divides into eight equal sections. The distance from the crown of the head to the chin is one eighth of the height of the whole body, and the navel about five eighths of the height of the whole body. As far as the horizontal measurements are concerned, from the outstretched fingertips of the left hand to those of the right hand is about the same distance as that from the crown of the head to the soles of the feet. When practicing figure drawing, it is a good idea to start by working within this sort of grid as a means of ensuring that you do not stray too far from the norm (**opposite**). Remember, though, that these rules are guides and no more; you should always be influenced by your own eye and perception.

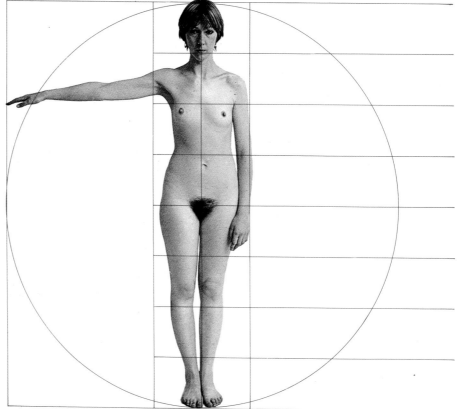

apart. Annotating another explanatory diagram he says, 'The span of a man's outstretched arms is equal to his height'. Dürer's theses have the same basis, but he developed them in far greater detail, describing a circle, for instance, that has the sterno-clavicular joint (the space between the collar bones) as centre and the circumference of which passes through the eyes and nipples. Other such refinements abound in the fascinating works of this great artist. Often the proportions are arrived at in the most complicated of ways, giving the impression that these became personal essays in dispensing unnecessary detail. At the time, no doubt, such information was used by young artists and amateurs, the rules taken as absolutes, but today we would find them stultifying if used to excess. Richter makes his figure seven-and-a-half heads tall, arms are three-and-a-half, legs four, hands just a little less than a head-length. The eyes are just about half way down the length of the head.

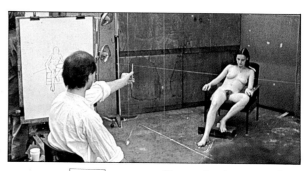

Above: Another means of measuring is by using your pencil and an outstretched arm. Holding your pencil at arm's length and closing one eye so as to avoid double vision, move your thumb up and down the pencil so that the proportions can be measured and the figure drawn to scale.

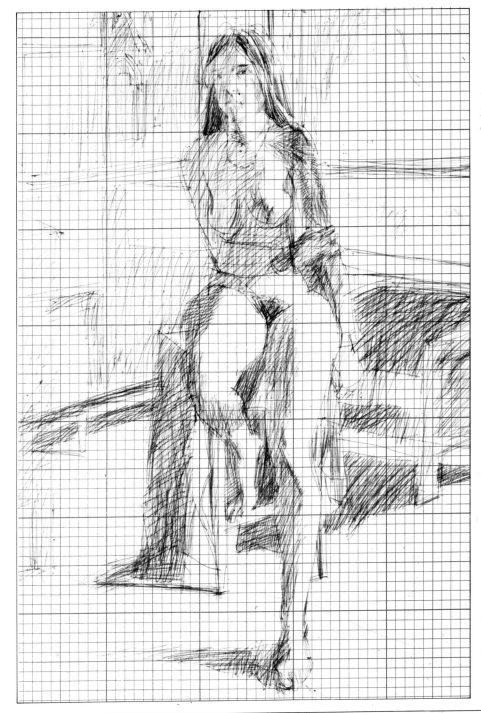

A grid is extremely helpful in assessing the relative size of various parts of the body on the picture plane. Establish one important point and use this as a reference; trail the pencil horizontally across the support until it coincides with another feature, and let the pencil trace a vertical line down from both these until they, in turn, meet other features.

HUMAN ANATOMY

Anatomical knowledge is based firmly on an understanding of proportion. It should not dominate your work, but an awareness of basic structure and proportion is a firm grounding for figure and portrait drawings. When working from a moving model, for instance, or making sketches in a café or theatre, occasions when speed of execution is essential, a well-seated understanding of basic rules will pay dividends. With experience and intelligence this theoretical knowledge will become almost instinctive, conditioning every line and smudge but without ever emerging to lay claim to the work, thus making it stilted and predictable rather than fresh and original in approach.

The basic structure

Some artists have based their work virtually exclusively on the human figure and have studied human anatomy in detail. For general purposes, however, this is unnecessary. A sound overall knowledge of basic anatomical structure will suffice, beginning with a study of the skeleton.

The three main masses of the figure are the ribcage, the pelvis and the head. All of these are connected by the

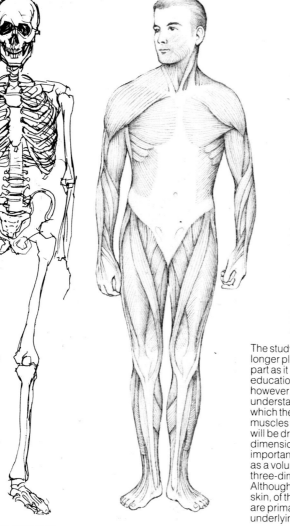

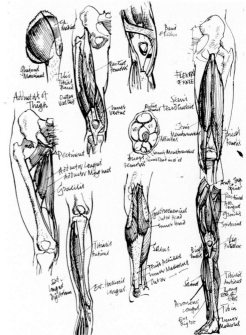

The study of anatomy no longer plays such an important part as it used to in formal art education. It is still necessary, however, to acquire an understanding of the way in which the skeleton and muscles are put together. You will be drawing on a two-dimensional surface, but it is important to think of the figure as a volume occupying three-dimensional space. Although it is the surface, or skin, of the figure of which you are primarily aware, it is the underlying structure of muscles and skeleton which are really responsible for the image you see. They create the figure's solidity, and it is depicting this solidity with which you will be concerned. By studying a good set of anatomical illustrations while looking at your model you will be able to see more clearly how the body is structured beneath its surface skin. Look at your model in different poses and try to work out how the positions of the muscles have altered, and at how they tense and relax in pairs.

spine, a column in the axis of the body comprising discs of bone alternating with discs of cartilage. The spine determines the limits of movement of the various elements of the body. The shape of the ribcage offers protection to the vital organs it contains. Similarly the pelvis has two large ring-like bones which protect internal organs – in this case the gut or large intestine. The pelvis also has attached to it, by sinews, the muscles of the torso and the thighs and legs, and it acts as the pivoting point for both sets. The head comprises two bones; the cranium, forming the largest part, and the mandible or lower jaw.

As well as knowledge of the basic structure of the skeleton, awareness of the functions of the muscle groups and their individual components is also essential. Simple logic suggests that extensors and flexors operate precisely as their names suggest. By lifting, stretching, contracting, they operate separately and in groups to make possible an infinitely variable range of actions. The muscular links between the bones can be thought of as generally arranged in opposing groups. One set of muscles relaxes in order to release energy, while the other clenches or contracts and therefore hinges up interrelating bones.

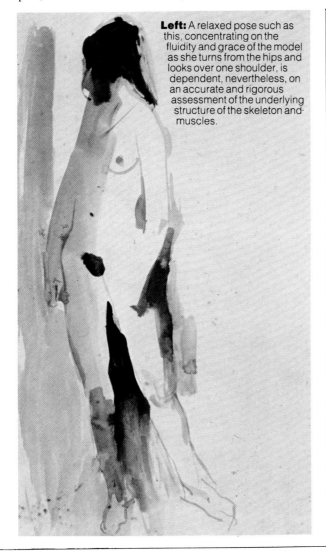

Left: A relaxed pose such as this, concentrating on the fluidity and grace of the model as she turns from the hips and looks over one shoulder, is dependent, nevertheless, on an accurate and rigorous assessment of the underlying structure of the skeleton and muscles.

MALE/FEMALE BODY SHAPES

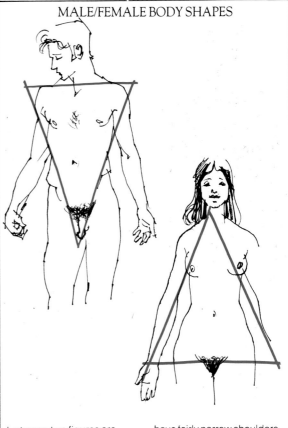

Just as no two figures are alike, neither do all male and female figures conform to the norm. In general, though, the structure of the female figure can be based on the shape of a triangle and that of the male on this triangle inverted. Women tend to have fairly narrow shoulders, spreading outward toward the hips in the classic bottom-heavy pear shape; men, on the other hand, usually have broader shoulders than hips.

PERSPECTIVE

There are a number alternative ways of perceiving and depicting space. The Chinese, for example, often used a reversal of western perspective, making parallel lines widen instead of converging onto the horizon line. Similarly, people or objects of importance were given status by increasing their size, and surrounding objects of lesser importance were overlapped to indicate that they were placed either in front of or behind each other on the picture plane.

Other civilizations or modes of painting have similarly displayed what may seem to western eyes to be naiveté where spatial relationships and the rules of perspective occur. Perspective was never used at the expense of the narrative with which the painter was concerned. Early Christian religious works were visual stories for the illiter-

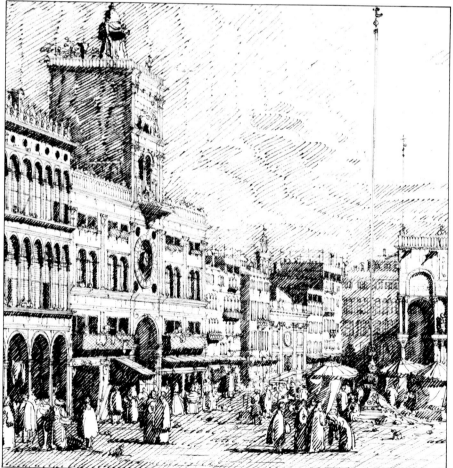

Over the centuries, artists have used widely differing conventions of perspective. In *St Ives Harbour* by Alfred Wallis (**above**) it appears as though the boats in the harbor are being viewed from above while the ships at sea are in varying scales. Chinese painting tended to make the more important figures larger than any others (**below**). The 18th-century Venetian artist Canaletto was an expert in the use of realistic linear perspective, as exemplified in *The North East Corner of Piazza San Marco* (**left**).

FIGURE PERSPECTIVE

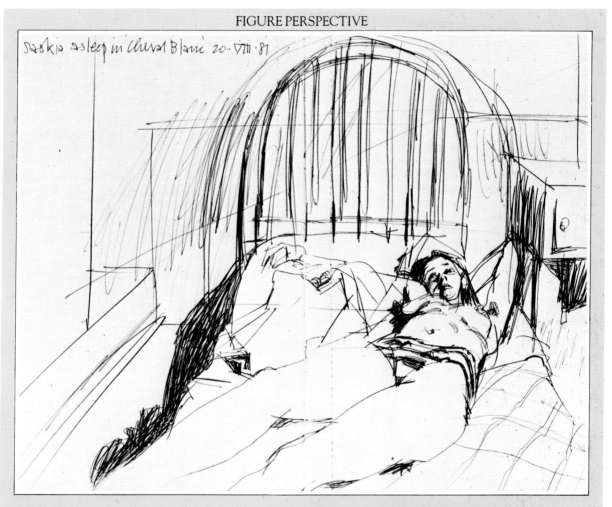

Saskia asleep in Cheval Blanc 20· VIII · 81

An understanding of perspective is essential if certain of the pitfalls of figure drawing are to be avoided. Work at a distance from your model that enables you to encompass the whole of the figure at one glance, so avoiding the optical distortions that arise if you are too close to head or feet. While you are still a beginner it is easier to make a properly proportioned figure if the feet, head, hips, breasts, hands and other parts of the body are all at the same distance from your viewpoint.

Within the figure, symmetry happily lends itself to a simple perspective structure, parallel features such as eyes, ears and nipples making it easy to relate one to the other spatially.

By the principles of foreshortening, objects closer to the eye appear greater in size than those at a distance. The creative use of this distortion can be incorporated into a drawing, although in the case of extreme foreshortening, when the figure is seen from very close either to the head or the feet as (**above**), there are many problems of perspective. We are familiar with the normal proportions of the adult and it can be difficult, under different circumstances, to make convincing the relationships of the various parts. It is necessary to measure carefully in the traditional way, by holding the pencil at arm's length and squinting.

The parts of the body nearest to the artist will appear much bigger than those furthest away, so that in this drawing of a girl on a bed the feet appear to be disproportionately large in comparison with the rest of the body.

ate, and the symbolic and narrative simplicity was far more important than visual correctness. A glance at these pictures will show that a work of art need not be geometrically correct. If you are preoccupied with the conventional rules of perspective they will become very restricting.

The conventional western system

Our eyes have become used to the system of linear perspective used by western artists for five hundred years. It was probably pioneered by Brunelleschi (1377-1445), the great Florentine architect and mathematician. Architectural studies were carried out with the same exactitude; the townscapes of Canaletto are good examples of the study of perspective and it is well worth examining them. These early studies, though, must be seen in the same spirit as that in which they were carried out – and any attempts to copy their methods should be seen as such.

The conventional rules of perspective exist to make the space which stretches out before us more plausible when seen in terms of a hypothetical space on the vertical picture plane. They must never become the overriding factor in a

drawing unless carried out as an exercise. All rules were meant to be broken, and many masters of perspective have used them to their own advantage. The plausibility of your drawing is not the only consideration; the aesthetic and visual aspects are also important.

By no means the only method of depicting an object on a flat surface, the western system has a vivid spatial illusion that has proved suitable for picture-making no matter how complicated the intention. The principles of perspective had already been laid down by Euclid in his *Optics* in about 300 BC, but not until the experiments in Florence in the 15th century did the artist devise a system suitable for his uses. Uccello (1396/7-1475) took the laws and discoveries made by Brunelleschi to great depths, displaying the thoroughness and excitement with which these Renaissance artists carried out their new-found ideas.

Basic principles

The ground on which the artist stands is known as the ground plane. His eye level will depend on its relation to the ground, in other words on whether he is standing or sitting. His perspective of the subject he is drawing will

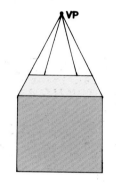

Two-point perspective
Here, three planes of the cube are visible, the top and two of the sides, so there are two sets of receding parallel lines and two vanishing points. The photograph of a street corner

(**bottom**) is a good example of two-point perspective, the two sets of lines from the top of the building and the sidewalk converging at two vanishing points.

One-point perspective
As above, only two faces of an object are visible and there is one vanishing point. A good example of a single vanishing point is provided by the photograph **above right**. The parallel lines of the sides of the road appear to converge at a point on the horizon.

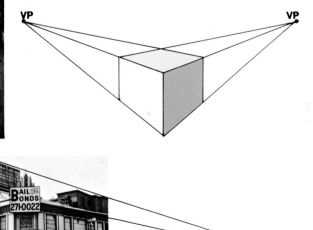

depend on its relationship to his eye level, on whether he is looking at the object from above, below or the same level, and on the angle at which it is placed.

The centre line of vision is an imaginary perpendicular line which is drawn from the artist's position to the horizon line, meeting it at right angles. If the artist is facing his subject full on then all lines which move away from him will appear to converge at the point on the horizon line where his centre of vision strikes it. This is the most simple form of perspective, known as one point perspective.

In fact, we normally look at objects from an oblique angle rather than straight on and one point perspective will only occur if, for example, we are standing in the centre of a road or railway track. Objects which show three or more planes will have two vanishing points, and if we look down or up to objects, parallel lines will converge on two vanishing points on the horizon line with a third establishing itself either above or below. Objects placed at differing oblique angles to the picture plane will have differing vanishing points.

When dealing with perspective, the most important aspect is establishing the horizon line. Without this there is no line upon which to place the vanishing points. In some extreme cases – if you are looking at an object almost directly from above or below – your horizon line might well be off the paper you are drawing on. The field of vision should also be established. This extends to about 180° but within this field clear vision is possible only within a range of between 30° and 60°. This narrow area of clear vision is known as the cone of vision and it will dictate the subject matter that can be included in your picture; to see clearly beyond the range of your cone of vision you will have to

Below: In this photograph the highest points of the building are viewed from well below, creating a third vanishing point where the vertical lines converge.

Three-point perspective
Three planes of the cube are again visible but there are three and not two sets of converging lines and three vanishing points. This happens either when the cube is viewed from very far above, as in the diagram **top right**, or from far below (**right**) so that the vertical lines also converge.

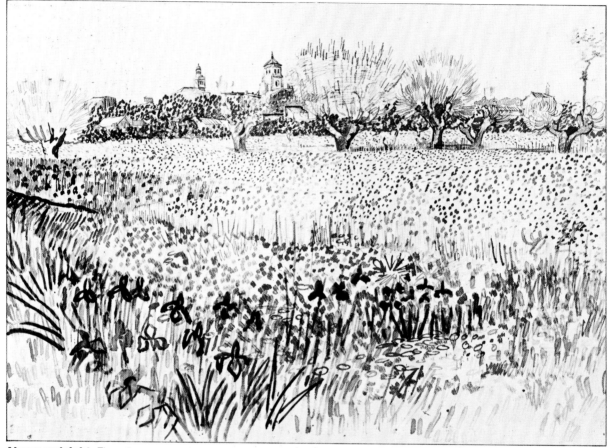

Above and right: These two works provide ample evidence of the fact that atmospheric perspective can be conveyed by methods other than that of varying colors. Without this means at his disposal, Van Gogh has nevertheless succeeded in creating an impression of depth in his pen and ink landscape drawing *View of Arles*. Similarly in *British Birds*, Thomas Bewick manages to suggest an increasing haziness as the background landscape recedes. He has engraved the bird with as full a range of tone as possible, but devised a method of achieving a much lighter tone for its surroundings.

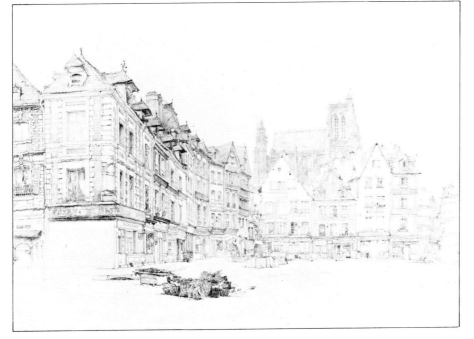

Left: Ruskin's drawing of the *Market Place, Abbeville* employs a combination of the accurate linear perspective of, for example, Canaletto to depict the foreground buildings and the blurring of the more distant buildings which is one of the devices and conventions of atmospheric perspective.

turn your head, thus altering your centre of vision and changing your perspective.

Aerial, or atmospheric, perspective

This type of perspective increases the illusion of depth by concentrating on the atmospheric conditions which intervene between the observer and the subject. The basic idea is that objects which are close up will retain their full color and tonal values and be clearly identified while distant objects will have their tones modified by the atmosphere.

In the time of Pieter Breughel (c. 1525/30-69), and during the 17th and 18th centuries, the suggestion of receding tracts of land or sea within a picture was achieved by means of a well-established formula. By the use of strongly contrasted tones in the foreground (usually browns), through bright green in middle distance and progressively paling blues in the far distance, the eye was encouraged to travel back and long distances could in this way be suggested. J. M. W. Turner (1775-1851) followed this method in a great many of his paintings and by this time the conventions for conveying distance were less rigid.

Although easier to suggest in paint with the benefit of a full color range, aerial perspective is nonetheless important to drawing too. Vincent Van Gogh (1853-90) made pen and ink drawings in which he employed a great range of marks – dots, dashes, strokes and lines – strong in pressure in the foreground and more delicate in the background. This variety expresses the feeling of travelling back into the distance. The wood engravings of Thomas Bewick (1753-1828) use a cunning device to suggest this 'blueing' of tones as they recede.

With only black on white available, engravings have a great deal in common with monochrome drawing and the problems encountered in making them. Bewick engraved the major elements of his design – usually a bird or an animal – with the full, rich tonal range of his medium. The related landscape context for his creature would be engraved with finer gravers and the surface of the wood would be very slightly lowered so that when spread with black ink and passed through a press, less pressure would be applied to these parts, resulting in a lighter tone.

Ingres (1780-1867) made pencil portraits in which textures and details are rendered with great fidelity in the subject figure or figures but the backgrounds are limited to relatively simple linear suggestions of buildings or interiors. This system works well, as do similar but more tonally complete drawings such as those made by Edgar Degas (1834-1917) or R. B. Kitaj (b. 1932).

LIGHT AND TONE

All types of drawing require an understanding of relative tone and the distinction between tone and shadow. In figure drawing the use of tone is particularly important, for when elaboration is required – for example into a portrait likeness or to describe fur collars or other textures – it is likely that purely linear solutions will prove inadequate.

Tone is dependent upon light; it is in effect the other side of the light area of a solid form. Examine a sphere with one source of light, in other words a stream or flood of light coming from one direction only, and observe through half shut eyes. This method of analyzing tonal values is very useful, for by narrowing the eyes in this fashion the relationship between darks and lights is heightened; with half tones, mid-grays to light grays for example, it proves essential.

The sphere sits on a flat surface, lit from one side. Apart from the shadow cast from it onto the supporting surface, a full range of tonal contrasts will be apparent within itself, from the area closest to the light source to the darker parts turned furthest away. This is the basis of understanding relative tone and its use in describing solid forms with

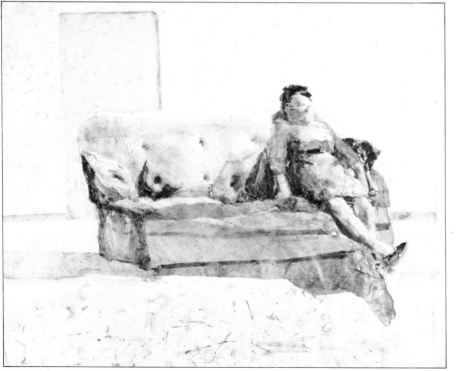

A combination of drawing and collage is used here to make a richly textured tonal image. Tracing paper is the basic material and the artist applies pencil (**above**) to create various tones. The paper is then torn or cut into pieces which are glued to a full sheet of cartridge paper (**top**) to build up the image. The effect is subtle and rewarding and is here applied to a simple but extremely well judged composition.

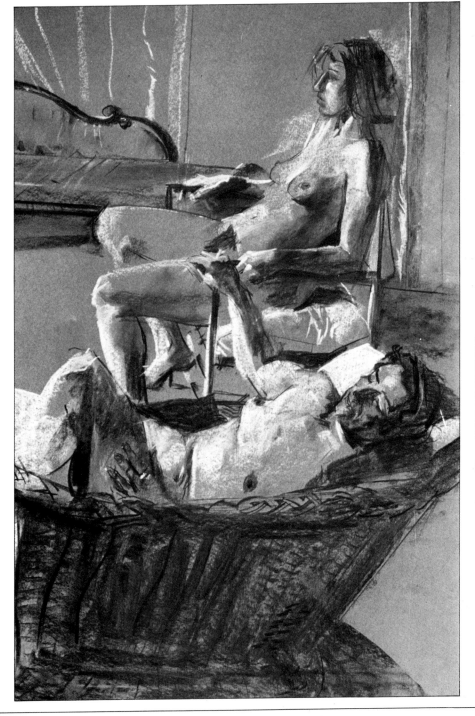

To arrive at the final image of
this double figure study the
artist worked from dark to light,
drawing on toned paper to give
an initial key to the tonal scale.
Identifiable outlines and areas
of dark shadow were
established first and gave a
basic structure to the
composition. Less emphatic
shadows were carefully
observed and blocked in with
charcoal and the artist then
started to work with white chalk
(**below**) to round out the
figures with pale tones and
intense highlights. The
arrangement of tonal values
indicates the single source of
strong light, in this case a
window facing the two figures.

Tinted paper is often a useful basis for a tonal study as it presents a value in the middle of the tonal range from which the artist can assess extremes of light and shade. The window and walls of the room (**right**) are treated simply as planes of white, the natural color of the paper and loosely drawn pencil hatching. The figure is given emphasis with line drawing and chalk highlights and a few patches of deep shadow are subtly described, such as on the shoulder and under the chin. An impression of strong sunlight is quickly achieved in the scene showing figures seated in deck chairs (**opposite**) by the vibrant contrast between heavy cast shadows and the bright color of the foreground plane. The colors used in this drawing are closely related and each is carefully given a suitable intensity to indicate spatial positions rather than local color. The interplay of complementary colors is exploited in the shadowy blue figure against the orange stripes of the deckchair. Each element in the composition contributes to describing a vista flooded with light, including the muted tones and indistinct forms in the background plane.

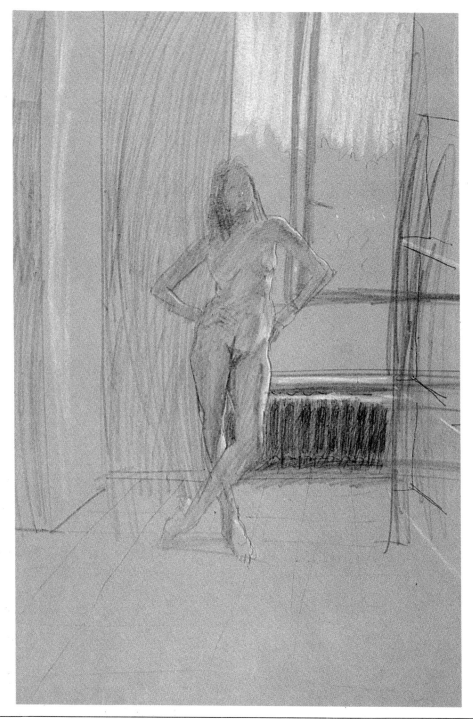

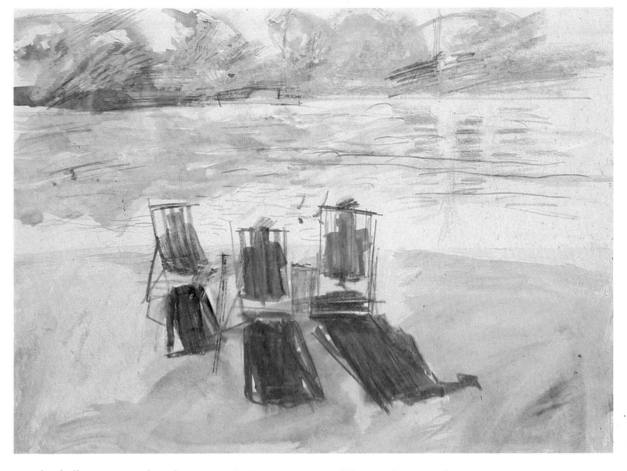

pencil, chalk, pen or other drawing tool. A diagram showing the effects of tone can be found on page 144.

Shadows are the projected shapes of the lighted object onto other surfaces – useful when understood fully but dangerous if misused or allowed to take over control. It is essential always to be aware of the differences between tone and shadow.

When setting out to draw the spherical form already described, the soft-edged dark tone should be very carefully observed, running as it will around the edge but probably sitting at some distance inside the contour. This is a significant distance and should be measured with great care.

To the outer side of this soft arc of tone is a fillet of lighter tone, not as light as the area of the form in the full glare of the light source but probably approximating to the lighter

middle tones between the extremes of light and dark. It is caused by reflection; light strikes the surface of the horizontal support and bounces back onto the underside of the sphere. This is known as reflected light and is a valuable aid to describing full, rounded forms; its position and tone relative both to the contour edge of the solid and the area of the solid in the full glare of direct light are likely to prove critical.

Many drawings, both ancient and modern, exploit this phenomenon of reflected light. In some works it is such an important part of the technique of analyzing tone that it is obviously overstated; in other examples it is used more subtly; in others still it is barely discernible. But in most cases it will be apparent, and once recognized can be observed in almost all solid forms, whether they be cylindrical or spherical.

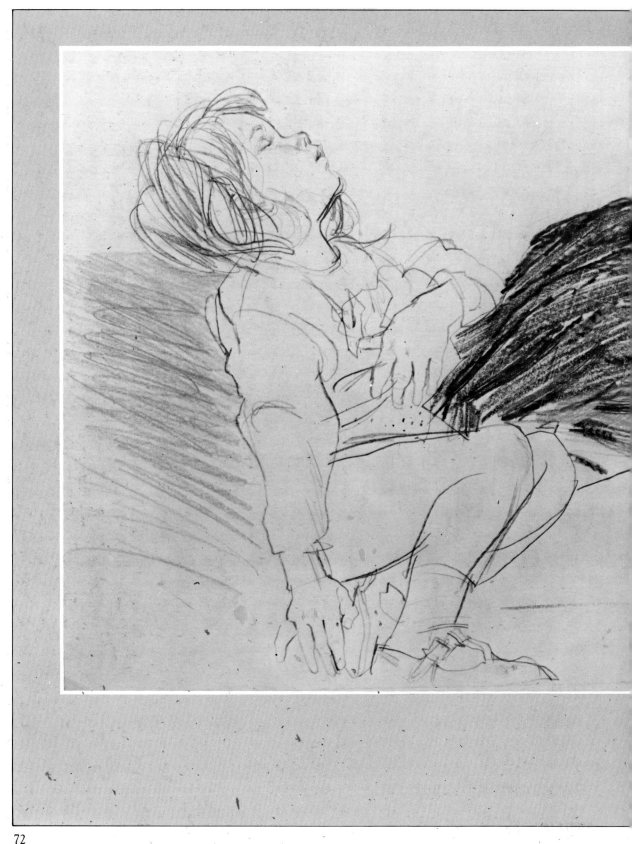

FIGURE DRAWING

THERE CAN BE FEW more satisfactory achievements than making a drawing of a figure, attempting to express its individuality, character and style. Never be discouraged if your early attempts seem far from successful; practice is the only route to better results and a classic method of learning is to continue to work at and improve your less than satisfactory drawings, rather than simply throwing them away and starting again.

Familiarity tends to lessen the acuteness with which we observe the physical characteristics of our fellow human beings. If the artist is to capture the individuality of his subject, however, he must adopt a degree of objectivity, even with those he knows very well indeed, and make fresh assessments as he draws. The set of the head on neck, torso on hips and the relationship of the legs to the overall stance need to be seen as though for the first time and then interpreted into pencil, chalk or pen, remembering always that the human body is a machine, albeit infinitely subtle.

Above: Children as a rule are unlikely to make long-suffering models, being unwilling to sit still for a sufficient length of time. By waiting for an opportune moment, this artist has achieved a sensitively wrought and detailed drawing.

FIGURE ANALYSIS

To base life drawing exclusively on a knowledge of human anatomy is both very difficult and inadvizable, so an alternative way of structuring the forms must be sought. Artists have usually acknowledged anatomical structure, but put it into simpler forms.

The geometric approach

The human body is a figure in space, a solid much like any other in that it has weight, mass and solidity. Unlike most others, however, it comprises four major parts; the head and neck, the torso, the arms and the legs. Of these the torso is the most massive single form and has the greatest limitations in its range of movements.

A consensus of opinion among artists ancient and modern would suggest the torso in terms of an elongated cube connected at the lower part to the legs and attached at the upper to the cylinder of the neck. On top of the neck is the head form, basically suggested by a cube or another elongated cube with the spherical form of the cranium on top. The arms are suggested as cylinders, hinged at the

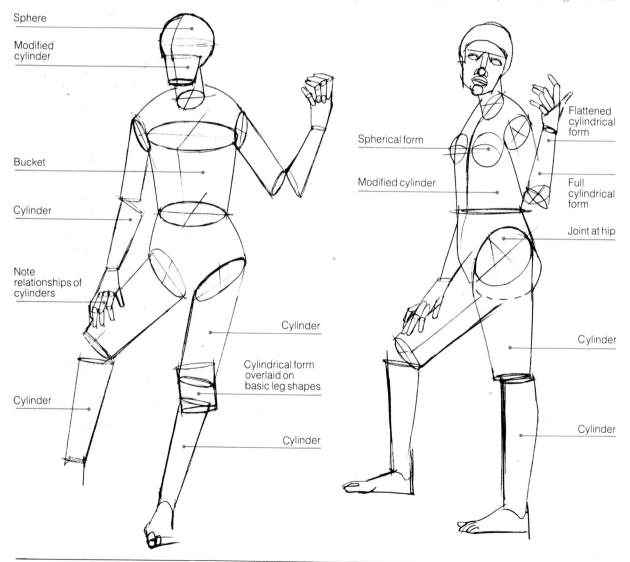

Sphere

Modified cylinder

Bucket

Cylinder

Note relationships of cylinders

Cylinder

Cylinder

Cylindrical form overlaid on basic leg shapes

Cylinder

Spherical form

Modified cylinder

Flattened cylindrical form

Full cylindrical form

Joint at hip

Cylinder

Cylinder

elbows, as are the legs, similarly hinged at the knees. Feet are attached at right angles and are considered as platforms; hands flatten, spatula fashion, the narrowing tube of the lower arm. Toes and fingers are cylindrical, radiating out from a point set at the centre of, respectively, the front of the ankle joint and the wrist.

This is a useful, very basic guide to figure construction, but it must be made more refined and sophisticated. Putting these various forms together in a pile, from the platforms of the feet up to the top of the head, would be unlikely to suggest a human body. This is because the interrelationship between parts is absolutely critical, the angles at which the separate bits join up being as important as the forms themselves. The neck is a good example, for it joins torso and head not as a cylinder placed in a vertical position, but as a cylinder tipped forward from the one and inserted into the other.

Axes and directional lines

Using simple geometric equivalents, the larger parts of the

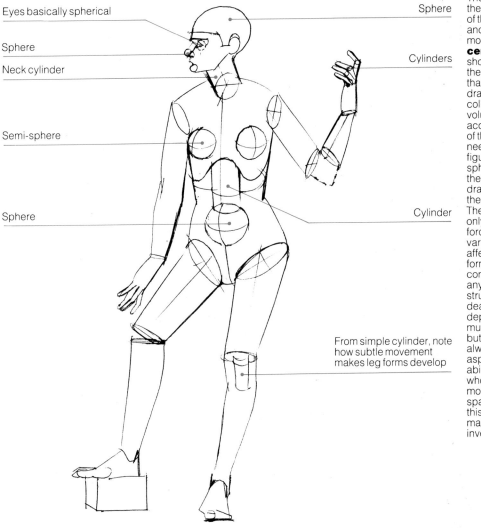

Eyes basically spherical

Sphere

Neck cylinder

Semi-sphere

Sphere

Sphere

Cylinders

Cylinder

From simple cylinder, note how subtle movement makes leg forms develop

These three diagrams show the basic geometric structure of the figure, using the cylinder and sphere together with modifications of each. In the **center** diagram a side view is shown, and in the diagram on the **right,** an elaboration of that on the **left.** Practice drawing the figure as a collection of these simplified volumes in order to help you acquire a firm understanding of this basic structure. You need not literally represent the figure in terms of cubes, spheres and cones, but bear them in mind constantly as you draw as a basis for interpreting the volumes of the figure. The figure will be subjected not only to gravity but to other forces resulting from the various postures it adopts. This affects the shape of the basic forms – flattening, stretching or compressing – but does not in any way change their essential structure. It will take a great deal of practice to learn to depict accurately this multitude of possible shapes, but it is important to remember always that the most important aspect of figure drawing is the ability to sum up the pose as a whole, establishing its movement and position in space. Only on a basis such as this is it worth the effort of making a detailed investigation of the structure.

figure are basically cylindrical, and each part has a central axis. Ease of feeling the axes is essential and they should be understood both in themselves and in relation to others. With practice, the limitations of movement and the pivot points become immediately apparent. Directional lines should also be established. Two such lines run across the shoulders and across the hips, lying horizontally and parallel to the ground plane. If the weight of the body is taken on one foot, the leg will be tense and firm and the other leg used primarily to balance. Michelangelo's famous marble statue of David in Florence is in just such a pose, and the angles of the shoulders' and hips' directional lines have altered accordingly. The hip is pushed upward on the side of the supporting leg and the shoulder drops toward the hip to compensate. Michelangelo's drawing of Adam for a fresco on the Sistine Chapel ceiling also shows these same two directional lines used to convey the rhythmic bend in the torso. Axes lines and directional lines can be used to establish the position of volumes in space.

Left: The fingers radiate from the wrist, with the thumb in opposition; it is essential to observe and understand the range of movement of the thumb.
Below: When making initial sketches it is a good idea not to attempt to treat the fingers separately but rather to draw their overall shape.

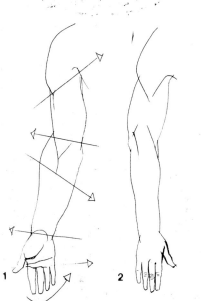

Diagrams **(1)** and **(2)** show the arm viewed from the front, while **(3)** and **(4)** show the arm viewed from the side. In **(1)** and **(3)** the arm is in its open position, with the palm turned forward; in **(2)** and **(4)** the arm is in its closed position, with the palm turned toward the back. Diagrams **(1)** and **(5)** demonstrate the relative angles through the arm and the leg respectively. Narrow point is diagonally opposite narrrow and broad similarly opposite broad; it is not possible to draw horizontal lines through these weak and strong points, in other words, each side of the limb goes in and out at a different level, and you should remember to take this into account when trying to depict limbs.

POSING A MODEL

The visual interest of the pose set should always be tempered by consideration for your model's comfort, although for quick drawings, up to ten minutes or so, a fairly complicated pose can usually be sustained. Choosing a viewpoint is an important aspect of making a figure drawing and should be carefully considered before you start. A simple straight on view **(1)** gives a true impression of the form; a profile **(2)** points up the interesting interrelation of angles such as the tilt of the neck, and a three-quarter pose **(3)** creates more variety in the angles, planes and forms. Your angle of vision in relation to the model can dramatically alter the effect. Viewed from above **(4)** the legs appear short and the body broad, while a low viewpoint **(5)** makes the body appear elongated and thin. The sitting poses **(6)** and **(7)** both on ground and chair, give an idea of some of the diagonals that can be introduced.

1
2
3
4
5

6
7

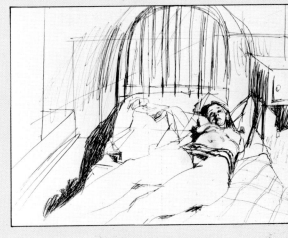

The fluid articulation of the human body ensures that the artist will have an infinite number of poses from which to draw. Simple props and clothes can provide further variety, as in the pose **(right)** where the dress helps to create the impression of an old photograph or print. The contrasting angles and interesting juxtapositions of shapes **(above)** make an ideal group pose, and the figure on the bed **(left)**, completely unposed and drawn simply as she happened to be lying, provides another example of foreshortening.

FEMALE FIGURE

With the exception of the obvious need to possess a basic knowledge of anatomical structure, particularly that of the skeleton, the main requirements for nude studies – one of the most popular types of female figure drawing – are the same as in other branches of drawing. A sensitive, fresh approach to the subject, however, is even more important than usual, though it is particularly difficult as far as the nude is concerned. It is an uphill, but essential, task not merely to imitate what has been done before, but to achieve an individual result. Never take a predetermined notion of 'painting the nude' into the studio with you. The real task is to be inspired by what you see and to discover ways of interpreting it effectively. Risk mistakes, if necessary, in order to achieve this.

Detailed study of breasts, head, lips and so on is one approach. Another is to relate the figure as a whole to the

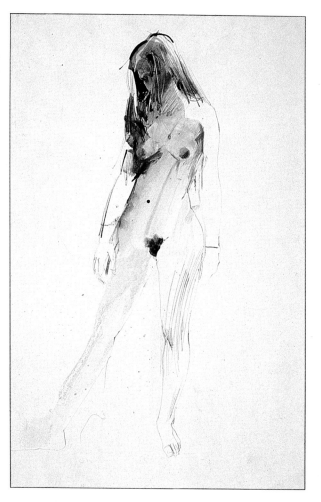

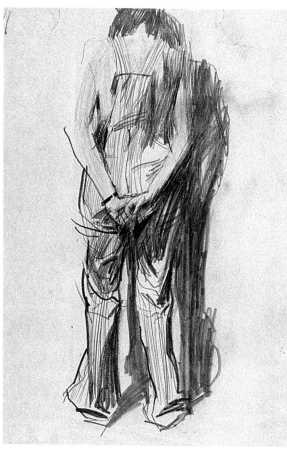

GIRL IN DUNGAREES
15 x 20in (38 x 51cm)

This is an unusual and very expressive pose and the lively drawing style gives the image a certain ambiguity. It is drawn on newsprint paper which has a pleasant, slightly warm tone. The loose hints of local color in the upper part of the figure are arrived at by a mixture of overlaid strokes of red, yellow, brown and green pencils. The overall form of the figure, shadows and pattern details are described in line and tone with an HB and a 4B pencil. The heavy black shadow echoes the hunched posture

YOUNG NUDE
15 x 22in (38 x 56cm)

The diffidence suggested in the attitude of the model is reflected in the drawing by the use of quiet grays and the gradually fading yellow to round out the form. Strong modeling in the head contrasts with the simple, linear treatment of arms and legs. This type of technique, combining pencil and watercolor as of equal importance in the drawing as a whole, can produce an intriguing effect.

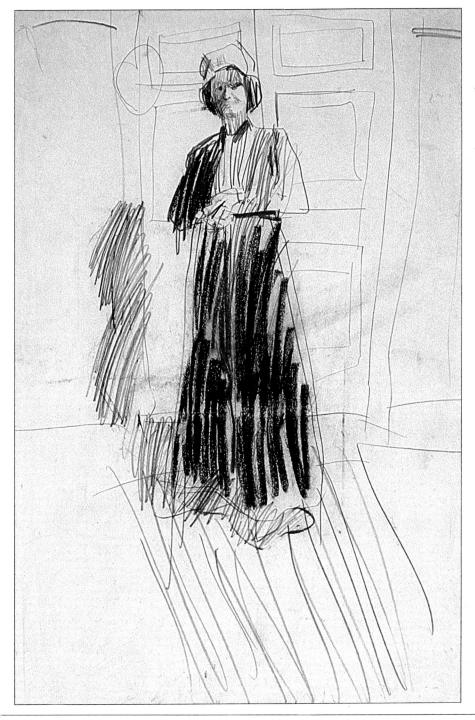

WOMAN WITH RED SASH
20½ x 30½in (52 x 77cm)

This drawing was intended to arrest the movement of the model while maintaining a sense of energy and freshness. The vigor with which the marks were made can hardly be in doubt. The red sash, picked out with a crimson oil pastel, provides the only splash of color, but an interesting comparison occurs between the heavy black of the Conte crayon used to lay in the mass of the long dress and the more restrained line and tone created by the use of graphite pencil.

Above: A brief outline of the figure indicating the pose and position of head and hands serves as a rough control for the activity of the shaded areas. A close examination of the drawing reveals how the artist has played the energetic lines of each medium together, working freely over pencil with Conte crayon and laying in the vivid red pastel strokes where appropriate. The confidence and energy of the artist are vital to the finished drawing and a tentative approach would deaden the appeal of this bold technique.

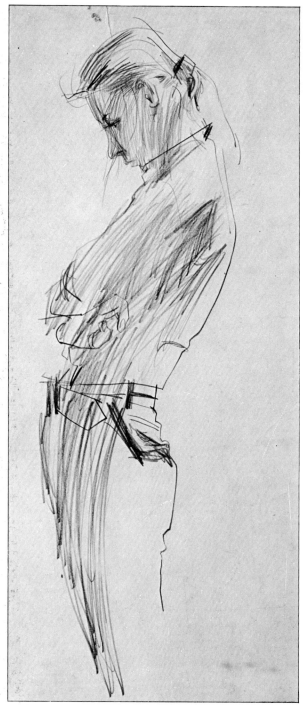

REFLECTIVE WOMAN
11½ x 20in (29 x 51cm)

This vigorous pencil drawing (**left**) appears to capture a temporary pause between one activity and the next, rather than a careful model's pose. The contrast between relatively fine lines and heavy emphasis on certain details is achieved by using progressively softer pencils and varying the pressure applied by the hand. Some of the loose shading has a grainy, gray texture which sets off the crispness of the outline.

GIRL IN STRIPED JUMPER 1,2
15 x 22½in (38 x 57cm)

These two drawings in Conte crayon and pencil (**below**) were of necessity made very quickly to capture the movement of the figure. In both the pattern of horizontal stripes describes the form by showing the direction of movement in shoulders, arms and torso. The pointed end of the crayon was used to trace the contours of head and limbs while the long edge was rubbed over the paper to block in solid tone.

NUDE LEANING ON BED
15 x 20IN (38 x 51CM)

The artist has introduced many technical elements to produce this lively study (**right**). The initial outline of the figure is in pencil, areas of muted tone are formed by pastel spread with a brush and rubbed into the paper. The bright color to the left of the figure is a combination of thick pastel and watercolor.

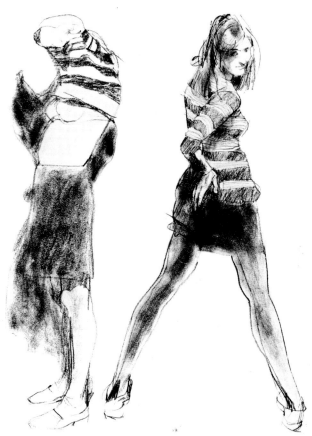

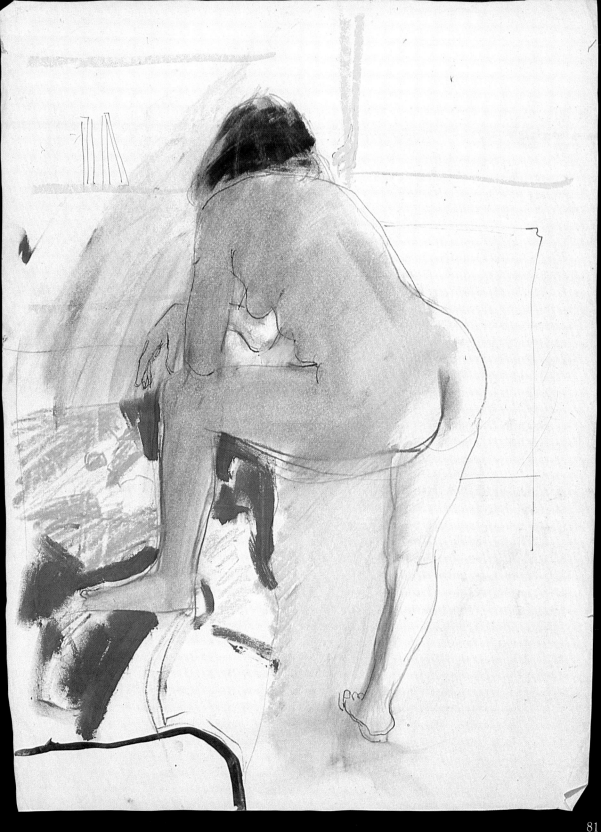

NUDE POSING
11½ x 22in (29 x 56cm)

The energy contained within this pose demanded to be matched by an equally lively line. Pen drawing was combined with the graceful line of diluted ink applied with a no. 4 sable brush. The general shape of the form was emphasized, rather than descriptive detail and the gestures made with pen and brush succeed in conveying implied movement. The delicate wash of pale gray over the whole figure, except for small areas touched directly by the light source, fuses the linear elements without overwhelming them and the brush lines are drawn naturally into the heavy, textured tone of the hair.

The vitality of this drawing rests upon the sensitivity of each line in itself and the interaction of broad lines with fine and curving with angular. The rounded tip of the brush naturally encourages a soft, curving tendency in the ink wash lines and the tone is gently graded by the movement of the brush across the paper.

An ink wash or brushed-in line dries unevenly and a concentration of tone at the edge of the damp area forms a subtle, broken line like a brief shadow of the pen drawing. Within the form, little pen drawing is used except to indicate the navel and the curve of one arm in front of the figure.

chosen setting. This involves a different way of working, with the nude becoming almost incidental in picture terms and certainly not the simple focal point it would remain if drawn completely independently of its surroundings. Most artists find this method the best; to establish basic planes of loor, walls and so on to suggest scale via other objects is rarely a waste of time.

This question of environment is even more important when it comes to drawing a clothed figure. The clothing itself will invite and suggest suitable settings, though not necessarily conventional ones. A flowing long dress, for instance, need not just suggest a ballroom or dance hall; remember it will also give emphasis to the lines of leg and hip that would not be discernable in a short dress or trousers and this point should be brought out in the setting, as well as the drawing. In this case, it might be a good idea to stress this line by making a virtual silhouette of the figure as a

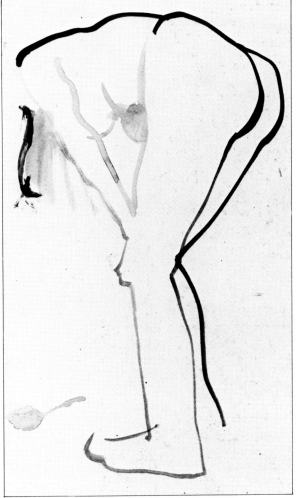

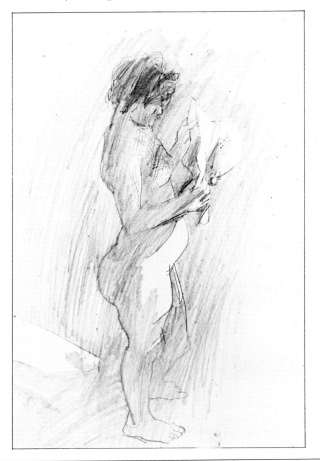

WOMAN WITH HAT
11½ x 16½in (29 x 41cm)
Strong light filters through the straw hat which the model holds, forming a flickering pattern on her breasts. This pencil study is basically concerned with light and shade, but a suggestion of color is also present in the heavy tone describing the hair. It is important to be aware of the difference between tone and color in the subject as the two elements are not always combined successfully.

NUDE BENDING OVER
9 x 22in (23 x 56cm)
In rather simpler terms than the drawing opposite, the brushed line here describes not only this moment of the pose, but the general feeling of movement in the body. This type of study provides essential practice in identifying this rhythm and putting it on the paper with a fluid and confident hand.

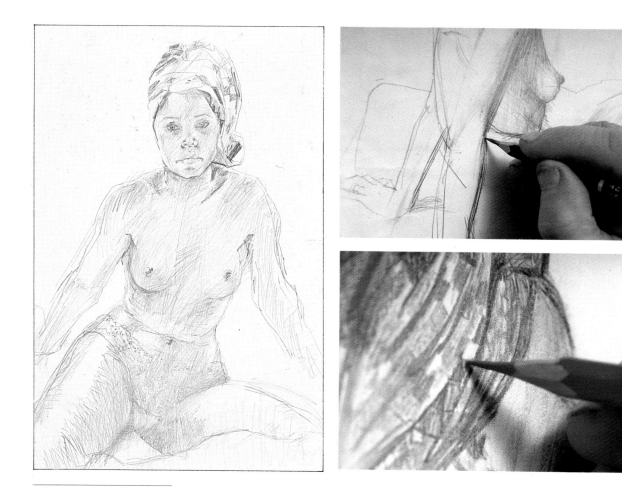

WOMAN WITH TURBAN 1
12¹/₂ x 20in (32 x 51cm)

This drawing has been
arranged to fit comfortably
within the paper area, filling the
space. The diagonal emphasis
of the pose gives the figure a
certain weight and energy. The
tonal effect describing the
forms is built up from a series of
nervous lines stroked across
the surface of the paper.
Suggestions of color as well as
tone are enhanced by the
sparing use of colored pencils
to imitate the pattern of the
headscarf.

whole, so that the torso leads into the fuller hip to create
flow without the hinderance of excessive detail. Depicting
the pull and creasing of folds over and across such a
garment can also be intriguing and original.

The pose you select should also be original. A standing
pose might seem the way to get the most from clothes, but
equally interesting studies can be made from a seated
model. Try posing the model in a more complex position,
with her hands featured, perhaps on her knees, or with her
legs up on a surface parallel to the chair or stool on which
she is sitting. Now observe the drooping, languid fall of the
cloth from bent knee down to floor level. Such a pose can
make a dress take on an entirely different meaning within
the drawing.

Trousers often reveal the form beneath them in a way
that simplifies it. Anatomical details are less assertive,

Above: Details of the drawing
on the opposite page show
how the artist traces the
outlines repeatedly (**top**) to
draw out the complexity of the
form and add emphasis and
depth. Hatching smudged with
the fingers creates the soft
tonal areas. Decorative detail
in color is added (**above**) after
the pencil drawing has been
fully developed.

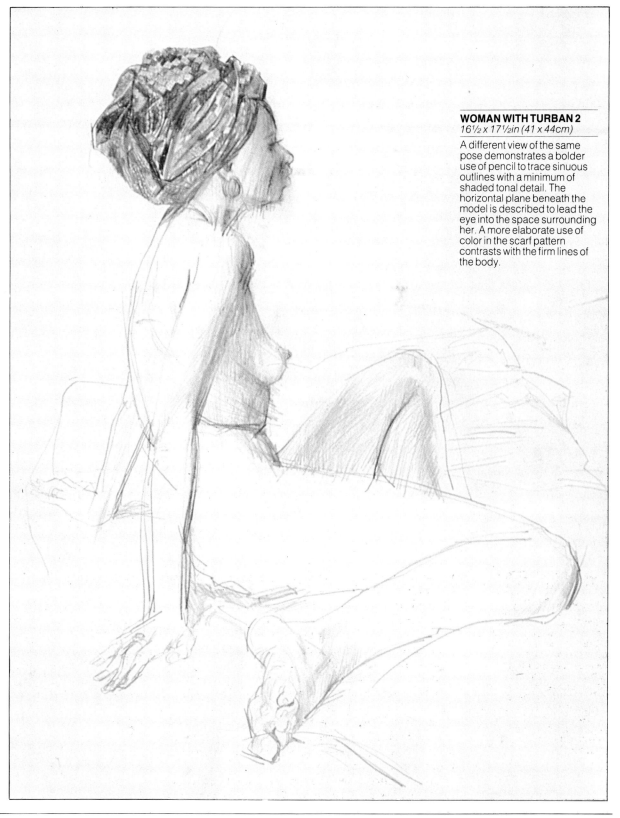

WOMAN WITH TURBAN 2
16¹/₂ x 17¹/₂in (41 x 44cm)

A different view of the same pose demonstrates a bolder use of pencil to trace sinuous outlines with a minimum of shaded tonal detail. The horizontal plane beneath the model is described to lead the eye into the space surrounding her. A more elaborate use of color in the scarf pattern contrasts with the firm lines of the body.

GIRL WITH LONG HAIR
15 x 15in (38 x 38cm)

The figure here is described by contour lines, carefully drawn with a 2B pencil. Soft smudges of tone are occasionally included to round out the forms. The same pencil creates the loosely laid in tone and linear detail of the chaise longue on which the model is sitting. The shape of the body is framed and pushed forward by this shaded area. As the work progressed, a cat briefly settled itself behind the model and this is lightly included, though in less detail so the overall form could be captured before it moved on.

while the overall shape and related angles of the limbs seem more convincing. Get your model to twist from the hips, so that the shoulders point in a slightly different direction, and try making the contrasting angles more acute.

The type of cloth worn will affect the appearance of the figure formsunderneath. Thin material will fall across limbs and hips in sharper angles, thinner ridges and more frequent creases. Heavy materials, such as wool and velvet, often have a looser, heavier feeling to their folds. Clothing style makes an enormous difference; to look, understand and interpret such factors is a fascinating and often rewarding exercise.

Color, too, has an immediate impact. Strong, vibrant tones have a different effect on the shapes beneath them than do quiet earth-based dyes. Hats make a great difference, sometimes seeming to change the appearance com-

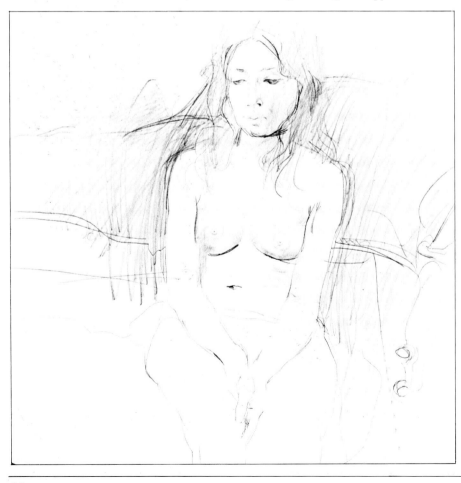

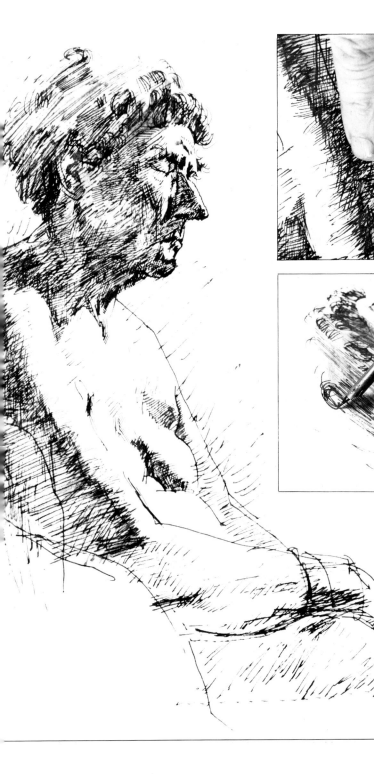

OLD WOMAN SLEEPING
16 x 14in (40 x 36cm)

A low eye level gives the artist a view of this pose as a strong silhouette against the background and a rising, monumental form. The drawing was made with a rapidograph pen to enable the artist to work quickly on the mass of textural detail, but where heavy linear emphasis was required a dip pen was also used. The contrast of light and dark comes from a slight simplification of the tonal balance so the fall of light on the body is clearly defined by comparison with the shadow on the face, neck and back. The dark tones are mainly the result of the network of densely cross-hatched lines, but in some areas the artist has smudged the partially dry ink with a dampened finger to spread a softer texture (**left above**). The use of bold strokes of the dip pen is most clearly seen in the curling lines of the hair (**left below**). These cut across the slanted hatching which describes a general tone to enliven the drawing and indicate the natural texture in more detail.

SEATED NUDE
15 x 20in (38 x 51cm)

This drawing has a rather abstract quality in the approach to both technique and composition. Pencil drawing is fleshed out in color with pastel and oil paint dissolved in turpentine. The lines of the figure flow freely. At certain points they merely suggest the curve of the form but in other places they are firmly scored to give heavy tone where one limb rests against another. The atmospheric effect of the thin washes of oil across the background contrasts with the vigorous use of pastel to lay in brighter color around the figure.

GIRL IN WHITE DRESS
15 x 20in (38 x 51cm)

Indian ink applied in line and wash was chosen as a suitable medium for this drawing because the artist wanted to treat the shape of the white nightdress quite simply and make it stand out against the background tone. The form is primarily represented by washes of tone, line being used minimally to assert features such as the hair and feet of the model. A touch of colored pastel introduces a new texture and enlivens the work.

pletely and others providing contrast and emphasis. To frame a head by lifting the hair and putting it under a hat can make a model who has been drawn many times before take on an apparently new look. Scarves, checks and printed patterns, and rough and smooth surfaces can all open the door to new thoughts and observations. Experiment and practice with all these and other variations and techniques. An artist should always feel free to find a personal way of drawing , since no hard and fast rules – except thos of proportion – exist. As many different ways are to be discovered as there are people to make them. Cultivate the element of surprise. This is an important part of most sketching and drawing – your aim should be to spring a shock upon yourself in order to bring about a change in approach, or in the hope of finding a fresh slant. Try using alien mixtures of materials and unconventional surfaces, or putting the subject into an unusual situation, and see what happens.

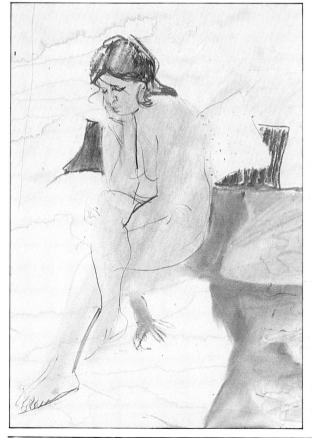

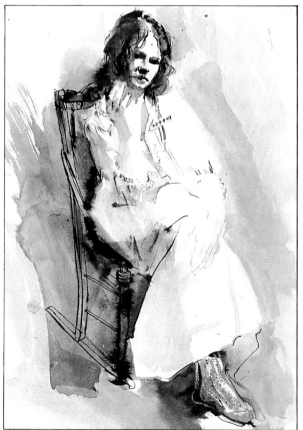

NUDE FROM BEHIND
15 x 20in (38 x 51cm)

A classic technique is used to convey the arresting simplicity of this pose. The lines were first drawn with pen and ink, quickly and freely to maintain a fluid quality. Light washes of diluted ink were then brushed in to model the massive form of the body. To balance the open, light tone of the drawing, a heavier wash was touched in to indicate dark shadows, but sparingly to avoid swamping the expressive line. Small details were then re-emphasized with further pen drawing.

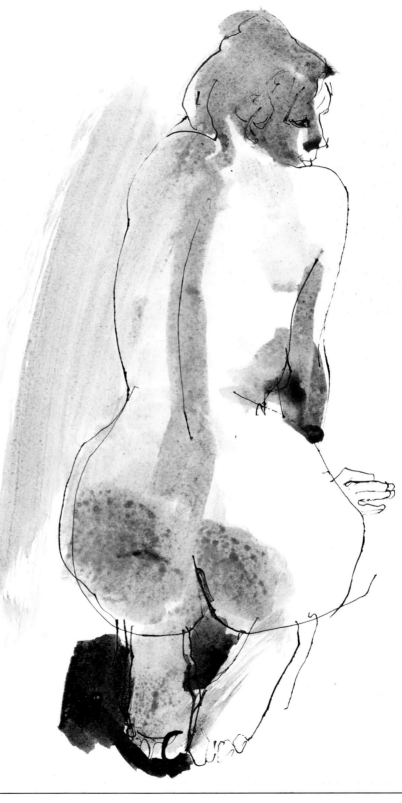

GIRL IN JEANS
11½ x 16½in (29 x 41cm)

This figure was drawn with a hard charcoal pencil, which has a different character from the traditional stick form of charcoal. It has a fairly harsh, grainy quality but blunting the point of the pencil will produce a softer line. The basic form of the figure is drawn with strong, active lines but to define the facial features a more detailed tonal analysis is made.

Above: The grainy tone of the charcoal shows here in more detail. The general shading is lightly blocked in and darker tones are adjusted by pressing more firmly on the paper. The pencil marks tend to smudge easily and the work should be sprayed liberally with fixative as soon as the detail is complete. Otherwise the subtle effects which can be achieved in this medium are lost.

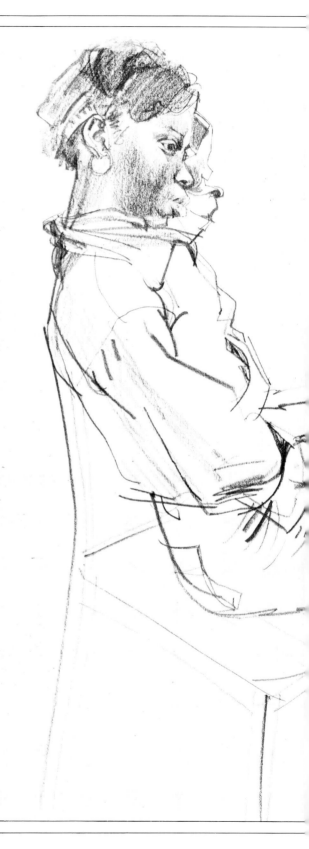

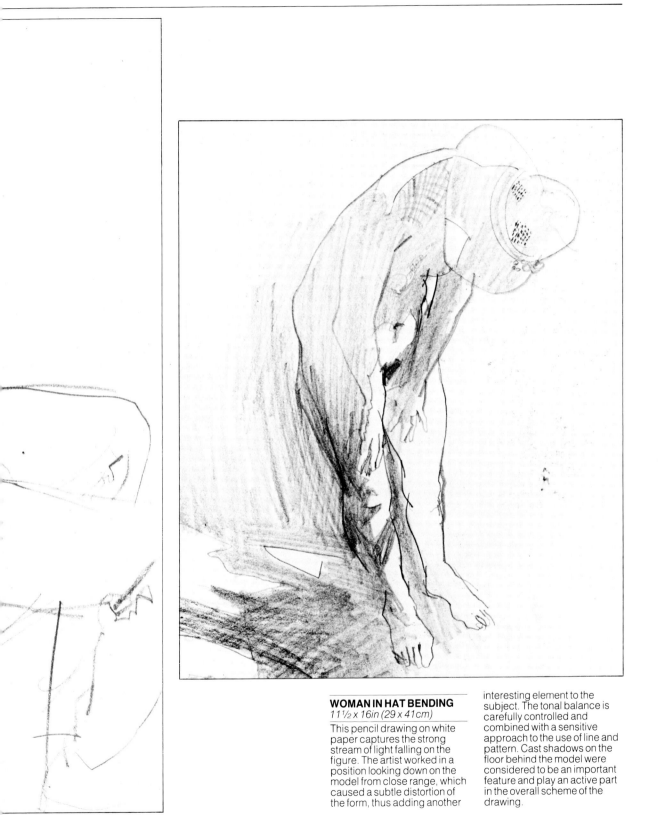

WOMAN IN HAT BENDING
11½ x 16in (29 x 41cm)

This pencil drawing on white paper captures the strong stream of light falling on the figure. The artist worked in a position looking down on the model from close range, which caused a subtle distortion of the form, thus adding another interesting element to the subject. The tonal balance is carefully controlled and combined with a sensitive approach to the use of line and pattern. Cast shadows on the floor behind the model were considered to be an important feature and play an active part in the overall scheme of the drawing.

MALE FIGURE

In all figure drawing, careful selection of pose, atmosphere and environment are imperatives. Because so many great artists of the past have worked in this area, it may be difficult for you to disassociate yourself from their work and come up with fresh, imaginative results. Nevertheless, if you bear these precepts in mind, even a small measure of experience will show up the exciting possibilities for new ideas, many of which arise through experiment with varied techniques and materials.

The main characteristic of the male figure is that it is more muscular than the female one. Choosing poses that reflect this is particularly important. In a study of a mature man, for instance, the ideal pose to aim for is one in which tense, energetic line reflects the well-marked musces. Study examples of the classical male figure form. This clearly depicts the breadth of the shoulders, tapering to slim hips, though age and other factors obviously affect this simple definition to some extent. Rember, too, that surplus fat sits on the muscles beneath the skin in different ways and places than it would on a woman.

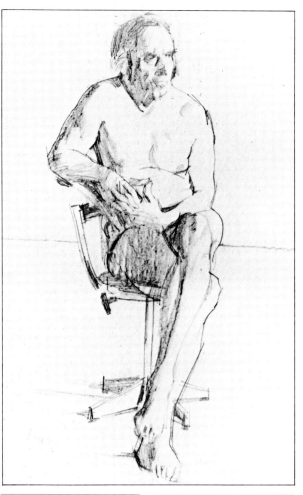

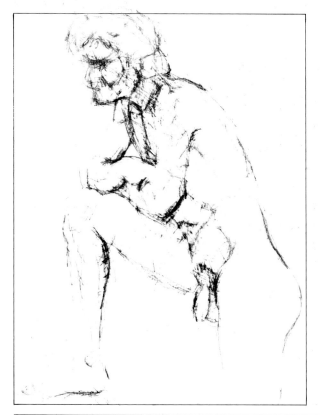

STUDY OF NUDE MAN
22 x 29½in (56 x 76cm)

This picture (**left**) shows an interesting drawing technique which produces an active image at the same time as an accurate record of the pose. The pencil constantly 'worries' gently at the paper, tracing the relationships of given points across the surface of the form and referring back from one to another. The marks are initially made quite lightly and as they are checked again and again, build up more densely. It may be useful to rehearse this technique on graph paper.

MAN SITTING ON CHAIR
15 x 19½in (38 x 50cm)

In this small pencil study of a relaxed pose (**above**) the artist has taken care to place the figure within the planes of the room by drawing the chair in some detail and anchoring the drawing with a horizontal line. The sensitive handling of line and tone provides a well-integrated study of the shape and volume of each form. In addition, the drawing unmistakably records a likeness, which is not always the case with a figure study, and the facial expression and features are highly descriptive.

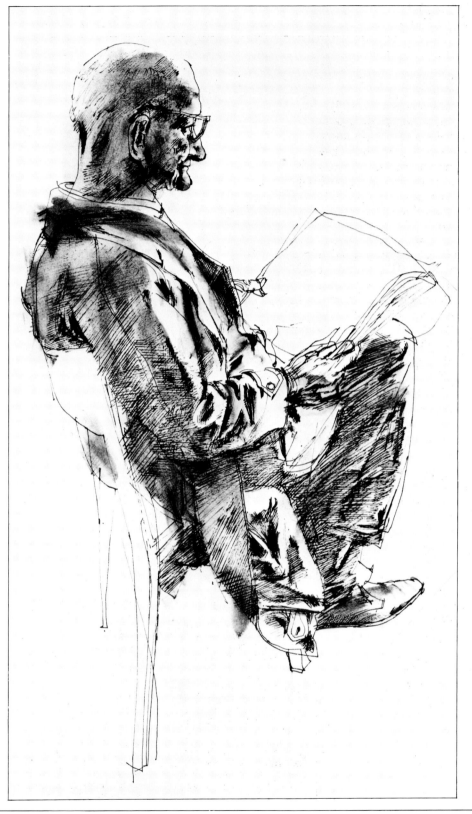

OLD MAN AND PAPERS
12 x 18¹/₂in (31 x 47cm)

Although there are many special pens designed for use by artists and illustrators, an ordinary cartridge pen, normally used for writing, gives a constant, free flow of ink for scribbling and hatching rich textures in a drawing. There is enough time before the ink dries completely to spread and soften the tone with a damp brush or finger. By carefully judging the right moment to smudge or blend the pen marks, you can add considerable range to the descriptive properties of the medium. This well-observed pen study of a man reading is full of character and expression, catching perfectly the curiosity and concentration of the subject. It is also a satisfying image in terms of the vitality of the technique and the clever arrangement of the tonal balance.

MAN IN UNIFORM
9 x 14in (23 x 36cm)

A ballpoint pen is a useful drawing implement, conveniently portable. It obviously lacks the range of marks that may be achieved with pencils or other types of pens, but it is reliable and consistent. A drawing of a model in period costume (**left**) exploits the regular, fluid lines characteristic of the medium. A controlled use of hatching and cross hatching enables the artist to block in tones which give substance to the linear form and vary the texture of the drawing. The ballpoint is sometimes regarded as an insensitive medium, but this depends very much upon the degree of skill and finesse which the artist can bring to it.

WOUNDED MAN
13 x 18in (33 x 45cm)

An interesting technique of analyzing and noting down the form of the figure is illustrated in this pencil drawing (**right**). The artist traced the form by scanning the figure closely, but did not look down at the paper while drawing the outline. The pencil was guided by instinctive response to the visual information. By this means a strangely condensed, distorted form appears in the drawing which may at first seem comical but is invariably original. This type of exercise can be a salutory reminder that it is easy to become lazy in observation and to fall back on formulae which have in the past produced successful drawings. In this example of 'blind contour' drawing, the form was later eleborated with tone and pattern to fill the shell of the linear form.

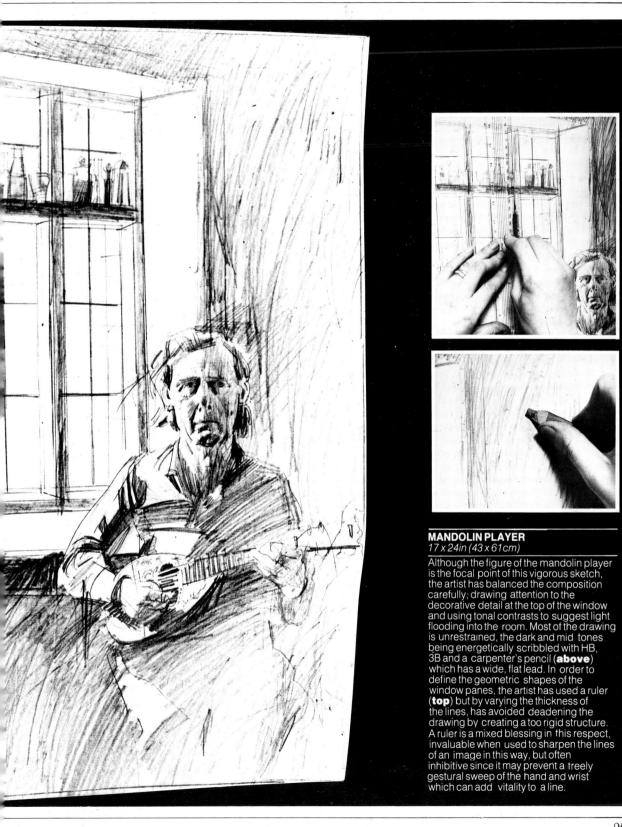

MANDOLIN PLAYER
17 x 24in (43 x 61cm)

Although the figure of the mandolin player is the focal point of this vigorous sketch, the artist has balanced the composition carefully; drawing attention to the decorative detail at the top of the window and using tonal contrasts to suggest light flooding into the room. Most of the drawing is unrestrained, the dark and mid tones being energetically scribbled with HB, 3B and a carpenter's pencil (**above**) which has a wide, flat lead. In order to define the geometric shapes of the window panes, the artist has used a ruler (**top**) but by varying the thickness of the lines, has avoided deadening the drawing by creating a too rigid structure. A ruler is a mixed blessing in this respect, invaluable when used to sharpen the lines of an image in this way, but often inhibitive since it may prevent a freely gestural sweep of the hand and wrist which can add vitality to a line.

CHILDREN

BOY IN RED BOOTS
15 x 20in (38 x 51cm)

This drawing is mainly pastel but broad expanses of color have been added to the walls and floor of the room with watercolor washes and there are patches of paint to show shadows on the figure. The boy's jacket was made of shiny fabric and this has been shown quite economically with the use of three colors and the contrast between hard edges on the painted marks and the soft grain of pastel. The pose of the young model and the angled view into the corner of the room establish a mood. It is necessary to work quickly when drawing children as they do not sustain interest in their task for long but restrictions may be partly overcome by pacing the work to allow frequent rests. Once an overall indication of the pose has been sketched in, allow the child to move or stretch and then settle him back into place. Draw in more detail of limbs and features and let him rest again. Continuing in this way you may arrive at a workable system acceptable to both artist and model.

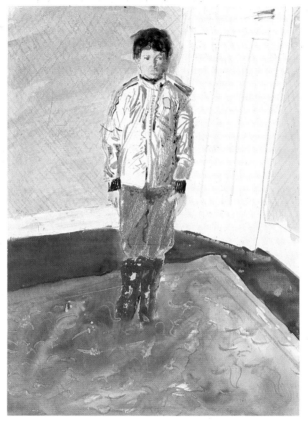

Making posed drawings of children presents an instant practical problem – how do you manage to keep them still for long enough to complete the drawing! A sleeping pose is an obvious answer, though, in the case of a baby, this can come up against the problem of pillows and bed linen. Older children are often initially keen to co-operate with an artist, but sometimes they promise what they cannot deliver, starting with good intentions that fade away through fidgeting and movement.

The real answer is speed and practice. Through the latter, the pace of drawing is increased, so that a number of brief sketches can be assembled from which to create a more finished piece of work. Lighting should not be harsh; it should be gentle, yet firm. Rember that the forms within young heads and bodies are small and subtle, but the forms themselves are often large and full. Taking the head of a child as an example, the head is a simple bulking form, the cranium being larger in proportion to the face than it

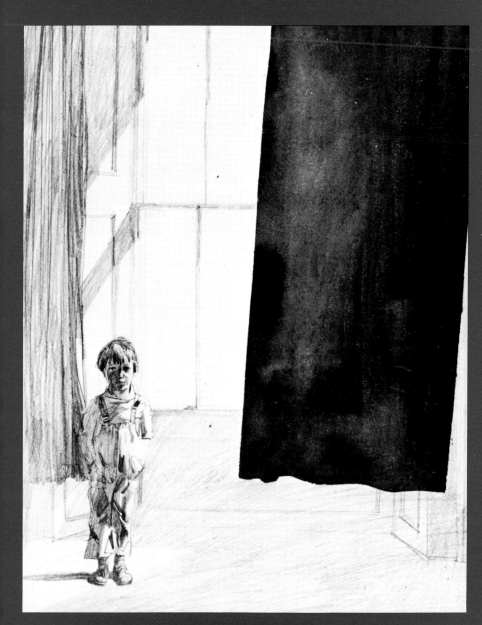

BOY IN DUNGAREES
15 x 20in (38 x 51cm)

The figure of the child is dominated by the large window so he appears isolated and vulnerable. This theme has been extended by combining detailed pencil drawing with a broad expanse of wash filling in the shape of the curtain. This almost destroys the balance of the image and is intended to emphasize a sense of threat. The wash is made with watercolor in Payne's grey, which has a heavy tone reminiscent of a stormy sky. The greys in the pencil drawing are quite different in quality and texture and it is an unusually bold idea to divide two sections of a drawing so emphatically by the techniques used. The child is drawn in detail, with his features clearly defined and all the creases in his clothes represented. The freely drawn shapes in clothing and curtains contrast with the crisp lines of the window which were put in using a ruler as a guide.

A well-sharpened 3B pencil is suitable for a fairly intricate drawing as it can be used to make sharp linear marks or to lay in areas of soft tone. The artist has made use of the full range of qualities (**left**) in drawing the figure. The wash of watercolor is laid into a brief pencil outline with a soft sable brush (**far left**). The tone is varied to suggest gentle undulation in the fall of the curtain.

would be in later life. Look carefully, too, at color, if you use it, since this will need to reflect the fresh, light quality of flesh tones and shadows as well.

The actual techniques that can be employed vary greatly, though there are some obvious limitations. The heavy charcoal lines of a Käthe Kollwitz-style drawing, for instance, are oikely to be less reflective of infant character than some others. This, however, does not mean that a thin, tentative tracing is the alternative; toughness and sensitivity go hand-in-hand when used by a sensitive draftsman. When drawing a nude child, select a pose that stresses the prime characteristics.

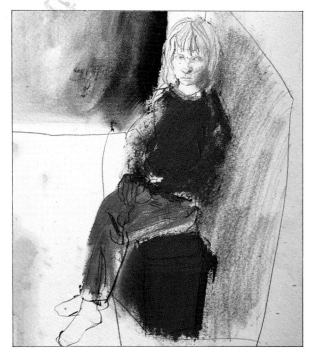

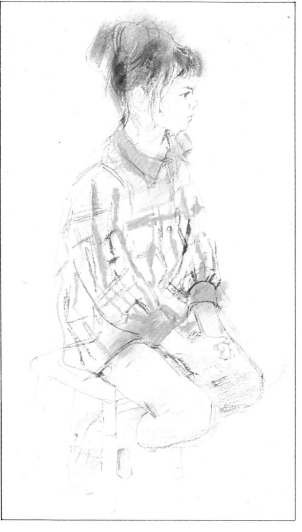

GIRL ON FIRE BOX
14 x 20in (36 x 51cm)

Using a pencil on a sheet of water color not surface, the overall design was indicated. A rag dipped in turpentine was used to apply color (right) with two tubes of oil paint, Cadmium red and Cerulean blue. Careful smears of both colors were used as suggestions of trousers, sweater and box.
Next, using an HB pencil as

well as the 4B, details were sketched in to relate the parts to each other. The turpentine was used again to dissolve the heavier black pencil marks in some areas to increase the sense of distance and to create atmosphere.

GIRL WITH YELLOW CHECK DRESS
12 x 24in (31 x 61cm)

This drawing uses water and acrylic paint to introduce color areas. The careful, nervous linear quality in the head colors and other parts is achieved with a 'stop and start' line, the artist looking hard at the subject and back to the support. The resulting pauses are seen in the ragged feeling of the line itself.

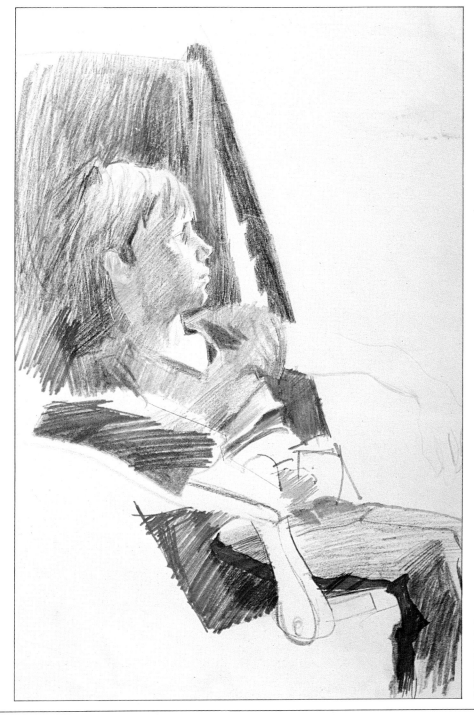

SEATED CHILD
6 x 10in (15 x 25cm)

In colored pencil drawings, the work's size is determined by the thin marks the pencils make. As flat areas to enhance a monochrome sketch, or when used for a complete work, the colors give a rich quality to the surface. Usually, the support is white; this allows the telling use of the transparent nature of the rubbed pencil lead.

This drawing of a seated boy

is on a sketch book page (colored pencils are ideal for use with a pocket-sized book). The main parts of the drawing were outlined in several different, lightly-toned pencils. Elaboration (above) was slowly built up, using single colors and juxtaposing two or more to achieve an optical color mix. Some areas were left in their original state to contrast with those considered to be more important, such as the head. As the mixture of color and tone (above) slowly described the forms of head and face, the values of cool to warm became increasingly important. Beneath the chin, for instance, the introduction of cool areas of reflected light can be seen. Alongside the warmer colors used for the facial features, this allows for the strong turn of plane needed here. In the hair, an apparently strong color area is in fact composed of differing tones and colors. Here, too, cool areas work alongside warmer ones, blues contrasting with browns. Shapes are seen as shapes, as well as parts of forms.

GROUPS

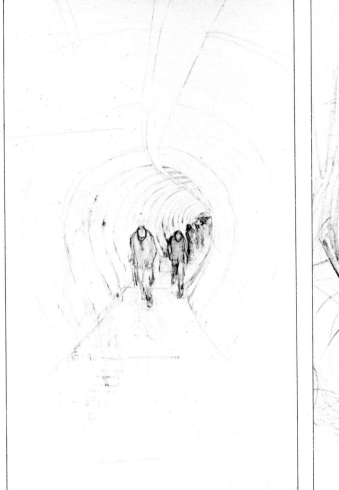

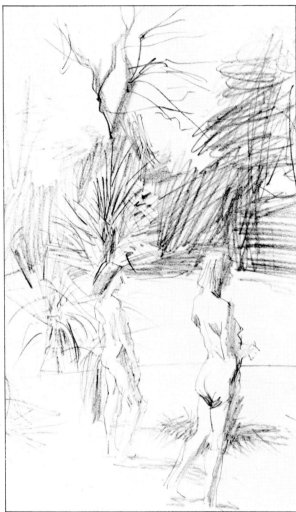

PEOPLE IN TUNNEL
21½ x 29½in (55 x 76cm)
The energy of moving figures is expressed in the active pencil marks with which they are described. This is offset against expanses of bare white paper which radiate from the central focus, defined sparsely with curving lines and interrupted by ghostly erasures.

Positioning a number of people in a group portrait raises its own problems for the artist. The first of these is choosing a suitable setting for the portrait. This can be informal, formal, cluttered with background activity or a deliberately isolated study of the group as a single entity. It all depends on your assessment of the situation and what atmosphere you want to convey.

What is important is that the figures in your drawing relate to each other and to the chosen background. They should never sit on the paper in isolation, looking like independent pieces of work. For this reason, it is often best to base the drawing on a series of preliminary sketches.

WOMEN IN GARDEN
11½ x 16½in (29 x 41cm)
This subject provides much interesting contrast to enliven the image. The difference between the solid forms of the figures and the heavy masses of foliage is complicated by the strong sunlight which causes a definite pattern of light and shade. Several pencils were used to draw out elements of the image; soft pencils for the plant forms and harder points to etch in the figures.

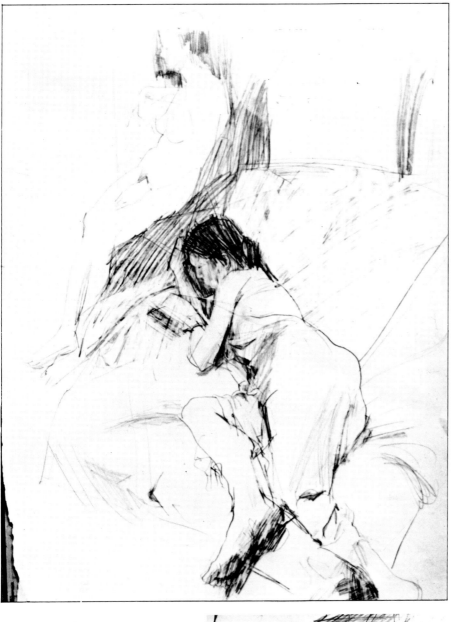

RECLINING NUDES
30 x 22½ in (77 x 57cm)

A study from life of a double figure pose is boldly drawn with a combination of line and tone, loosely laid in with densely scribbled marks. The texture of the drawing is partly achieved by erasing some of the pencil marks with a putty rubber (**below left**). This softens the image and vitalizes the mid-tones. The reclining figure is simply covered with drapery and the folds of the thin fabric show the stresses created by the underlying forms. A basic anatomical structure can still be clearly seen.

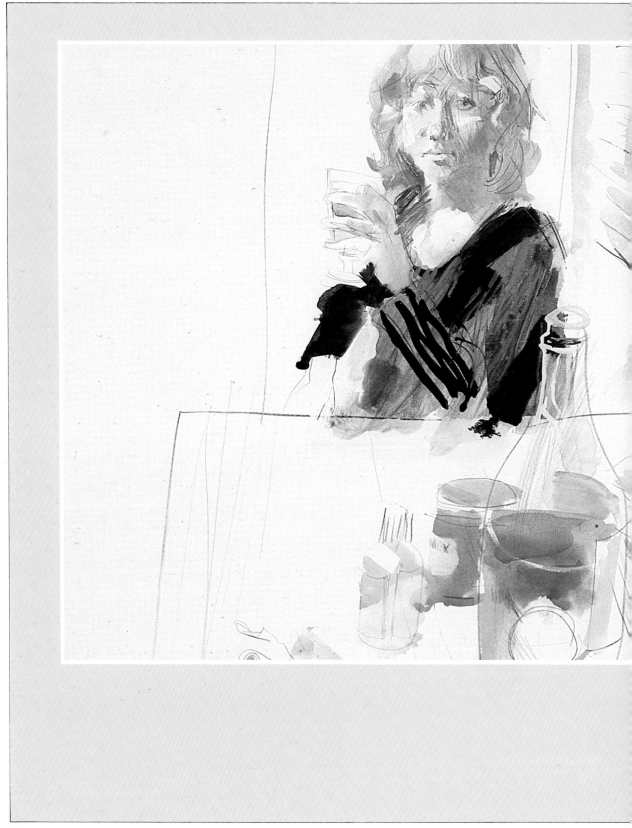

PORTRAIT

OVER THE CENTURIES, each period of art has produced its own groups of portraitists, with practically all the great masters working in the genre. Their aim – as yours should be – was not to produce photographic-type reproductions of their sitters; though achieving a reasonable likeness is important, a true portraitist should aim to produce something more. The ideal is an almost magical blend of elements that give some insight into the character of the sitter as a whole.

The key to this is a combination of finely focused observation with a logical technical approach. Many artists, for instance, use the 'gridding' method of drawing. They project the face and head forward on to an invisible, yet understood, grid on the support. The system enables horizontal and vertical reference points to be established more easily. Look across the face of your sitter and plot the key horizontal points, working down vertically from each one in order. It is best to start with the eyes, as this enables you to pick up the corners of the mouth, nostrils, jaw line and so on. The process will ensure accurate location of all features. It is also advisable to examine your sitter from all angles, so you understand the complexities of facial structure better when work starts from one position. Even an awareness of the possibilities of caricature is not out of place, at least at the start!

Above: A formal portrait is not always the best way of capturing the personality of your sitter. Stan Smith has chosen a more relaxed pose, putting his subject in familiar domestic surroundings.

PORTRAIT ANALYSIS

The physical structure of the face is complex, but with intelligent observation accurate and sensitive drawings can be achieved. This, however, is not the only aspect to be taken into consideration, for in addition to building a head in chalk, pencil or pen and ink, there is another dimension to our understanding of the human face. Concepts such as personality and communication through eye contact cannot be ignored. The face in repose might not fully express the individual and a drawn likeness must capture tilts and twists and other infinitely subtle movements.

Head shapes

Before examining features, both independently and in groups, consider the mass of the head and its relation to the skull. Just as students are taught to base the figure on geometric forms – cylinders, cubes and spheres – this same principle can be invoked in describing the head. Some artists choose an egg form and represent features by cutting into and adding onto it – making a deep cut to form the eye sockets beneath the brow or rendering the nose by adding a half cylinder. Others prefer a block form, based on an elongated cube and chiselled to express the character and

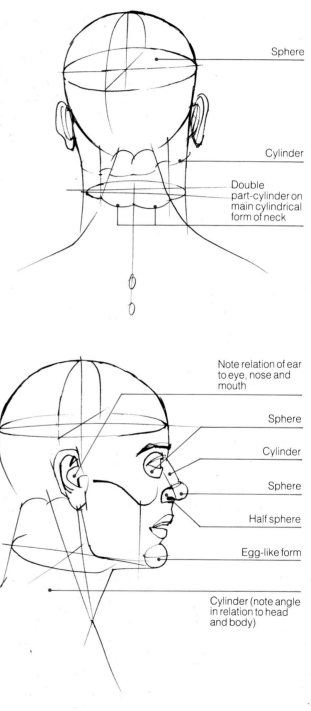

Sphere

Cylinder

Double part-cylinder on main cylindrical form of neck

Note relation of ear to eye, nose and mouth

Sphere

Cylinder

Sphere

Half sphere

Egg-like form

Cylinder (note angle in relation to head and body)

Below, right and top: Side and back views of the head showing how the basic shapes can be expressed in terms of geometric forms. It is important to note the angles at which these shapes interrelate with each other.

Sphere

Sphere

Sphere (note angle of front face of eye)

Note angle of neck as it attaches to the head

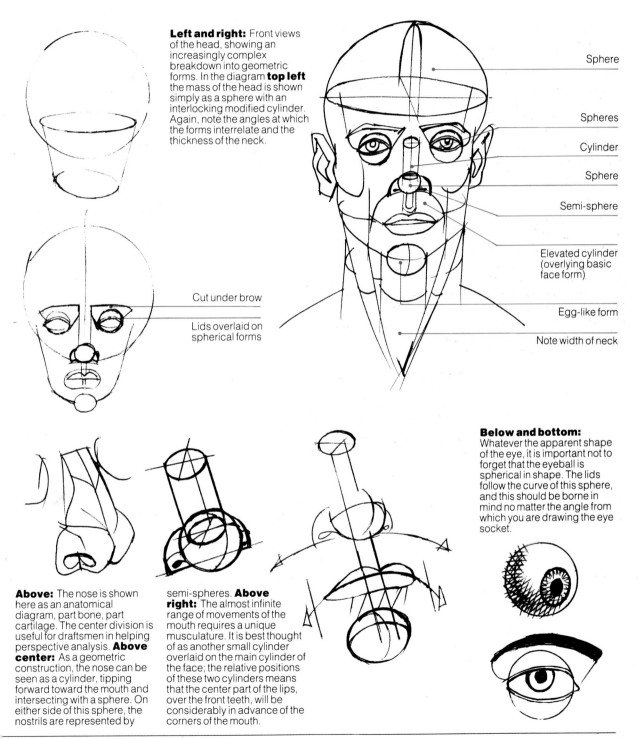

Left and right: Front views of the head, showing an increasingly complex breakdown into geometric forms. In the diagram **top left** the mass of the head is shown simply as a sphere with an interlocking modified cylinder. Again, note the angles at which the forms interrelate and the thickness of the neck.

Sphere

Spheres

Cylinder

Sphere

Semi-sphere

Elevated cylinder (overlying basic face form)

Egg-like form

Note width of neck

Cut under brow

Lids overlaid on spherical forms

Below and bottom: Whatever the apparent shape of the eye, it is important not to forget that the eyeball is spherical in shape. The lids follow the curve of this sphere, and this should be borne in mind no matter the angle from which you are drawing the eye socket.

Above: The nose is shown here as an anatomical diagram, part bone, part cartilage. The center division is useful for draftsmen in helping perspective analysis. **Above center:** As a geometric construction, the nose can be seen as a cylinder, tipping forward toward the mouth and intersecting with a sphere. On either side of this sphere, the nostrils are represented by semi-spheres. **Above right:** The almost infinite range of movements of the mouth requires a unique musculature. It is best thought of as another small cylinder overlaid on the main cylinder of the face; the relative positions of these two cylinders means that the center part of the lips, over the front teeth, will be considerably in advance of the corners of the mouth.

105

AGEING

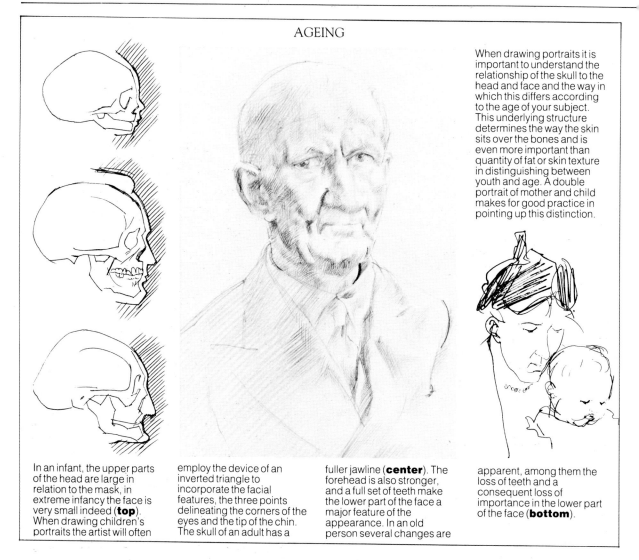

When drawing portraits it is important to understand the relationship of the skull to the head and face and the way in which this differs according to the age of your subject. This underlying structure determines the way the skin sits over the bones and is even more important than quantity of fat or skin texture in distinguishing between youth and age. A double portrait of mother and child makes for good practice in pointing up this distinction.

In an infant, the upper parts of the head are large in relation to the mask, in extreme infancy the face is very small indeed (**top**). When drawing children's portraits the artist will often employ the device of an inverted triangle to incorporate the facial features, the three points delineating the corners of the eyes and the tip of the chin. The skull of an adult has a fuller jawline (**center**). The forehead is also stronger, and a full set of teeth make the lower part of the face a major feature of the appearance. In an old person several changes are apparent, among them the loss of teeth and a consequent loss of importance in the lower part of the face (**bottom**).

shape of the features. Yet again, others will mix the two or select a form comprising a sphere on top of a smaller elongated cube, thus suggesting cranium and lower face and jaw. The latter form is dependable and tolerably accurate in anatomical terms. Onto the chosen base the nose and other features can be placed, and it is important that the type of form selected is easy to place into the rules of perspective.

The mask within which the features are located can best be expressed by being enclosed inside an inverted triangle – this is a good general guide – and it will vary considerably according to sex, age and type. The overall relationships of cranium to face differ greatly according to age – an infant has a much bigger brain case relative to the mask than an adult, and the eyes are bigger in proportion to the other features, just as the mouth tends to be shorter in width but fuller in the lips. As the child moves through adolescence and into adulthood, the proportions of the face change.

There are distinctions too between the facial structures of the different sexes and an understanding of these is essential if portrait drawing is ever to be attempted. The differences are best seen in profile, where the overhanging angle of the forehead and protruding jaw line of the adult male contrasts with the gentler arc of the female forehead and the smaller structure around the muzzle, where the chin is less aggressive and more delicate in its line. From the front, the mouth of the male tends to be wider, the brow deeper and the jawline harder.

Eyes

The eyeballs are cylindrical and as a result the eyes are not vertical when looked at in profile but take on a slight diagonal, tilting forward and upward. From the front, the eyes are rarely set on exactly the same horizontal line as

each other, and they tip either up or down according to the individual or racial type. The eyelids cover the eyeball, thus describing the underlying cylindrical shape.

The shapes and forms of eyes vary greatly and there is a surprising range of difference in the size of the eye relative to the mask of the face. Some things, however, are more or less constant, for instance the tendency of eyes to slant upward from the nose when the subject is smiling and, conversely, downward when displeasure is expressed. In an adult, the eyes are usually the same size as each other and symmetrical, and the space between them is equal to the size of an individual eye.

Mouth

The mouth is second only to the eyes in expressing an individual's character. When recalling appearance, its mobility is a major factor in establishing the likeness, and this makes it one of the most difficult features to draw convincingly. It is continually moving, responding to emotions from despair and fear to anger and joy and being formed into a myriad of shapes to expel air in the form of speech. Smiling, scowling, shouting or whispering all depend on the mouth's complex of delicate muscles.

All the features are laid on the solid cylinder of the face and the eyes and nose are symmetrically placed on it so that each eye and nostril is mirrored by the other. In the case of the mouth, however, there is a complication to this general rule; the mouth itself rests upon a cylindrical base – the set of teeth – overlaid on the basic form. Therefore the diminishing lines of perspective will be on one plane for eyes, jaw, nose and hair but on a different level for the mouth. Close examination will help you to understand these subtle angles – especially the study of master drawings in the three-quarter front view. These drawings by Rubens, Ghirlandio, Degas and Watteau will teach you a great deal about facial structure and the relative angles of eyes, nose and, especially, mouth.

Other features

The nose lends itself very well to rules of perspective, having as it does the two wings of the nostrils on either side of the centre line of the face. By carefully locating it in position centrally placed between the eyes and the mouth, it is possible to draw the nose through an understanding of light source and shadow rather than by the use of line.

The lower jaw is hinged to the main bony form of the skull and it moves to open the mouth, the only independent power of movement in the skull. Because of this the

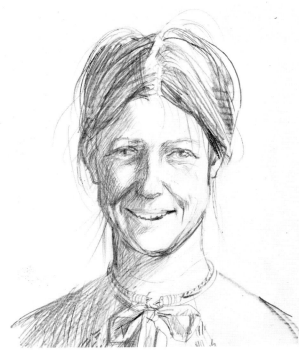

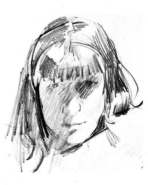

Above and left:
In a smile, the eyes are narrowed from below, resulting in the upper parts catching the light, creating the well known 'twinkle in the eye'. This narrowing is caused by the corners of the mouth pushing up the cheek muscles and the pads of fat under the eyes. In a scowl or frown the eyes are depressed at the outer corners, creases accumulate in the middle of the forehead and the eyes are dull.

head is inclined to move slightly backward when the mouth is opened very wide.

The neck is a cylindrical form that curves slightly forward. It consists mainly of a pair of strong muscles on each side of the head which attach into the pit of the neck beneath the chin. The chin is lower than the nape of the neck as seen in profile and from the front the neck is the same width as the face. Pitfalls in understanding the form of the neck are many and of several kinds; sometimes it is stuck vertically on to the chest, the base of the neck as low at the back as in the front, or is too thin to support the head.

*F*EMALE *PORTRAIT*

OLD WOMAN
12 x 17½in (31 x 44cm)

A rapidograph is an excellent drawing instrument because unlike other fine pens, for example mapping pens, it does not suffer the ink starvation which interrupts the drawing process. It is possible to make extremely fine lines and to draw continuously, relying on a full flow of ink. An artist should take a disciplined and objective approach to a portrait study – flattery and compromise can play no useful part in the acute analysis of form necessary when embarking on a drawing. In this case an elegant, ageing model has been honestly described. The creased flesh, which has lost its former elasticity, is faithfully rendered by the delicate marks of the pen. The curves and hollows of the face are further elaborated with hatching to establish the tones.

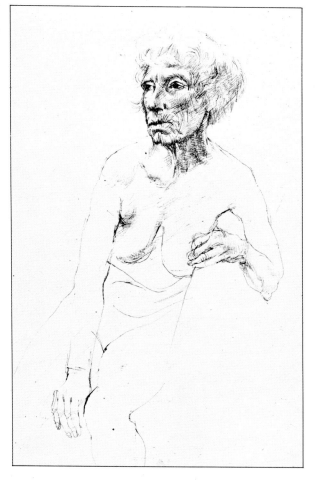

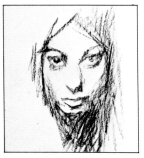

GIRL WITH LONG HAIR
7 x 12in (16 x 31cm)

A simple portrait in charcoal is given a dramatic and brooding character as the artist has moved in on the face. The large, deep set eyes are starkly framed by the hair. The unmodified, pale tone of the face seems lit theatrically against the heavy surrounding tone

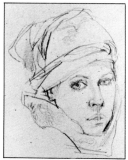

GIRL WITH SCARF
15 x 22in (38 x 56cm)

The model for this pencil sketch on toned paper had a towel wrapped round her head after washing her hair. The appearance is reminiscent of the style of classical Flemish portraits, as is the three-quarter view of the face, the most popular choice in all portrait poses. A headscarf similarly alters the mood and gives a new aspect to the subject.

Throughout her lifetime, a woman's face can reflect many moods. At any given time, for instance, the same features within a mother's face can show love, concern, worry or compassion – qualities that are reflected in quite a different way from the same ones in the face of a man. The task of the artist, therefore, is not only to depict accurately the physical differences between female and male features; it is also to capture these inherent, subtle, variations in emotional reaction between the two.

As in all drawing, the best way to learn is through experience, both in terms of practice and close observation. The latter allows you to assess even more than immediate and instinctive reactions and enables you to recognize – and capture – every extreme nuance of expression, however understated.

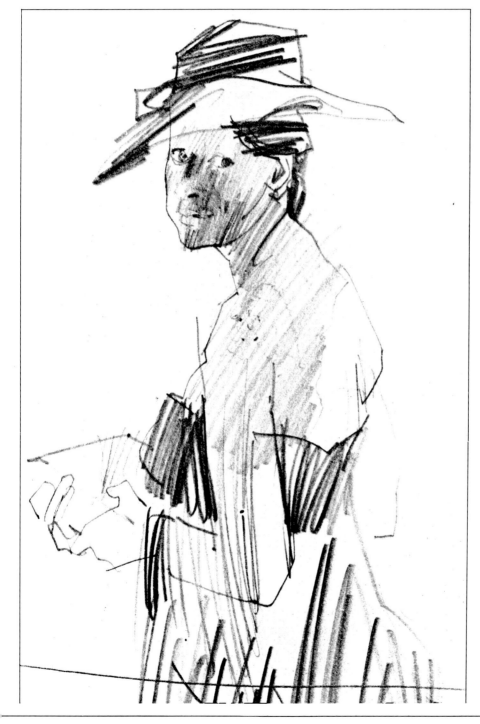

GIRL IN SUN DRESS
11 x 15in (27 x 38cm)

This pose forms an interesting shape as a whole and the face is nicely framed in the position of glancing back over the shoulder. When arranging the subject, it is worth considering some way of emphasizing the natural elegance of the features and here the neck and shoulders form a graceful line around the axis of the figure. The drawing is one of a series of sketches towards an oil painting and in such circumstances many different elements can be tried in the pose and clothing of the model. The heavy tone on the dress and hat gives the artist an impression of how the painting will balance when color is applied. The line which cuts into the drawing horizontally defines an alternative positioning of the image on a canvas, should it be decided to alter the proportions. The detail (**below**) shows how the pencil is held at a shallow angle to produce the broad, grainy lines in the hatching.

MALE PORTRAIT

Top: Use the side of the stick of charcoal to shade your support and make a consistent gray background from which to work. Rub the charcoal dust into the paper with your hand to distribute it evenly; even with a fine-toothed paper the grain will show through this layer.
Above: Dust your prepared support gently with a rag to remove excess charcoal before you start to work.

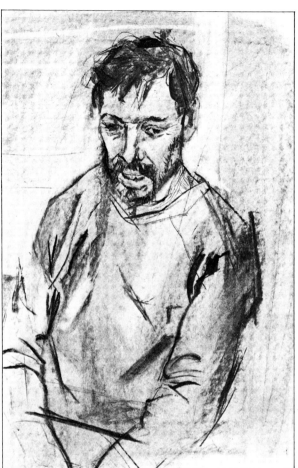

MALE PORTRAIT
24 x 18 in (61 x 45 cm)

Charcoal is a particularly suitable medium for portraits, one of its main advantages being that refinements can easily be made and the drawing can remain in a state of flux until the desired effect has been achieved. This portrait uses plenty of dark tones and gives a good impression of the somber mood of the sitter. Charcoal smudges easily and work should be 'fixed' as soon as it has been finished.

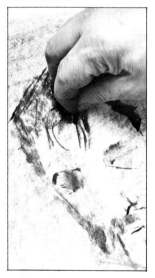

Above: The side of the charcoal stick can be used to put in details as well as for shading large areas. Alternatively, hold the piece of charcoal as you would a pencil.

The male face is dominated by extremes; its harder, more acute, lines must always determine the general feel of the finished drawing. Male portraits, therefore, should be approached in a different way to those of women or children. Lighting becomes particularly important, because the harder, bony brow of the male, the deeper recesses below the lower lip and above the chin and the thicker neck will all be better seen through high contrasts of tone. Traditionally, figures are lit from above, but drama can be increased and features emphasized by use of a different lighting system. One interesting variation is to light the sitter from both sides, with one light striking the subject directly and the other bounced from light paper. If the sitter has interesting features, best seen in profile, back lighting can be a useful method.

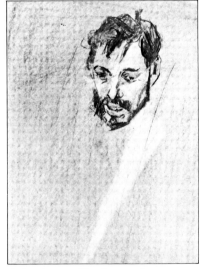

1. Many charcoal drawings are worked 'from the darks', a technique which requires the surface of the support to be covered with an even layer of charcoal forming a flat, mid-gray tone.

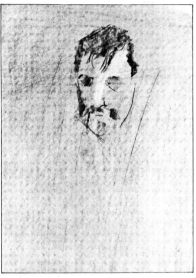

2. Use a kneaded or putty rubber to start picking out lighter areas, or negatives, so that the gray background is punctuated with white. Make the first positive marks, using lines or smudges of charcoal.

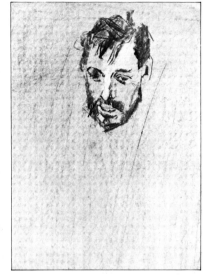

3. Start to pick up the expression in the face; remember to put in eyelids as well as the top line of the eye itself.

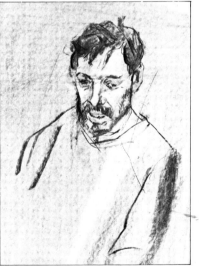

4. Continue working the negatives, rubbing back to leave wiped off areas which will indicate highlights.

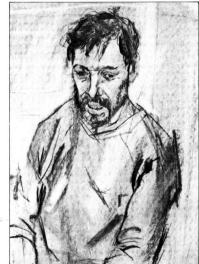

5. Build up the form of the body, using firm positive strokes to mark the outlines but concentrating on showing varying areas of tone.

6. Make final adjustments. Consolidation of both negatives and positives allows great scope for making changes, so that subtle alterations can be incorporated right up to the very final stages.

CHILDREN

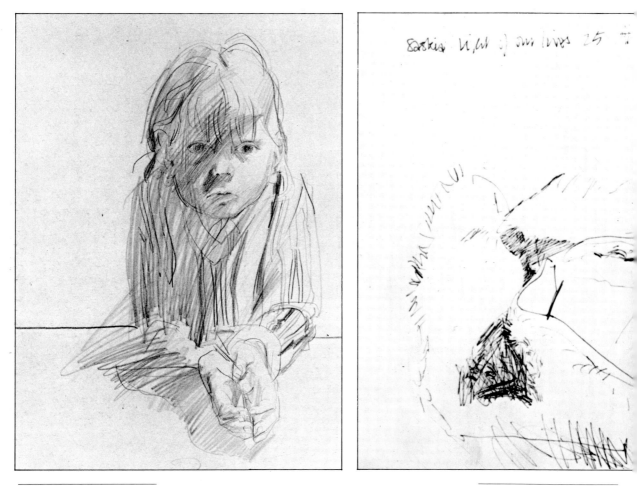

YOUNG CHILD
20 x 14½in (51 x 37cm)

The child's hands are drawn with the optical distortion apparent when working close. This device was deliberately emphasized as the hands were felt to be a distinctive feature of the whole pose. As usual when a child is the model, speed was essential and a 2B pencil was used on plain white paper to make a simple drawing in line and tone. Being forced to work quickly need not be a handicap but it is vital to avoid a superficial approach.

Children's faces contrast strongly with the strong, sculptured look often found in the head of a man and the elegance and interest of a mature woman's expression. They therefore deserve special study. One basic fact to remember is that there is a continuing change of proportion over the years as opposed to the slower rate of change in the adult face.

In babies, for instance, all the facial details are small in relation to the size of the head, while the neck, which at the earliest stages cannot support the head, remains thin and unstable for quite some time. Its entry into the base of the cranium also differs markedly from that of the adult form. The cranium itself grows only slightly larger, but the eyes seem over-large at this stage.

BABY GIRL
11½ x 8½in (29 x 21cm)

This brief note of the alert expression of a recumbent baby was drawn with a ballpoint pen on thin notepaper. Various details of tone and texture were required to explain the forms clearly and the artist was obliged to be quite inventive in this respect. This type of exercise – catching a fleeting moment with the materials immediately to hand – is well worthwhile as drawings can begin to appear stilted if you rely on familiar working methods.

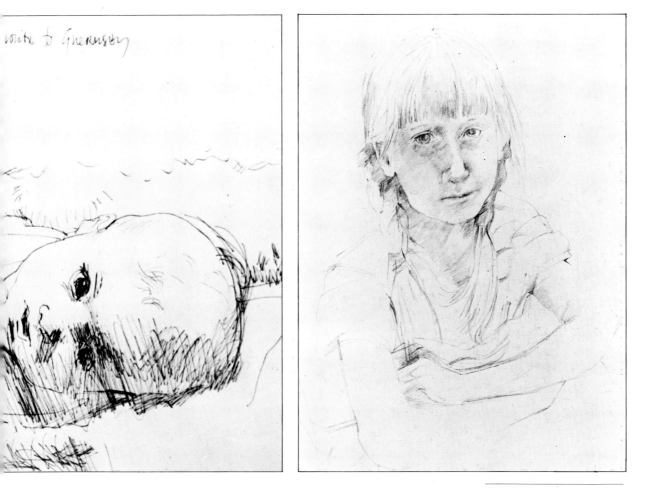

GIRL WITH PLAITS
14½ x 22in (37 x 56cm)

This sensitive drawing betrays a sympathy with the subject which illuminates the image. The fine pencil marks are reminiscent of the silverpoint technique which was an earlier drawing practice. The style is particularly well-suited to the feeling of gentleness and repose in the child's attitude. The lines in the drawing, whether fluent or broken short, seem to feel their way across the contours of the head.

Such factors present serious, but not unmanageable, problems. In addition, there are others, not the least of which is the problem of pose. Since it is a prerequisite of portraiture that the subject must remain at least tolerably still for long enough for the eye to sum up the overall form and probe deeper into individual shapes and nuances of line, choose an easy pose at first. A sleeping baby is often an ideal first study.

From such studies, you will gain the experience necessary to progress. In general, the techniques to be followed are very similar to those you would adopt for drawing wild life. Remember that although the process of putting down what you see on paper is obviously important, prolonged penetrating preliminary observation is the key to success.

GROUP PORTRAITS

Sometimes, you may find that drawing a conventional portrait of a single person palls. If this happens – or if you are presented with the possibility of a subject consisting of a number of people, rather than an individual – you should never be afraid to tackle it. The challenge brings with it not only new problems, but also new possibilities, based around the inter-relationships that must exist between the faces, the figures and the setting.

Some of the traditional principles of composition are well-suited to group portraiture. Single shapes can be contrasted with grouped ones, so that the picture surface is a kind of overspill of simple patterns, derived from and combined with complex ones. One key point to remember is that, while you are looking for contrasts in appearance to

make your drawing striking, these must never be overstated, or the result will look crude. Hair color is one of the main factors you should use to point up differences; the relationship of size is the other.

This need not only be the case when the figures are juxtaposed – sitting together at a table, or conversing in a clustered group, for instance. It can also be achieved by using relative scale on the picture plane. The laws of perspective decree that objects of similar size change their apparent size relative to each other, when seen at different distances from the eye. By placing the figures you are drawing in an imaginary grid – like a giant chess board – you can position them in such a way that large contrasts and complements small.

Above: The artist works from top to bottom of the drawing to avoid smudging the work unintentionally. Pen and ink, unlike pencil, is a medium which does not allow for much alteration to the drawing, so it is important to consider carefully the size of the figures, their relationship to each other and the placing of the composition within the rectangle of paper.

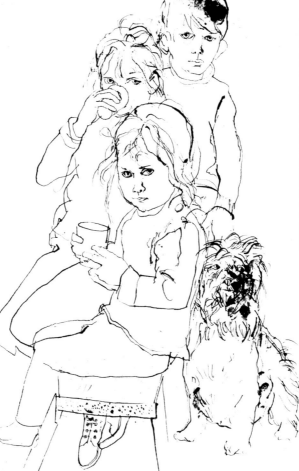

CHILDREN AND DOG
16½ x 23in (41 x 59cm)

The pyramid arrangement of figures in this composition neatly implies the mixture of curiosity and shyness shown in the faces of the children, as if they are drawing away from the artist while yet inquiring into his activity. Line drawing is used carefully here, never rushed, so that each detail is finely felt and expressed. The quality of the drawing has due consideration in its own right as well as in its relation to the subject. The suggestion of tone and texture in the dog and the little boy's hair is the result of lightly smudging the ink while still wet. Tiny areas of spattering to produce a dotted texture are made by tapping the end of the pen.

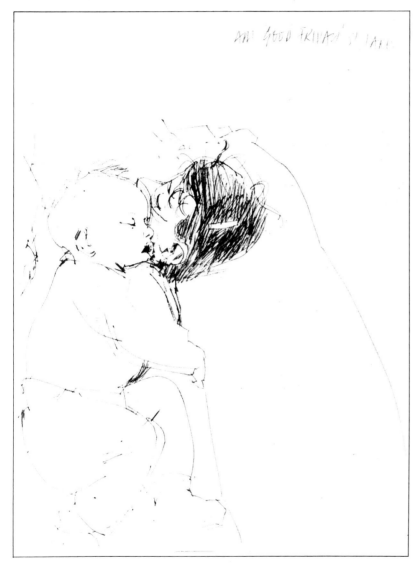

MOTHER AND CHILD ASLEEP
7 x 9½in (18 x 24cm)

The mother and baby lying asleep proved an irrestistible subject for the artist. Particularly interesting is the right angle formed in the relationship between the two figures. The viewpoint was probably determined by necessity and the drawing had to be completed quickly before either of the subjects should wake. The heads are quite similar in size, although the bodies differ proportionately, but the comparison is not directly made as only the baby is shown at full length. The tilt of the baby's head is well established by the position of the ear and linear detail showing the eye and nose. The form of the body beneath the pyjamas is hinted in the use of creases in the fabric at thigh and knee. Note how the curving lines at the ankle describe the solid cylindrical shape of the leg. Clothing and drapery is invariable descriptive of the underlying anatomical forms but each different fabric has its own character due to weight and texture.

GIRLS IN CAFÉ
7 x 10in (18 x 25cm)

This lighthearted study in ballpoint pen on cartridge paper (**right**) includes a drawing within a drawing. The figures in a seaside setting are indicated rather than investigated in depth. The fine lines traced across the whole paper surface describe a considerable depth between foreground and background features, moving from the appearance of the artist's own hand and work to a suggestion of the distant horizon.

The stress of the lines is quite even throughout the work and the perspective is provided by the degree of detail with which each part of the scene is described, so that the weight of the composition falls on the forms and figures within immediate range.

CARICATURES

All portrait artists know the value of the caricature; the element is contained in all good likenesses. The art is an extremely ancient one, many artists over the centuries having created caricatures along with their other work. Examples range from Leonardo da Vinci in the 16th century to Picasso in the 20th.

Traditionally, the caricature has been seen as a political art form, closely associated with social comment and criticism. Frequently, too, it is associated with humor – indeed, it is often attached to an intended smile or guffaw. The drawings usually tend to be in pen and ink, or brush and ink, largely because of the demands of photo-mechanical reproduction; however, both watercolor and pencil lend themselves readily to the art form.

Your main task is to extract the essential character from your subject by selection and emphasis. Often, these changes are of a very subtle kind, despite the popular notion that most caricatures are extreme in their distortions. A successful caricature preserves a balance between reality and exaggeration, retains a strong feeling of identification with the real world, yet underlines the features that best express the individual.

Below: The overall design of this drawing works extremely well and the various individuals comprising the band are described with great gusto and humor. The rich detail of physical shapes and features is neatly combined with a formal attention to pattern and tone. This expressive, if not particularly flattering sketch (**right**) was made as preparation for an etching. The atmosphere is vividly captured and the contrast of lightly traced lines and heavy stripes creates a lively image. This was achieved by delicate handling of a mapping pen and black ink.

Above: An interesting contrast is set up between the imagination exercised in drawing the physical features of this loping giant and the tasteful control applied to coloring the image. The success of such a drawing depends upon a knowledge of form, gained through careful observation, from which exaggerations and distortion can be projected. The figure is drawn in detail and delicately tinted with washes.

Left: In common with other approaches to painting and drawing, a complicated caricature intended to convey activity and atmosphere must observe principles of balance in the composition. In the meeting of witches there is a strong interplay of diagonal emphases and a subtle use of complementary colors to create the space and set off one figure against another. Again, invention based on detailed examination of form gives power to the artist's expression of a fanciful subject.

Political comment in cartoon and caricature has a long history and these drawings by Ralph Steadman (**left**) show the range of possible images which may occur as the artist follows a basic idea.
The symbolic dollar sign is put to use figuratively (**center far left and left below**) while the other drawings graphically illustrate a different aspect of the idea. The linear qualities in the drawing vary from sketch to sketch and this will later aid the artist in introducing tonal emphasis and textural detail to a finished drawing based on these roughs. Comment on a particular situation is also implied in the drawing of doctor and patient (**right**), but this artist takes a light hearted approach.

Above: These sketches were made at an airway terminal and they vividly capture the resigned air of concentration which the subjects display as they are kept waiting. The drawings were done with ballpoint pen, originally in a sketchbook of white paper. In transferring them to a pad of tinted paper, the artist has added another dimension to one (**above left**) by silhouetting the form as a cutout shape. The sketches are essentially quite simple but a wealth of detail is described in patterns and textures, and in the sharp observation of facial features.

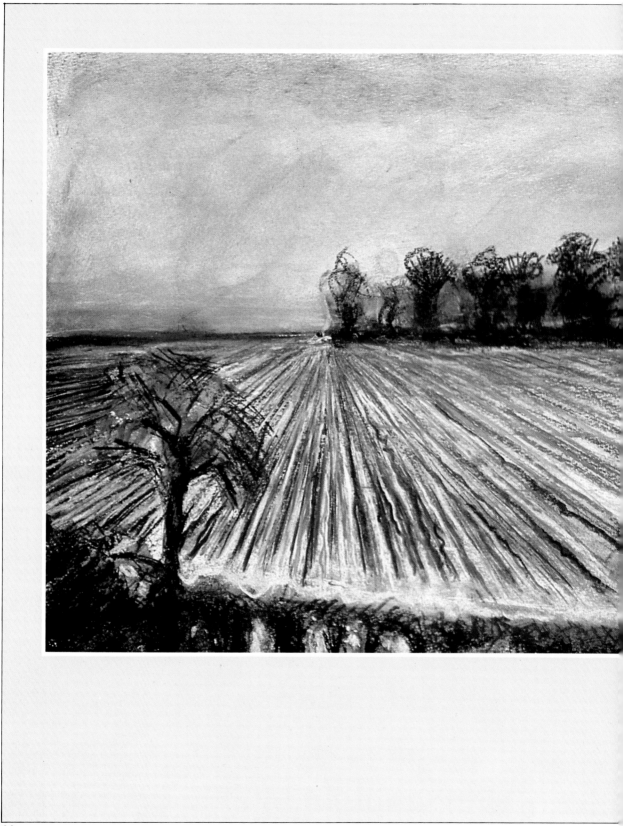

LANDSCAPE AND ARCHITECTURE

IT SHOULD BE THE AIM of the landscape artist to encourage others to view the familiar surroundings amongst which we live as though never seen before. There is a great deal of pleasure to be found in attempting to view things afresh, with a personal vision, and transmitting this unique approach via the final picture; bringing features so little regarded into a tighter focus will encourage the viewer to look again, and more intensely, at the landscape.

It is not enough simply to copy exactly what you see; adjustments are often necessary, perhaps in the scale of relative parts or in tones. When selecting a point of view, bear in mind the quality that inspired you to choose the scene in the first place, possibly a good skyline, the varied character of some tree shapes or a particularly fine sweep of hills. Urban scenes can frequently provide just as much interest as the more obviously beautiful rural views. You may find that it is necessary to remove a feature altogether if it is spoiling your view; the perfect landscape is very hard to find and the results you achieve will depend on what you can do with the material available.

Above: Different media and styles of drawing can help bring a sense of freshness and discovery to familiar views. Tony R. Smith has used pastel and conté crayon over wash to make an effective drawing of an agricultural landscape.

LANDSCAPE ANALYSIS

One of the most important aspects to be taken into consideration by the landscape artist is that of the composition or proportion of his drawing. A well known formula put forward as a guideline is that of the Golden Section, described in Chapter 3; if you were to take a number of landscapes produced entirely instinctively it would be interesting to note how many of them conformed to this ideal, particularly as regards the division between the sky and land masses.

Rules, however, should never be allowed to become a stranglehold on the picture being produced; they should be resorted to as a useful starting point, as for instance when working a large scale work from a tiny sketch containing information but little else. Thumbnail sketches, scribbled fairly quickly, can be a great help, perhaps covering several variations in location and a different selection of elements.

Light plays an important part in determining the atmosphere of your drawing. As well a creating the general mood, it can also be responsible for dramatic effects, with strong light giving rise to deep, dark shadows or an unusual quality causing a weird unnerving glow. Geographical location will affect the quality, as will the time of day. The qualities of thin, early morning light, of midday sun high in the sky or of warm evening light can totally alter the scene

Right: The composition of this drawing of boathouses and trees on the banks of a river was arrived at by means of a series of preliminary sketches (**below**). It is just one solution to the problems presented by the view chosen by the artist and is a combination of some of the ideas sketched out in an exploratory way.

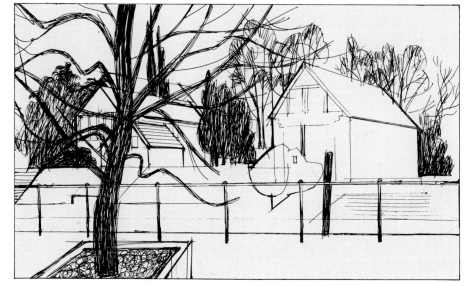

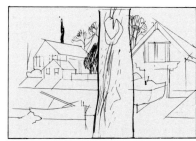

View 1 The tree is dominant, splitting the picture plane down the middle. It is an unsatisfactory solution, allowing the tree, not a particularly interesting form in itself, to occupy about one fifth of the drawing; the boathouses, occupying most of the rest, are too symmetrically balanced.

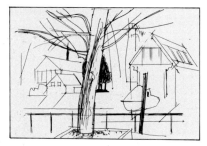

View 2 The draftsman has moved back, allowing the horizontal shapes of boughs and branches to occupy the top of the composition. Tonal stress is more varied, and a railing is introduced to the foreground to give a stronger sense of lateral and vertical structure.

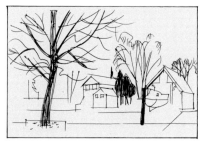

View 3 Another shift of position allows the eye to read from the main tree form in left foreground into the middle distance across the river. An unfortunate coincidence of verticals divides the picture into three and the mooring post on the right coincides with the edge of the boathouse.

Above: The same view, but completely different effects. Lighting is one of the most important factors to be taken into consideration when planning a landscape drawing; as an exercise, it is well worth taking the trouble to return to the same place at different times of day and make sketches to compare the view under different lighting conditions. You may find that it looks at its best in the cool, flat light of very early morning, or with the sun overhead at midday, when the shadows cast are few but very dark, or with evening light casting much longer dramatic shadows. A change of viewpoint can also make the same building or view appear completely different. In the photograph **right,** the interest is provided by the perspective of the building; viewed from straight on (**below right**) it is its sheer mass and architectural form that somehow make more of an impact, with only the contrasting irregularity of the trees to detract from the strength of the visual image. In contrast with the large masses of complete buildings, you may prefer to concentrate on a detailed drawing of smaller areas. The verandah **far right** is an excellent example of a subject worth close observation and a minutely detailed approach.

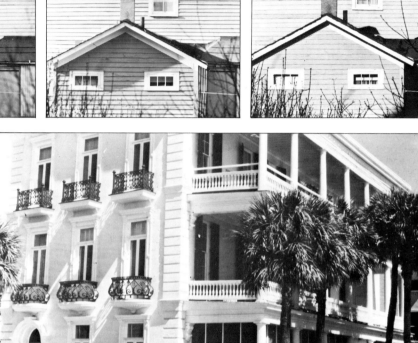

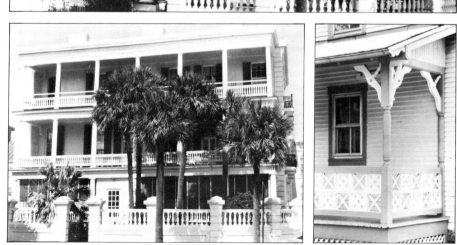

123

LANDSCAPE

We all are affected by the landscape around us; it has a profound influence upon the way we live and our view of life. We appreciate it not simply through our eyes, but with all our faculties; the changes of weather, wind, sun, the dark and the dawn all become a part of our experience.

All these factors have combined over the centuries to form an intrinsic part of the artistic tradition, together with the different reactions each individual view produces. This occurs on two levels. The apparently limitless horizons of moor and downland, or the sea, obviously encourage different reactions to those produced by the harsher lines of a dense cluster of buildings. How these reactions are interpreted, however, totally depends on the nature of the artist. He or she can produce a romanticized view of a rural landscape, or a dour and somber one of a townscape; equally, the townscape could be approached romantically and the rural scene more realistically.

What you should aim for are inventive and surprising angles, views and atmosphere. Edward Hopper's New York rooftops, for instance, differ from the landscape etchings of Rembrandt, or the sketchbook drawings of Turner, just as the places shown vary. Start with a familiar subject and look at it in the most concentrated way possible, even before making a single mark on your support. This kind of concentrated consideration will often surprise you and your eventual drawings can only benefit as a result.

As you explore the possibilities, you will find that landscape is a subject with many advantages. It stays still, except when blown by winds or lashed by storms! It can take on many different and interesting moods. Light moves across fields and trees, for instance, to bring rapidly

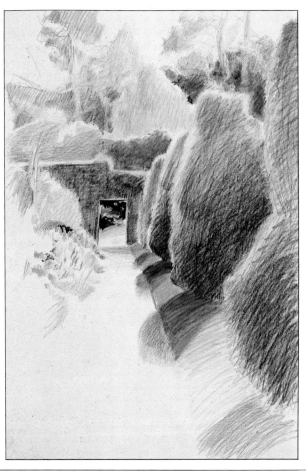

GARDEN SCENE
15 x 22½in (38 x 56cm)

When practicing landscape drawing it is often unnecessary to travel far to find appropriate subjects. Your local park or, in this case, garden can provide plenty of interest and variety. The strong, dark shapes of the yew trees contrast with the bright, delicate flowers.
Above: Use a technique of hatching and cross hatching to build up several layers of color.
Left: Test the effect of a dark background by cutting out a piece of dark paper of an approximately similar shape and holding it in the appropriate area.

1. Lightly draw in general composition, paying particular attention to the yew trees which are the strongest forms and to their shadows.

2. Block in the masses by building up layers of hatching, using an underlying Naples yellow or Cream for the yews to provide a light surface other than that of the paper itself.

3. Continue to build the color and shape of the yews, overlapping various colors – a bluish green, a bright dark green, Purple, Burnt Sienna, Vermillion red.

4. Put in cross hatching to build up color until the final effect is achieved.

5. Work more detail into the background and into the middle area of the drawing, adding definition to flower bed on left using Orange, Crimson lake and Yellow.

6. Put in a dark background – Tuscan red, Black, Real green, Peacock green, a red; Buttermilk to lighten real darks. Balance back and foreground shapes.

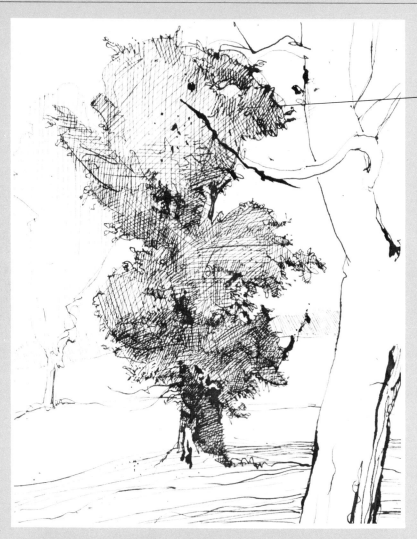

TREES IN PEN AND INK
8½ x 30 in (20 x 33 cm) above
12 x 8 in (31 x 20 cm) right

When drawing trees the most interesting aspect is generally the overall shape, whether concentrating on one tree (**above**) or placing several in a landscape (**right**). With very little pressure, allow the pen nib to move around freely to achieve a very loose effect. Many layers of overlapping are possible; you can cover your tracks as you go. Try to work with a light pressure. If you press heavily you will both wear the nib down making the line less interesting, and pick up too much paper, so that it acts as a blotter.

Crosshatching (**left**) can be used to develop dense and varied tonal areas.

1. Block out the general composition, thinking in terms of the three planes – fore, middle and background. Put in hatching to develop the middle tree, the most carefully indicated part.

2. Use crosshatching to round this tree out into clumps; for leaves, suggest multiplicity by intervals between dots and tiny marks. Put in background tree more carefully.

3. It is easier to put in the back tree by hatching, using very delicate lines close together, than by drawing a straight line. Dark lines on the front tree suggest the foreground plane.

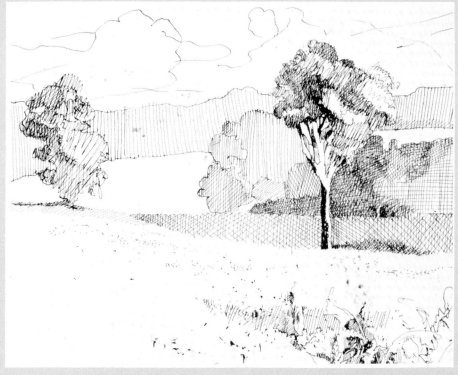

shifting relationships of tone and color. Skies, which are sometimes thought to be the single most important feature in a landscape drawing or painting, also vary widely. They can range from leaden gray, dark and threatening, against which features stand out as bright and highly contrasted, through the huge, cloud-filled variety to a bright, clear backdrop to rich foreground detail. Never fall into the trap of disregarding the sky, or relegating it to the status of insignificance.

Bring this same perception to the question of color. Green is the dominant color of landscape, but it is easy to make it thin and acid. It requires real sensitivity to achieve an effective, living, vibrant foliage, or grass, green. You can only achieve this by constantly varying the range of

ABSTRACT LANDSCAPE
15½ x 20½in (39 x 52cm)
A simple approach to perspective in this drawing, done with pen, brush and waterproof ink. Although the forms are given impression rather than detail, the carefully noted differences of scale and tone in each area of the image serve to suggest distance and recession. Indentations on the pathway are indicated to lead the eye through the foreground plane and the rolling moor behind, studded with dark patches representing trees and scrub, describes the dip and rise of the skyline.

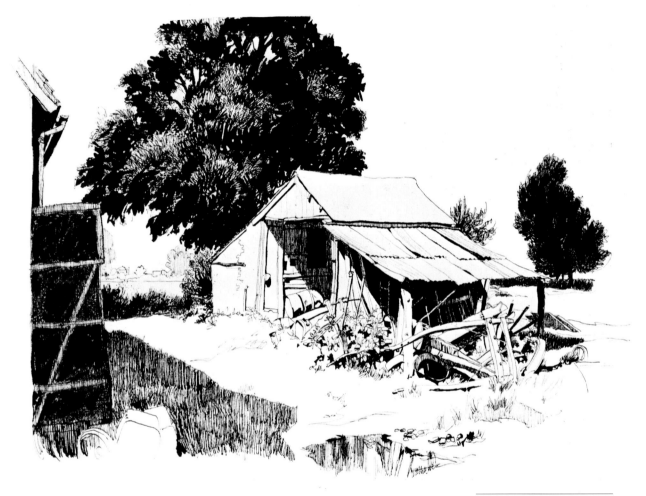

color with which you are working; no single green can possibly reproduce accurately the range of colors seen in nature.

Each element of a successful landscape will have the same degree of careful consideration brought to bear on it. Here, associations and identifications are likely to be involved and decisions made accordingly. Wind, for instance, causes movement. It bends trees in the direction in which it is blowing, while the sky will generally be light in tone. Therefore, all parallel surfaces, such as lakes, fields and rivers, will tend to be light. Objects standing against the sky – vertical forms such as trees and buildings – tend to be dark. Use such simple, basic guidelines to help you select a viewpoint and a theme, or subject.

FARM OUTHOUSE
17 x 12½in (43 x 31cm)

The subject chosen here enables the artist to relate strong areas of dark tone to line drawing of a highly descriptive kind. Heavy cast shadows and the dense foliage of the trees are put down in black, but because of the nature of the pen marks this is not a flat, lifeless tone but is enlivened by small areas of white and rough texture. The dark tone is carried right through the space described in the drawing, from the foreground on the left to the trees at middle ground and distance.

URBAN ARCHITECTURE

For many people, an urban environment is the most familiar setting for both work and recreation. This makes it an immediately accessible subject for drawings, and it may renew your interest in your neighborhood to walk through it with an eye to aesthetic features. Complex arrangements of walls and rooftops and the rich colors and textures of buildings invite interpretation in various media and techniques.

Landscape can be created effectively in monochrome. Here, bulk and the sense of massive distance and weight of

VENETIAN SCENE
30 x 22½in (77 x 57cm)

A combination of pencil, gouache and watercolor on toned paper allows the artist to include many details of line and color in this architectural study. The line drawing is approximate rather than a slavish rendering of rigid structure and this gives the work its original character. In the same way the color is not strictly accurate, but it establishes an idea of light and shade and impressions of local color in stone and brick enlivened by strong touches of green, blue and red. Pencil shading is also used to indicate dark tones and linear drawing with a brush loaded with white gouache (**detail center left**) is used to pick out highlights. Details of the watercolor washes (**above and below left**) show that the pencil drawing dominates the structure of the composition, color being laid carefully into quite complicated outlines.

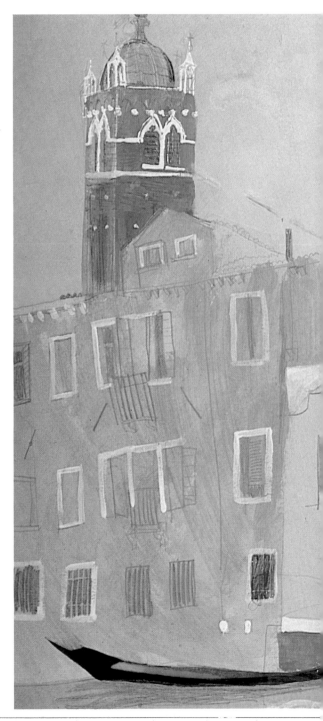

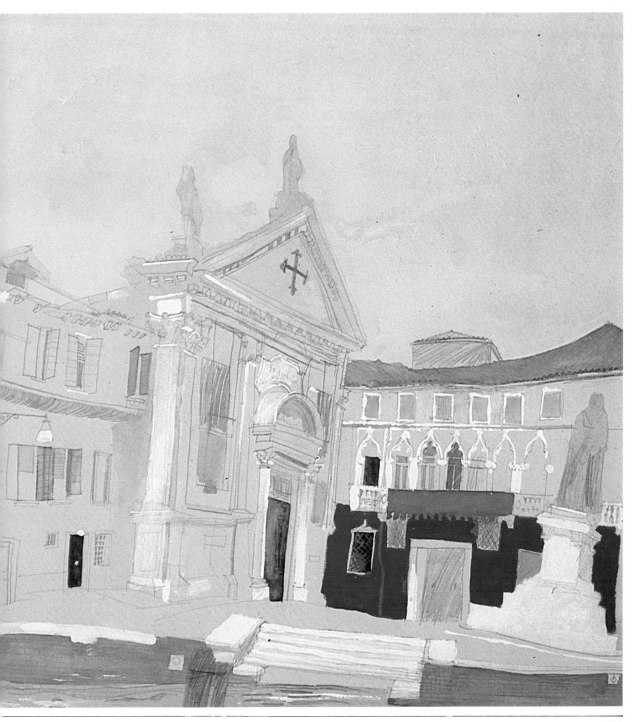

TERRACED-HOUSES
17½ x 14in (44 x 36cm)

Pencil is an excellent medium for drawings in which the artist wishes to include all the complex details of a densely textured subject. Such a drawing requires patience, skill and minute observation and the results can be highly rewarding. A 2B or 3B pencil can be given a fine point for linear detail, but is also soft enough to provide a good range of tones. Heavier pencils may be useful for putting in areas of pure black or grainy grey tones.

the parts involved are the things you should aim to achieve. An archaeological site, for instance, is ideal for such a treatment; large standing stones, or deep ditches, will take dramatic shadows, just as trees do in a different context. Avoid the pitfall of sitting square to lines – whether of stones, trees, or hedgerows. Taking a diagonal view can bring additional visual interest, if properly exploited. The composition, too, should be thought of as endlessly changeable, as is the stuff of nature itself.

Obviously, it is best to work on location, whenever possible, though your sketches can serve as a basis for a reinterpretation of the subject in the studio later, if you so desire. Some artists use photographs as visual reference points and certainly the photographic technique of backlighting – used to sharply delineate the silhouettes of trees, for instance – is a telling effect that can form the basis for an inspiring interpretation.

Do not feel inhibited by the conventional approach to media. Graphite powder, rubbed onto the surface to create

VIEW OF CHURCH
14 x 20in (36 x 51cm)

In this drawing the artist has combined the use of pen and ink, pastels, oil paint and turpentine, pencil and chalk. This mixture of materials and the bold spirit informing the work are intended to suggest the vigor of a building which has stood against the elements for centuries. The invention with which the scene is depicted shows in the rich textural effects. Ink is etched into the paint both with the pen and with the pointed, wooden end of the paintbrush to vary the quality of the lines. The intention in this drawing was to develop a visual equivalent to the impressive character of the church, to reflect the impression of what was seen.

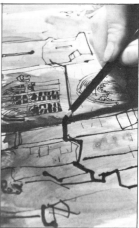

Paint applied with a sponge (**left**) has a different density and texture from color which is brushed in. Light sponging produces a mottled texture but repeated applications give a flatter, more opaque tone. The variety of linear features in this drawing is achieved by combining ink laid with pen or brush and the use of heavy black pencil and crayon (**above**). Drawing and painting mediums are interwoven to create depth of tone.

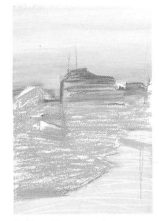

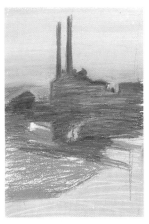

1. Block in the major shapes – the mass of the building, mud bank and towers. Put the sky color right over the chimney area, rubbing it into the paper with your fingers.

2. The color of the water, although similar, is less hot than that of the sky, together providing two different light shapes intersected by the dark mass of the building.

3. Pastel is more or less opaque, but a light will not cover a dark so the sky has to be finished before the chimneys are put in. Start to put in areas of dark shadows across the mudbank.

4. Build up layers of color experimentally on the chimneys and building; it is easy to rework pastel, trying different combinations of colors – for example Burnt Sienna, Ultramarine and Deep purple.

textures and lay in general tones, is an excellent way of beginning. It is easy to carry and easy to apply, as long as a strong wind does not scatter it from your hand! Use a torchon with it and elaborate on this basis with pencils, or pen and ink. Remember you will need to fix your work with the appropriate spray if this method is adopted.

As far as media are concerned, colored pencils have a special place, particularly when you want to capture the effects of sun and shadow. You can use them to build up layer upon layer of subtle color, the end result being almost transparent in texture. Pastel also produces surprisingly subtle results and can be blended with the fingers to produce areas of solid tone. Cross-hatching is a valuable foil when trying to achieve differentiation in tone and emphasis. When using graphite pencils, a putty rubber is a valuable aid in creating highlights, while pen and ink lends itself to spattering and other interesting effects.

Never reject a possibility as too difficult to tackle. Rain, for example, brings in its wake fresh visual excitement, while the late evening sun, shining red through low cloud, will create interesting long shadows and warm lights. Snow, or mist, will transform even the most familiar of landscapes into something exciting and different. The range of possibilities is almost endless and the suggestions given here are no more than ideas

You will need some knowledge not only of linear pers-

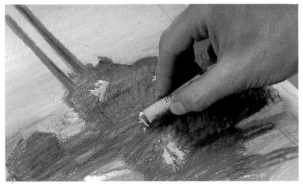

Right: Although it would not be possible to cover the dark of the buildings with, say, yellow, pastel is a sufficiently opaque medium to enable light areas to be worked into the pale tone of the sky as one of the finishing stages. **Above:** Put in some of the lights to provide contrast and interest.

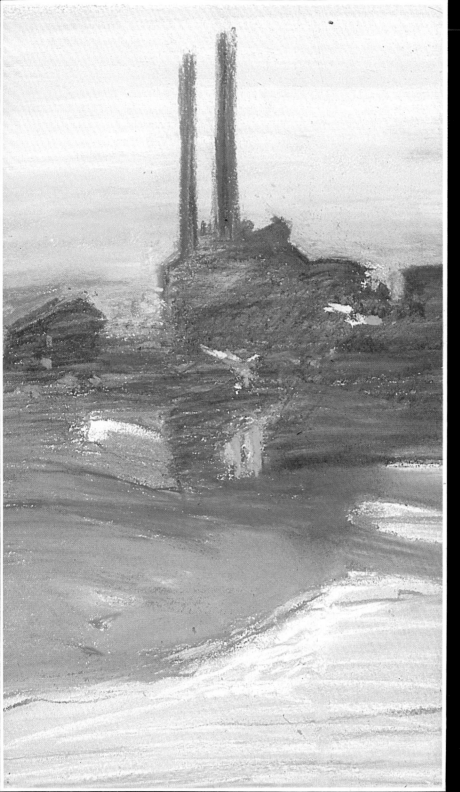

POWER STATION
12 x 16in (31 x 41cm)

Although applied stroke by stroke, pastel can be blended with your fingers to produce surprisingly subtle results and build up blocks of fairly solid tone. The dramatic, abstract effect of this drawing is achieved by concentrating on the contrasting areas of light and dark and the interesting shapes they make.

ST PANCRAS STATION, LONDON
13 x 18in (33 x 45cm)

A drawing intended to be a precise record of architectural detail requires much initial preparation, confidence in your technical skill and a good deal of patience. Here all the decorative elements of the old station have been faithfully recorded and the firm but sensitive handling of linear style does not waver. The detail (**right**) shows part of a rough study made to provide information for the finished work.

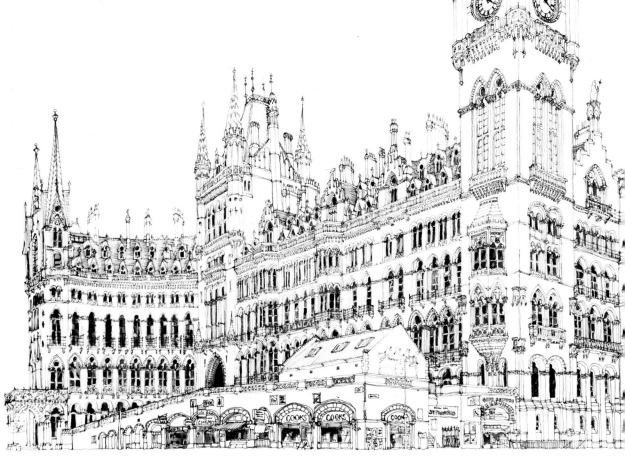

HOUSE IN CHARLESTON, USA
10 x 8in (25 x 20cm)

An elegant façade fronted by tall palm trees provides plenty of pattern and texture for a detailed pencil drawing. In this state it can be seen how the outline of the forms has been drawn in quite accurately to establish an overall sense of design and the artist has worked back over individual features to elaborate tones and the decorative effect of shutters, columns and a wrought iron gate. Pencil is the ideal medium for this type of work as it is precise and delicate but can be erased if necessary to enable adjustments to be made.

pective, but also of aerial, or atmospheric, perspective. The latter is the effect of distance on definition, with objects in the foreground being stronger in tone and tonal contrasts within forms than those in the middle distance. These, in turn, are stronger in relation to things in the far distance.

As the tones lessen in strength, they take on an increasing blueness. A range of hills or a building in the far distance, for example, is likely to be almost entirely seen as a limited scale of light blues and blue grays. Objects in the middle distance will appear to be a greenish blue, while foreground features will appear in the full range of colors and tones, almost as if existing independently. You must formalize these visual facts into a reliable system of working. Examples of how this can be accomplished can be seen in the work of Poussin, Turner and others, while Leonardo da Vinci makes reference to it in his writings on painting.

Remember, too, that although it is important to be true

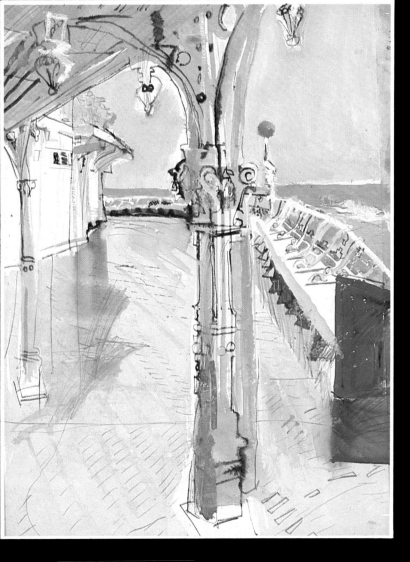

BRIGHTON PIER
14¹/₂ x 21¹/₂in (37 x 55cm)

Washes of watercolor and gouache establish distance, atmosphere and local color in this drawing but the impression of detail and texture is dependent on work with pencil and pen and ink. The strong vertical which divides the picture plane in the foreground is the focal point from which the other elements recede towards the horizon line. Different linear qualities are achieved by drawing with ink over both wet and dry paint so that in some places the line is crisp and precise while elsewhere it diffuses gently into lighter tones.

URBAN SCENE
9½ x 11½in (24 x 29cm)

The thickness of a pastel stick makes it more suited to a fairly coarse drawing style than to fine, detailed work. In this case the relative clumsiness of oil pastels has been turned to advantage. Broad, generalized color areas are contained by linear drawing to evoke the atmosphere of late evening.

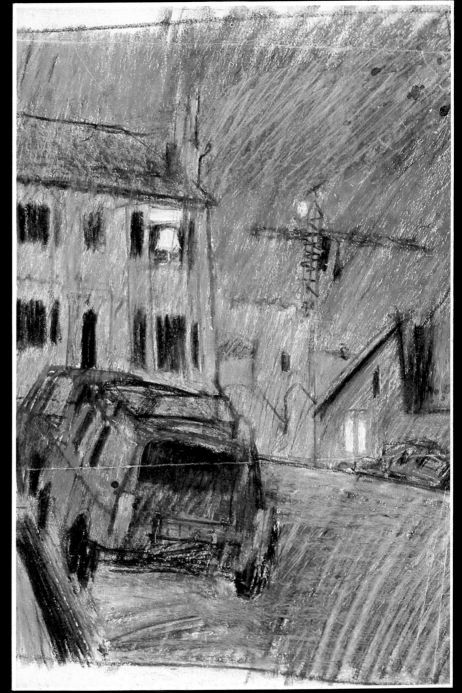

Dark tones created by a series of vigorously overlaid colors are occasionally relieved by small areas of bright color which represent the clarity of a lighted window shining through the twilight. The linear form of a giant crane rising on the skyline behind the buildings is treated with the finer marks made by a pastel pencil. The structure cuts across the grain of the underlying blue pastel marks

**DUNCAN STREET
DEVELOPMENT, LONDON**
14½ x 9in (37 x 23cm)

There are many fine aspects of an urban environment which may provide a subject for drawing, from closely observed details of individual buildings to sweeping views following the length of a whole street. To create an artist's impression of a building yet to be erected the artist must project from ground plans and elevations and combine this with knowledge of perspective and observed information from the locality to describe it vividly as if in finished form. This example was drawn with fibre tip pen on watercolor paper, with conte crayon used to add a grainy tone. Although this is a highly specialized discipline it is a useful drawing technique and the idea of projecting a view might be of interest when you have developed a thorough knowledge of a town or city.

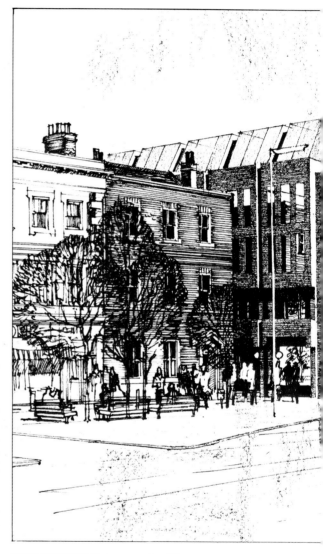

to nature in your choice of colors and so on, it is almost inevitable you will have to make some adjustments in your version of the natural scene. It is a good idea to use a viewfinder at the outset to help you select a suitable composition, while the composition itself can be strengthened on occasion by moving an object within your drawing, or even introducing an element into it! Such creative licence has been used by many of the greatest landscape artists over the centuries.

Above all, be practical, especially when you are working, whether in rural or urban areas in the field. Always pre-plan your day as far as possible, so that you can limit the amount of equipment you are taking with you to what is really necessary for the drawing in hand. There is nothing more annoying than struggling to carry a lot of heavy and cumbersome materials, only to find that you could quite easily have left most of them at home. In some urban settings, speed is of the essence and you may well find yourself having to take prompt action to avoid oncoming traffic. Always be ready to sieze a passing opportunity, too; many of the best landscape drawings and sketches are the result of an impulse, rather than meticulous, careful rendering. They need not even fill the whole of the support!

Right: Experiment with different media to find the best way of rendering skies, trees and brickwork; conté crayon and felt tips can create some particularly interesting effects.

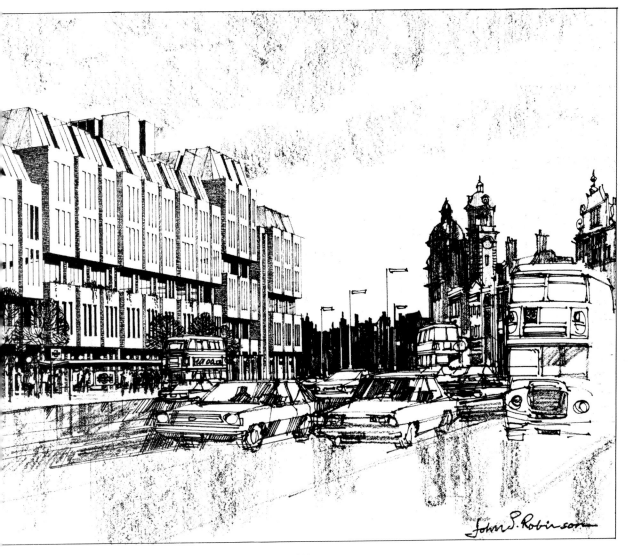

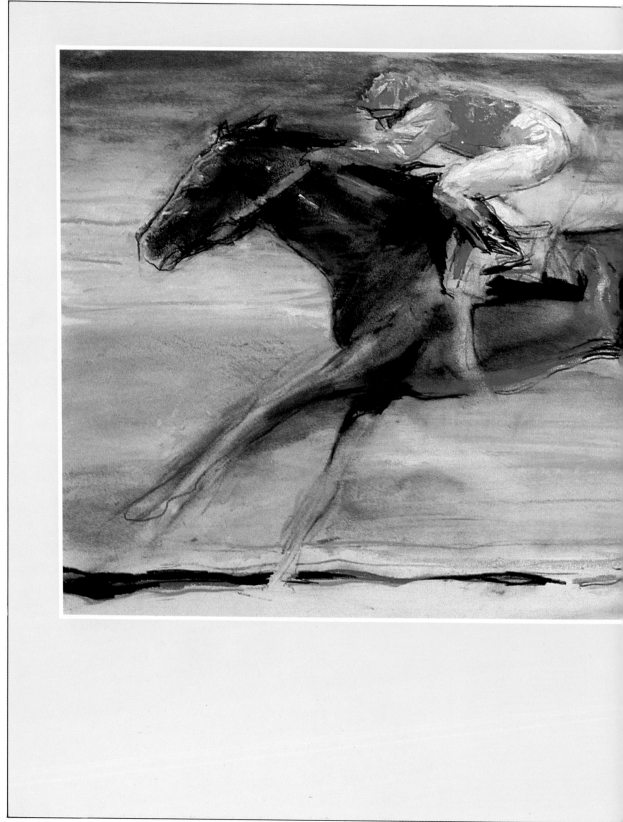

STILL LIFE AND NATURAL HISTORY

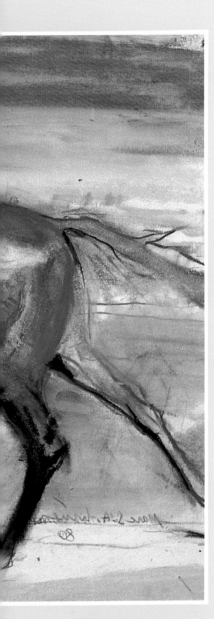

Above: Marc Winer's drawing of a galloping horse provides an excellent example of the accuracy and detail at which you should aim when drawing birds and animals.

THOUGH STILL LIFE as a subject area is more commonly associated with painting rather than drawing, there is no reason in the world why it should not prove suitable for you as a draftsman. One of its chief virtues is one of convenience; in the still life's commonest form, drawings are created from the everyday objects of life, often with strikingly attractive results. To capture the form and relationship of a group of pots, pans, jars and fruits – the traditional components of the still life – as and where they occur is frequently highly rewarding. An alternative is to mount a deliberately staged arrangement of objects.

Here, composition has an important role to play. A useful aid to this is the viewfinder, a rectangle of the same proportions as the support to be used and through which you can view the subject in varying ways. By holding the viewfinder at arm's length and looking through it, it becomes possible to decide upon the best composition simply by moving it fractionally up and down or from side to side.

Natural history is also a favorite subject for artists and draftsmen. Here, the essence of drawing animals and birds from life is speed and immediacy. Note that your subject matter is not confined to the animate; it includes shells, sponges and even stuffed animals and birds!

STILL LIFE ANALYSIS

Three aspects to be taken into consideration when setting out to draw a still life are the selection of objects to be drawn, the arrangement of your group and the way in which it is lit. The most mundane of everyday objects can make suitable subjects for still life drawings; there is no need to go to any expense in buying things specially. Their arrangement is one of the most important stages and it is worth spending a considerable length of time trying out alternatives.

Light sources are usually from above – either the sun or artificial light. Light from a single source such as a window is also common. It is important to remember that this light will not all strike the forms you are drawing directly; some will pass it by, only to strike other planes and bounce. This will lighten the supposedly dark side of a form, and will be a particular aid in describing spheres and cylinders.

Arranging a still life 1. A symmetrically arranged group such as this is in danger of becoming predictable. Classical triangular structure is to be recommended, but all the items are at the same level, and this is parallel with the bottom of the picture.

2. A rearrangement of similar elements, in which the angles create a more dynamic series of shapes. Some fruit is grouped together and single fruits offer contrast. Although still based on a triangle, this group has more visual potential.

3. Here, rhythmic elements are harnessed, the hyacinth and drape providing contrasting linear sweeps. The busy surface of the upper area contrasts with the lower surface, as does the staccato effect of the small fruits.

LIGHT AND TONE

In the diagram of the sphere, most of the light from above and the left hits the sphere, but some travels on, bounces off a vertical plane and returns to lighten the dark side. The darkest area on the sphere is at the greatest point of turn, and this is a good general rule to be observed. The lighting of the cube, coming from above and left, causes two differing tones on the planes, the one furthest from the light source being the darkest. Shadows help establish the surface on which the cube stands.

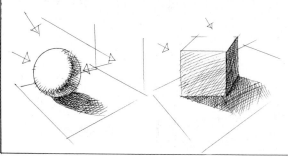

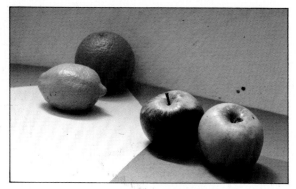

Practicing on simple shapes will give you an opportunity of observing the effects of light and tone. Here, the shadows also provide a point of interest, those cast on the gray paper being less distinct and clearly defined than those cast on the white.

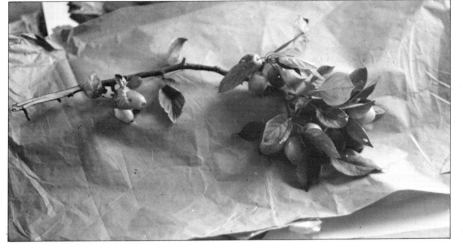

The choice of subjects for a still life depends partly on which aspect of drawing interests you most. In the photograph **left**, the background paper is as much of a challenge to the artist as the branch of crab apple itself, providing a middle tone and a crinkled texture. The very simple nature of the items **far left** is emphasized by their newspaper support; in this case color and contrast is provided by the background posters so that, once again, the background has an important part to play. The close-up view of a sliced orange (**bottom, far left**) would give a draftsman ample scope for exploring texture. Texture is also an important aspect in depicting the complex shape in the flowers **below left**; this group would also require an understanding of the effects of backlighting. It makes a pleasing composition with the jug of flowers framed in the window and urban architecture in the background. One very rewarding way of drawing natural history is to leave it in its natural environment, as in the case of the water lilies below, 'arranged' to much better effect than would be possible if they were pulled up and carried home to the studio.

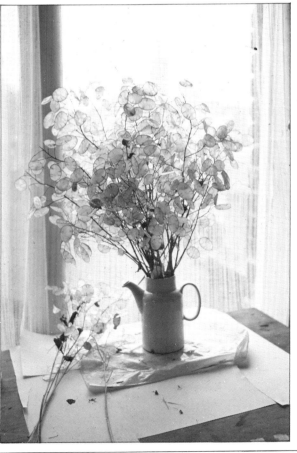

STILL LIFE AND NATURAL HISTORY

Everywhere your eye falls possible still-life subjects come to light. Remember, though, that this vast potential brings obvious pitfalls in its wake. An obvious trap is that of making a fleetingly glimpsed, fortuitous arrangement substitute for a well thought-out and balanced design, even though the former has its own charm and energy. When the eye takes in a picture, it is the organization – that is, the relationships of shape, size and texture – that is the first to be seen and appreciated. This is the abstract element every picture possesses, one which is always present and which any artist disregards at his or her peril.

You should always consider carefully the relative scale of the things you are drawing. Should the final design use objects of similar, or different, sizes for instance? Can you comfortably work with a rich interlacing of filigree and fretwork, or are these too similar in feeling? Should you contrast one or two elaborate objects with simpler shapes and forms (this often creates good potential designs)? Whatever you choose, each element will have at least two roles to play – as an object containing its own characteristics of weight, shape, form and so on and as part of the whole. Another trick well worth bearing in mind is to offset an area of intense visual activity with calm, simple patches of tone. This, too, will heighten your composition's interest by introducing a feeling of contrast.

Natural history inspires artists in all kinds of different ways: some in the close examination of a hedgerow;

STUDY OF BOTTLE AND GLASS
12 x 16in (31 x 41cm)

It is not difficult to find suitable subjects for a still life drawing; basic everyday objects that are readily available can make interesting pictures – as always, it is not what you draw but the way that you draw it that is important. **Above:** Putting in the ground color, avoiding the area of the base of the bottle and glass and rubbing it into the paper with your finger. **Left:** Using a dark color to put in shadow on the stem of the glass.

1. Take care when making your initial drawing – it is difficult to make each side of the bottle and glass the same as the other.

2. Start to build up color, using your finger to smudge and blend a number of colors together and work areas of lights and darks.

3. A light background defines the dark shapes of the glass and bottle, emphasizing the tension between them – they are similar, but the glass is smaller and rounder.

4. Work shadows and reflections on the glass and bottle; there is nothing mysterious about reflections – just keep looking hard to see where highlights should go.

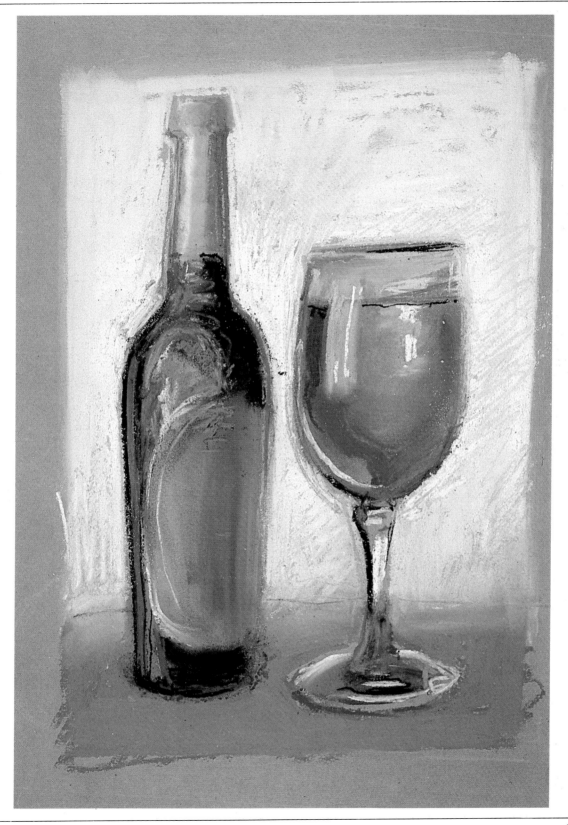

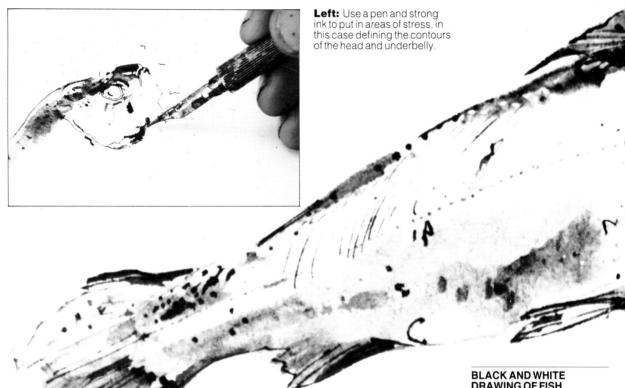

Left: Use a pen and strong ink to put in areas of stress, in this case defining the contours of the head and underbelly.

BLACK AND WHITE DRAWING OF FISH
22½ x 15½in (57 x 39cm)

Any commonplace, easily obtainable kitchen object makes an interesting subject for a still life drawing; an elaborate and expensive group is certainly not necessary. Pen ink and wash is an ideal medium for working detailed markings and surface texture, allowing for frequent adjustment and correction. Various strengths of ink have been used – strong for stressed areas, in washes of varying density and very dilute to suggest scaling.

others in a riverside study of water rats, or otters, at play; some in the lofty flight of an eagle, or other bird of prey; still more in a closely-worked drawing of a lion cub or the gentle face of a doe in her natural surroundings. Whatever the subject, the challenge is to capture it in a way that combines accurate depiction of what you are seeing with the spontaneity of the unrehearsed event that is taking place before your eyes.

The chief technical problems that have to be taken into consideration are those associated with capturing the nature of movement, while still showing the true nature of form. Here, experience naturally brings its benefits – speed of execution, as long as it does not bring with it sleight of hand and avoidance of the necessary acute observation, will show movement better than a slowly stippled study. For a beginner, however, it is probably better to work from sources other than life at first; making a detailed study of a dead bird, for instance, will enable you to discover the best

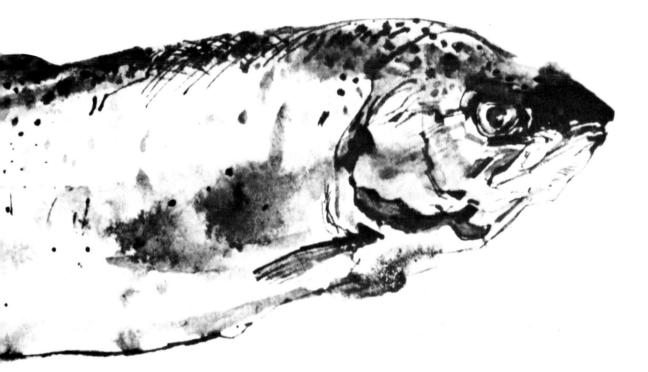

1. Start drawing with diluted ink rather than pencil to get the main shapes and proportions of the fish; try to indicate the interrelation of the various parts rather than expending a lot of effort on achieving a perfect outline.

2. Continue to work on basic shapes, using a brush to put in wash at this early stage so it is an integral part of the drawing. Develop tones to pick up the form, and strengthen the contour lines.

3. Suggest the surface texture of the fish by adding various tones of wash, being certain to leave areas of highlight. On the back, spot marks into a wet wash so that they blur.

4. Draw the tail, observing linear detail to get the radiation correct. Put in eye detail with a fine brush and stipple stronger markings into the back. Continue to work details and adjustments.

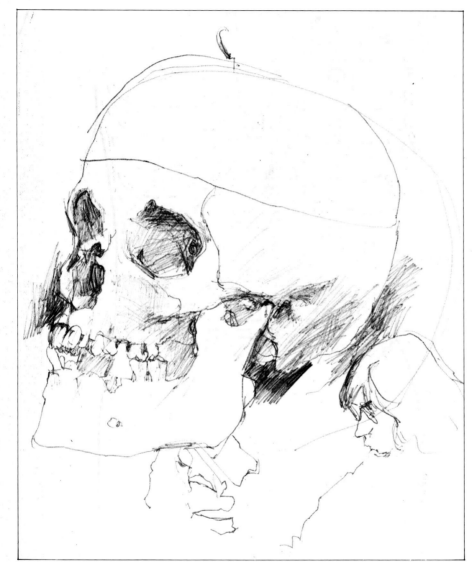

RHUBARB
7 x 10in (18 x 25cm)

Nature studies are an endless source of interesting material and present an opportunity to practice many techniques. Colored pencils can easily be carried with a sketchbook so that the delicate structure and rich hues of plant forms can be noted. The drawing of rhubarb (**right**) is one such example and proves that with simple, portable materials no chance encounter with a suitable subject need go to waste.

SKULL
6 x 6in (15 x 15cm)

Museums and collections offer opportunities for prolonged study and provide information on cultural heritage and basic anatomy, both real and as interpreted by earlier artists. The skull (**above**) was a specimen used for drawing exercises for a group of students. In the ballpoint pen study a close-up view shows details of the bone structure and includes a brief sketch of a fellow student.

BEARDED MAN
9 x 15in (23 x 38cm)

A charcoal drawing of a male head (**above**) is unmistakably from an effigy, not from a live subject. The heavy grain of the paper encourages a subtle use of tone and is also evocative of the stony texture of the ancient sculpture.

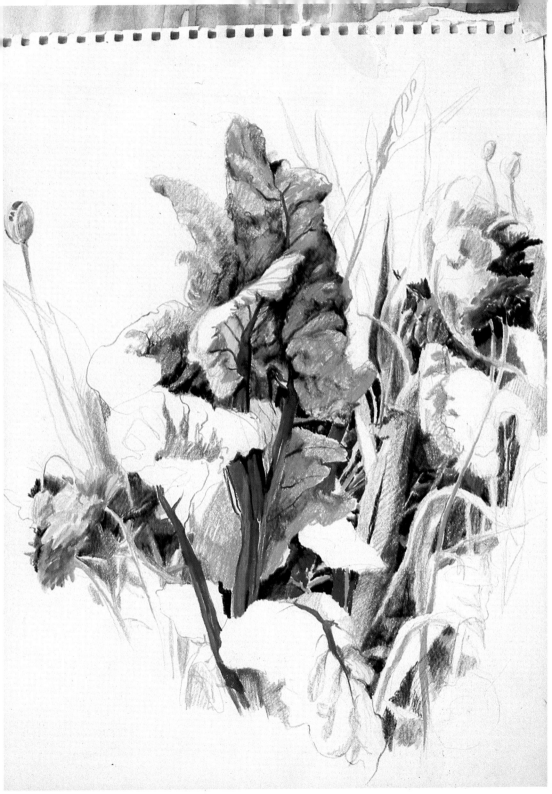

BLACK-THROATED DIVER
14 x 10in (36 x 25cm)

This type of study is typically drawn from a stuffed specimen bird in a natural history museum. In this way the artist has time to examine thoroughly the details of form, color and pattern. This fundamental understanding of the appearance of the bird can then be put to use in work from life, where the subject is moving too freely to be seen in such minute detail. It is then possible to fuse the lively impression gained from studying the creature in its natural habitat with an accurate perception of its true characteristics. Written notes on color provide very useful reference, particularly if the drawing is called upon long after the initial study.

marks and tones to use to describe the lightness of its feathers. In addition, you should practice drawing details related to the overall structure of the body, the claws, or the shape of the wings in enlarged form. Such practice is much more than a mere exercise in drawing. It can be used as a basis for a subsequent finished study and certainly is essential if you are to develop an adequate understanding of anatomical detail.

Having such reference ready to hand is particularly important, especially when you consider the nature of the materials you will be using for the finished drawing. Pastel, for instance, is very much suited to some natural history subjects. Here, you sketch in the outlines lightly to provide a framework for the eventual blocks of solid color. Pencil – particularly when used in combination with a color wash – is also extremely suitable, while willow charcoal and pen and ink are both highly suited to certain subjects.

Above all, never be put off if your first studies seem unsuccessful. If you cultivate the habit of intelligent observation, an awareness of the structure of the things you are drawing and, where appropriate, work hard to master the secret of how they move, you will have established the foundation for eventual success.

In this initial stage of the drawing of a bird of prey, a general impression of tone and color is lightly laid in. Ink applied with a dry brush technique on coarse paper gives the grainy effect and a light wash is also used.

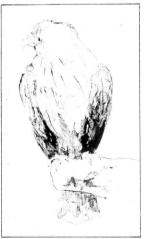

After lightly building up a denser tone with the brush, the artist starts to work into the shape with a pen to articulate the form. With hatched lines and a variety of swift strokes, the feathery texture is described.

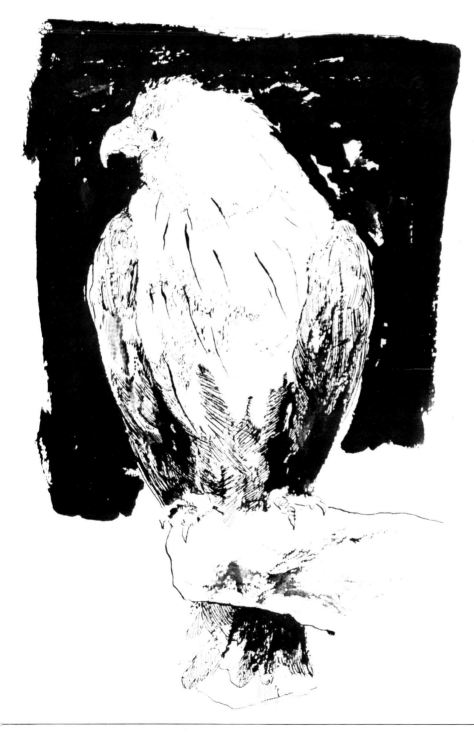

EAGLE
9 x 12in (23 x 31cm)

The grandeur of a large bird of prey deserves careful study and this is possible in a zoo as the confined situation encourages the birds to sit very still for long periods of time. Pen and ink is a highly suitable medium for such a drawing as the marks made are necessarily linear or textural and correspond well to the complex mass of feathers. In addition, there is often a definite tonal contrast in the coloring of birds which is readily portrayed in black and white. The shape of the bird in this drawing has been finally emphasized by laying in a heavy black background which frames the light-toned head and balances the drawing.

Above: The grain of the heavy paper does not easily flood with ink, so as the background tone is painted in the effect is of broken color, especially as the brush begins to run dry. The texture prevents the black from deadening the drawing and produces an effect in keeping with the whole work.

LEOPARD
17 x 13in (43 x 33cm)

Animal studies require much patience and concentration in examining and describing the nervous, energetic subjects. In this drawing of a leopard, the general color was roughly laid in with diluted paint, applied with a rag. Over this, heavy patches of oil pastel were used to add detail of color and pattern and the sinuous lines of the creature were fluidly drawn with pencil and pastel (**left**).

CHIMPANZEE
13 x 15in (33 x 38cm)

A chimpanzee is more restless even than a big cat so this drawing developed in a series of separate marks over a period of half an hour. Caged animals tend to repeat behavior patterns and it is possible to gather information gradually as they come and go. An initial drawing in red chalk was consolidated with free strokes of a soft black pencil to imply the form and express the texture of the soft fur of the animal.

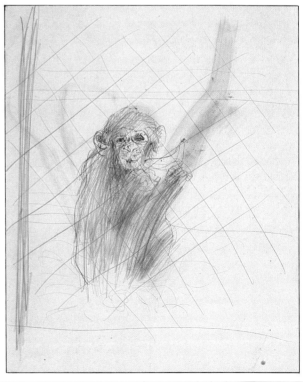

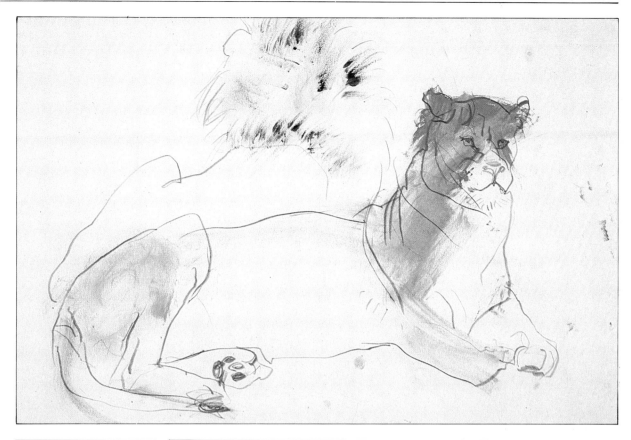

LIONESS
17 x 13in (43 x 33cm)

This lioness, as if cooperating with the artist, sat in the same pose for a length of time in which a drawing could reasonably be made. The image therefore expresses the feeling of solidity and power which is so characteristic of these large felines. Smudges of Yellow ocher acrylic paint were put in to indicate the length of the body and rise of neck and head. Over the dried paint, the contours were firmly drawn with a 4B pencil. The shape of the lion behind, almost forming a mirror image, was more briefly described, with small touches of ocher and Burnt umber to suggest the ragged mass of his mane.

CAT
10 x 13in (25 x 33cm)

The peaceful domesticity of this cat is an interesting contrast to the temporary relaxation of the zoo animals. A combination of paint, pastel and pencil is used to express the soft bulk and attractively colored fur of the creature. The general rhythms and shapes are broadly defined and enhanced by intermittent concentration on the tabby patterning. When using a combination of materials, it is worth risking failure in the effort to achieve a lively and original drawing. If different qualities of tone, texture and color are freely mixed the result is often encouragingly successful, but even if the image is lost, the work has provided valuable experience which cannot be encountered by playing safe with familiar techniques.

FLOWERS

1. Start by drawing the basic forms of the main flower, trying to get the effect of the radiating petals. Work out the tones of the inner forms; they are complex and must be very closely observed.

2. Be certain to make the smaller flower relate spatially to the one above. Draw in the stems and leaves, making a definite contrast between the fairly simple forms of the leaves and the complexity of the flowers.

3. When drawing the attendant blooms, keep them simpler and use a straighter, more linear technique so that they have less tonality than the foreground head and recede in comparison.

Varied textures, colors and shapes all make plants and flowers one of the most attractive and challenging artistic subjects. The spectrum of what you can draw ranges widely; you can choose to create a simple study of a single flower, or, at a more ambitious level, you might decide to draw a complex, sprawling ivy, or a complicated flower arrangement. Whichever you choose, remember that plant drawing is a mixture of still life and natural history. Obviously, you can set up many subjects in the studio, but, at the same time, you should never forget that what you are drawing is a living thing and should be rendered as such. One of the best things to try is putting the plant – your main subject – into the most natural setting you can find. The surrounding colors will frequently make the final study more sympathetic.

Pencil is the ideal base medium, since its use will enable you to achieve high standards of draftsmanship. The tool gives you the ability to capture the intricacies of detail and so analyze the problems of shape and form. Make the best possible use of the chosen support, allowing the plant almost to 'grow' upwards and outwards across its surface. Use color sparingly, but decisively, making the fullest possible use of the resources of mixed media. A slight descriptive touch of local color, for instance, can enliven the study of something as simple as a rose twig.

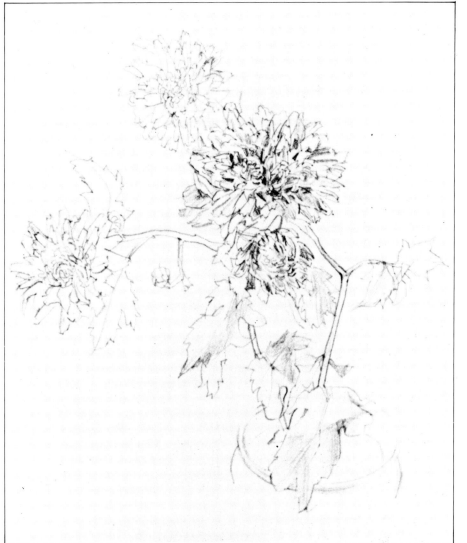

CHRYSANTHEMUM
15 x 20in (38 x 51cm)

Plant drawing is both enjoyable and extremely challenging; somehow it must suggest the continuing life of the subject while ensuring great fidelity in the detailing of leaf, petal and flower. A major consideration should be the retention of the overall solid form, while describing the fragile, intricate quality of petal and leaf. The fold of form over form in petals and of interlocking and interchanging planes in leaves must all be expressed and explained. Close observation is the clue to achieving the best results; we see these things so clearly in real life that to summarize or paraphrase would be a betrayal of the truth. **Below left:** The outer shapes of the flowers are fairly simple and can be drawn quite firmly, whereas the inner areas (**below right**) are much more diffuse and complex and should be very closely observed.

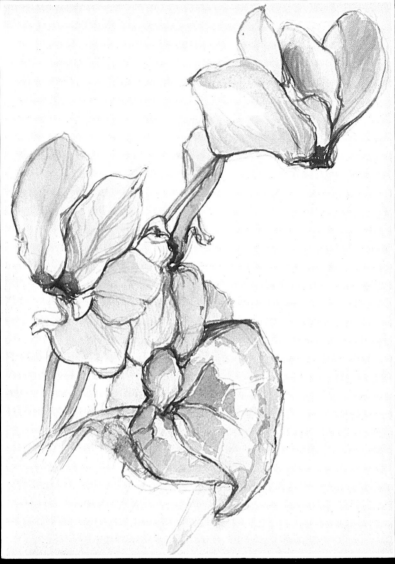

The finished drawing of this cyclamen shows how the use of watercolor has produced a finely rendered version of the finished form. The basic drawing is carried out in the same way as you would if you were using a pencil and enables you to establish both basic shapes and work out the finer points of detail. The wash-like treatment of flowers and leaves gives the subject that added touch of life which is the hallmark of all good plant and flower drawing. Help nature to help you by making sure that any plant or flower you draw remains in peak condition for the entire time it is in your studio or on your drawing board.

CYCLAMEN
6 x 7½in (15 x 19cm)

It is possible to 'draw' in watercolor, using a signwriter's brush. This is a particularly suitable method for depicting the flowing shapes of flowers and leaves. Use the same technique as when drawing in pencil, but remember that wet lines will smudge. It is possible to achieve a great variety of line – from thick to very thin – and a wider range of darks and lights

than when drawing with pencil, when the darkest tone is soon reached. **Above:** Place the cyclamen where you can see it as clearly as possible – perhaps on the drawing board itself; it is necessary to observe very closely indeed when making a still life drawing.

1. Start to make your exploratory drawing, using a signwriter's brush and watercolor. Use very faint, dilute color to begin with and gradually work up the strength of the line.

2. Continue to look for the form of the plant how the leaf is shaped and folds into the stem rather than the actual pattern on it. Remember that when you go over areas again to 'redraw' it is necessary to let the paint dry first.

3. A light wash helps to distinguish between the two areas, leaf and flower, and sets them off against the white of the paper. Continue working and reworking the line to suggest internal shapes.

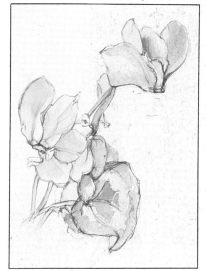

4. Strengthen the washes to introduce more color. Purple added to both the red and green will tie the areas together. Make the foreground shapes darker. washing out some of the color with water to make less important areas recede.

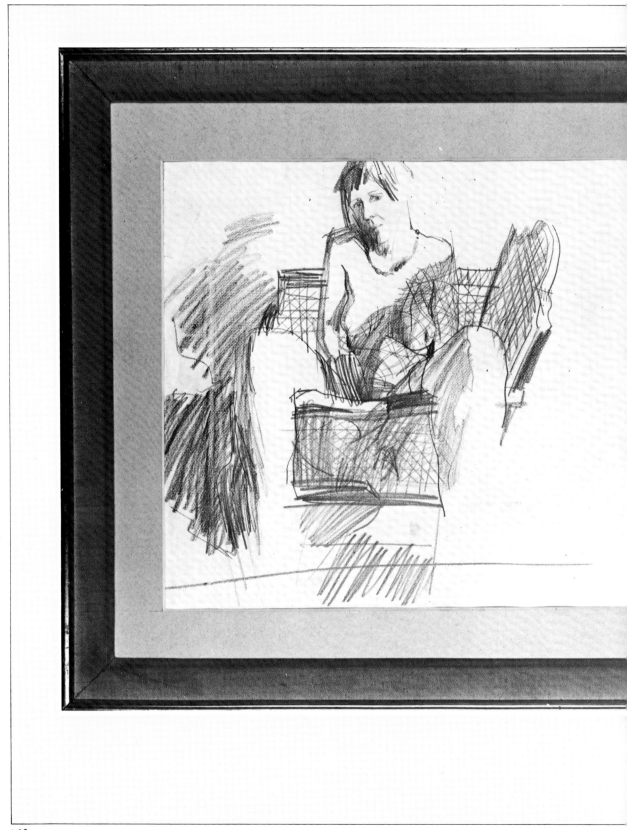

THE
FINISHED
DRAWING

YOU MAY HAVE no more ambitious plans for your finished picture than that it should grace the walls of your own studio or perhaps be given to a friend as a present. But even if you have no intention of submitting it to galleries, any drawing or painting will look much better if it is properly mounted and framed. These jobs can be handed over to a professional, and indeed many small specialist firms will be happy to discuss alternatives with you and give you the benefit of their experience. It is quite possible, however, to do the work yourself, saving money and adding another dimension to the business of making a picture.

Even if much of your work remains unframed and unmounted, try to cultivate good habits in looking after your pictures. It seems a great pity to expend a lot of effort on producing a drawing or painting and then either to lose it under a pile of unsorted papers or to allow it to become damaged by one of the accidents which are almost inevitable when inks, paints, water and other spillable materials are in use. Always take the trouble to put work away carefully in a safe place such as a portfolio or plan chest.

Above: An unusual approach to mounting and framing, with the drawing placed asymmetrically. The way which you finish off your work can make a great difference to its appearance and this is worth considering carefully before you take any decisions.

MOUNTING

The procedure for mounting a drawing is different from that to be followed for a painting. A drawing is usually set within a mount inside the frame; this mount is cut with a bevel edge and is either of white card or of a restrained, neutral tone that is sympathetic to the work. Once the drawing has been mounted, one or several lines may be drawn round the inner edge of the mount using colors that either reflect or contrast with those used in the mount or the drawing.

Another distinction between the treatment of paintings and drawings is to be found in the glazing. By tradition, oil paintings are unglazed – framed without a glass cover – but watercolors and drawings usually are glazed. The reason for this is that whereas oil, acrylic or other non-water soluble media can be wiped clean of dust, watercolors and drawings cannot and so must be protected. A glass cover will also help to protect a drawing from the effects of direct light and sun, making warping and fading less likely.

Above: If you plan to mount your drawings yourself it is worth investing in the correct equipment; this will help to ensure that you make a good job of finishing off your work.
1. Cutting board
2. Dividers
3. Set square

4. Fine sandpaper
5. Masking tape
6. Craft knife
7. Long steel ruler
8. Long straight edge

2. The four pin pricks mark the inside corners of the borders. Cut carefully from one pin prick to another, using a sharp Stanley knife and a metal ruler.

3. Check the fit of your picture under the window you have cut; double sided tape is helpful in positioning it accurately. Once you are satisfied with the position, tape it securely.

Cutting a window mount
1. Cut the board to size. To mark the inside edges of the frame, cut a template by measuring the width of the borders outward from a hole

cut in a piece of card. Place this template flush with each corner of the card in turn and make a mark on the board through the hole with a pin.

4. This mount has been cut with a bevel edge, at an angle of about 45°. It takes practice to cut a bevel edge successfully.

5. The mounted picture. An optical illusion makes it necessary to have the mount slightly deeper at the bottom in order to make it appear that the painting is centrally placed.

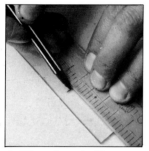

Cutting glass 1. Glass cutting tools are quite easy to handle but if possible, practice on small offcuts of glass until you are quite confident. Mark the glass for your frame with the measurements, checking these carefully and using a set square and ruler.

2. Rest the glass on a flat supporting surface, place a metal rule between your marks and guide the cutting tool along the ruler. Picture glass is quite fragile and if the surface on which you are cutting is not absolutely flat, pressure may cause it to snap.

3. Glass cutting tools are available in different sizes. The head is set so that the wheel which makes the cut is centered.

4. Make a score in your glass and place this along the edge of a table, letting the excess glass snap gently along the cut. Make sure you cut your glass a fraction smaller than the inside of the frame so that it is not wedged in.

Dry mounting with an iron 1. Cut a sheet of shellac tissue slightly larger all round than the picture you intend to mount and tack it to the center back of the picture using the point of a cool iron and pressing lightly.

2. Trim off the edges to the exact size of the picture, using a steel ruler and scalpel.

3. Position the picture and tissue on your mounting card, already cut to size, and lift the corner of the picture to enable you to tack each corner of the tissue to the mount, again using the point of the iron only.

4. Lay a sheet of heat resistant paper over your picture to protect the surface and iron over this protective layer, exerting firm pressure and working from the center outward.

Mounting with rubber gum 1. Use a card or spreader to apply the gum to the card in smooth upward and downward strokes.

2. Cover the entire card, then apply gum to the back of your picture in the same way.

3. Place tracing paper between the glued surfaces, peeling it back as you apply pressure through another sheet of paper.

4. Use a cow gum rubber to clean off excess glue from the borders of the mount.

FRAMING

In common with all paintings, drawings are framed in order to enhance their appearance, concentrate the attention of the viewer and for protection. Choosing the frame requires just as much thought as the selection of the mount, and these decisions are mutually dependent, a coolly colored mount requiring a thinner frame and a warmer toned card a wider, stronger surround.

Frames are made from mouldings, readily available from artists' materials stores, and they come in a vast range of sizes, types and colors. Fashions change and the heavy rich mouldings of Victorian times are less popular today, having largely been superseded by simpler designs. Similarly, gilding is no longer indispensable; many frames are now finished in natural wood or covered with canvas or hessian. Suitability is a matter of opinion, but a few commonsense guidelines can be observed; too heavy a frame in too positive a color are faults easily seen and corrected. Other qualities, however, are less obvious. Texture, color, weight and depth have to be balanced up against each other and related to the drawing in question.

Although a professional framer will provide you with advice on mounting and framing, it is considerably cheaper and much more satisfying to frame your work yourself. If you feel hesitant about mitring, the shop where you bought your framing will often do this for you if you give them a ready-prepared list of measurements. When measuring, check and double check until you are satisfied that the measurements are absolutely accurate.

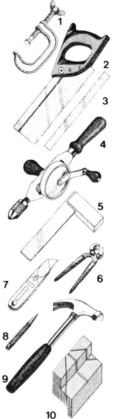

Left: As with mounting, the correct tools for the job will help to ensure successful framing.
1. Clamp
2. Tenon saw
3. Metal ruler
4. Hand drill
5. Square
6. Pincers
7. Stanley knife
8. Punch
9. Claw hammer
10. Mitre saw guide.
Below: Moldings are available in a wide variety of styles.
1. Box
2. Reverse
3. Flat
4. Half round or hockey stick
5. Raised bead and flat
6. Box
7. Spoon
8. Composite.

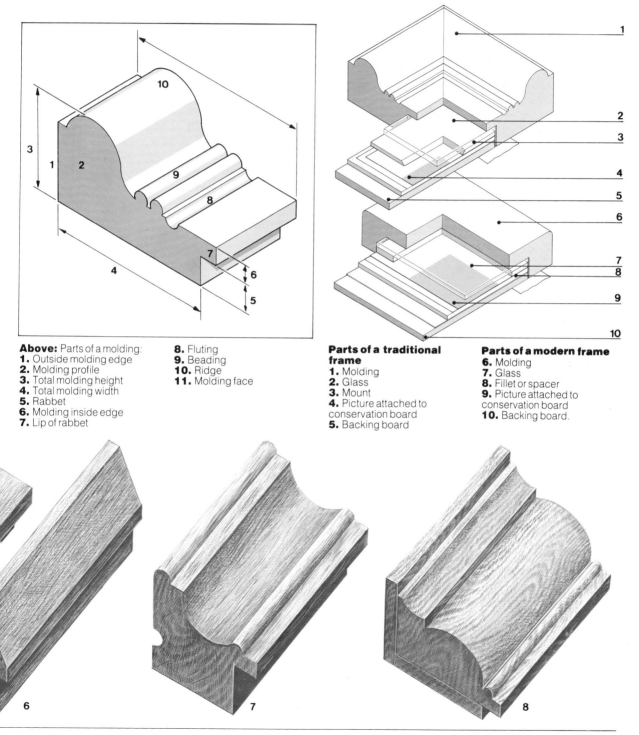

Above: Parts of a molding:
1. Outside molding edge
2. Molding profile
3. Total molding height
4. Total molding width
5. Rabbet
6. Molding inside edge
7. Lip of rabbet
8. Fluting
9. Beading
10. Ridge
11. Molding face

Parts of a traditional frame
1. Molding
2. Glass
3. Mount
4. Picture attached to conservation board
5. Backing board

Parts of a modern frame
6. Molding
7. Glass
8. Fillet or spacer
9. Picture attached to conservation board
10. Backing board.

Cutting a miter 1. Secure a length of molding in the miter clamp, protecting it with small pieces of spare wood.

2. Measure the length of molding you need from the inside edge of the mitered rebate.

3. Mark the next cut; this mark must be visible when you are cutting, so transfer it to the top side of the molding. It is most important to work accurately; always use a set square to fix the angle at 45°.

4. Move the molding slightly in the miter clamp so that you can cut exactly where you have made your mark. Repeat the process of marking and cutting for the other three sides of the molding.

Assembling a frame
1. Assemble an 'L' shape in the miter clamp by putting together one long and one short side of the frame. Tighten the clamp securely and check the fit.

2. Release the clamp and remove one of the pieces of wood; spread glue evenly over the mitered faces of the piece of frame.

3. Replace the glued piece of wood in the clamp, pushing it firmly against the other piece. Tighten the clamp securely again and wipe away excess glue that has been squeezed out before it dries.

4. Moldings tend to split when panel pins are driven straight in; in order to prevent this, drill shallow holes before you endeavor to insert the pin.

5. Insert the panel pins at a slight angle toward the outside of the molding; this also helps to prevent splitting, and it makes the joint stronger. Your joint should now be firmly secured.

6. Repeat this process with the other two sides of the frame, then bring the two 'L' shapes together and glue them firmly.

An alternative method of securing a miter 1. Make two horizontal cuts and force some glue into them. Insert small pieces of veneer into the cuts and wipe off surplus glue before leaving to set securely.

2. Cut away the excess veneer, then sand with fine sandpaper until the pieces of veneer are absolutely flush with the molding.

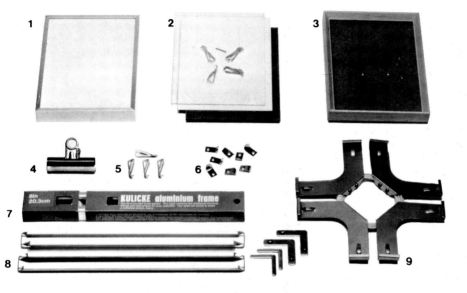

Left: Ready made framing kits include: **1.** Emo interchangeable metal frame **2.** Emo framer's pack **3.** Ready made frame **4, 5** and **6** Bulldog, spring and mirror clips **7** and **8** Kulicke and Daler metal frame kits **9.** Hang-it frame kit. **Below:** The way in which you mount your picture can make an enormous difference to the final effect. Too small a mount (**left**) can make a picture look rather cramped. Beveled edges (**center**) give your mount a much more professional finish but they are difficult to cut accurately without a great deal of practice and are not essential. When drawing lines around your mount (**right**) choose a color which sets off your picture to best advantage.

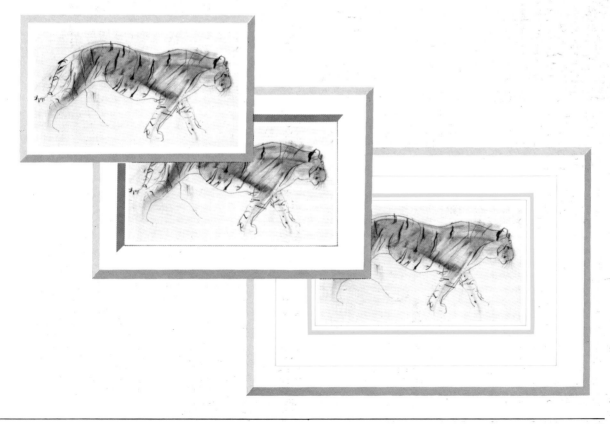

EXHIBITING

M any artists are content with 'exhibiting' the results of their efforts and commitment on their own walls. In many cases, however, their work would be worthy of a wider audience and suitable for submission to exhibitions, whether public or restricted. The mystique which surrounds the world of exhibitions is enough to put most artists off, but even at the national level it is not only the professional or highly experienced artist who will succeed in having his picture hung and even purchased. At a local level, certainly, art societies, libraries and neighbourhood galleries are always open to the submission of work. Lists of future exhibitions are published regularly, showing submission fees, venues and size restrictions.

Right above: There are several ways in which you can present work to potential exhibitors. Transparencies are particularly convenient, and black card window mounts look effective as long as you are not planning to send them through the post, in which case greater protection is essential (**see opposite**). A portfolio with a ring binder system will protect your pictures; pages from your sketchbook can also be included, and work that has been mounted. **Right:** If you are lucky enough to have your pictures hung in an exhibition you may have no choice as to the way in which the gallery is arranged and the facilities for lighting they have at their disposal. A tremendous variety of lighting is available, one of the most popular systems being the ceiling spotlights shown here. The background against which your work is hung and the method by which it is suspended are other matters over which you may have no control. Try to ensure that your pictures are hung on a white or neutral-colored wall in such a way that the method of support is as inconspicuous as possible.

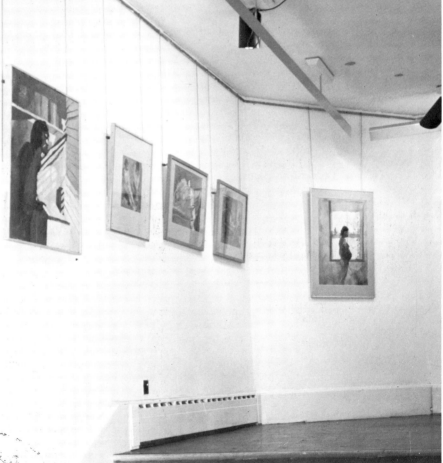

PHOTOGRAPHIC RECORDS

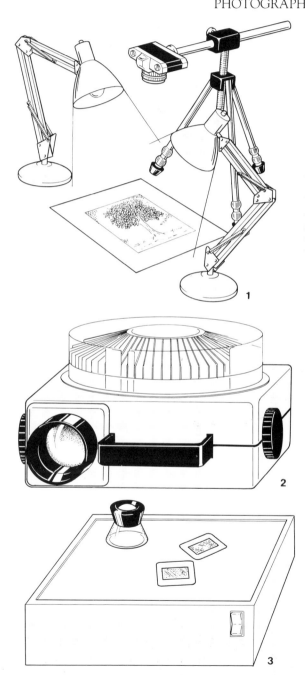

It is useful to keep a comprehensive photographic record of all your work and slides are probably the most convenient method. The quality of your photographs is important and it is best to mount your camera on a tripod so that it is steady throughout the exposure; a pair of angelpoise lamps should provide sufficient light (**1**). Slides should be viewed through a proper projector (**2**) or with the aid of a light box and eye glass (**3**); if you plan to submit your work to galleries and exhibitions, the administrators will have such aids at their disposal. Mount your slides carefully using plastic slide mounts with glass windows (**4**); this type of mount provides by far the best protection for your slide. Make sure the slide is dust free before clipping the sides of the mount together as any specks will show up badly when the slide is projected. Label each slide clearly (**5**) and record the details in a card index so that you always have a record of your work. If sending slides to a gallery, make sure they are clearly marked with your name, the title of the picture and date painted, as well as its dimensions and the medium used.

STAN SMITH 17.5.82

INDIAN TIGER

510 mm

LONDON ZOO
PASTEL 4/1/A 5

GLOSSARY

Aquarelle A drawing colored with thin washes of watercolor paint or a painting consisting of overlaid transparent washes.

Aqueous A term which refers to a pigment or medium soluble, or capable of being suspended, in water.

Binder A medium which can be mixed with a powder pigment to maintain the color in a form suitable for painting or drawing. For example, gum is the binder used in making both pastel sticks and watercolor paint. Oil binders produce materials with different properties.

Bistre A brown pigment prepared from charred wood used as a monochromatic wash for adding tone to drawings and also in the form of ink or chalk.

Blocking in A technique of roughly laying out the forms and overall composition of a painting or drawing in terms of mass and tone or color.

Body color Paint, such as gouache, which has opacity and covering power. Body color may be used to add highlights, tone or patches of local color in a drawing.

Broken color An effect in painting achieved by using colors in a pure state, without mixing or blending them, and dragging paint of a stiff quality across the support so that previous layers can be seen through the new application.

Calligraphic A term referring to a linear style of drawing, Characterized by flowing, rhythmic marks. This may develop as a mark of the artist's personal style, analagous to handwriting.

Caricature A representation of a person or object showing the characteristic features exaggerated, often intended as a humorous or satirical comment.

Cartoon A drawing or sketch, sometimes containing an element of caricature, showing the comic side of a situation. The term is used in another context to refer to a full size drawing made to map out the composition for a large painting, mural or tapestry.

Charcoal A drawing material made by reducing wood, through burning, to charred, black sticks. All charcoal tends to powder but sticks are available in different thicknesses so the qualities in a charcoal drawing can be varied.

Chiaroscuro This term literally means 'light-dark' and was used originally in reference to oil paintings with dramatic tonal contrasts. It is now more generally applied to work in which there is a skilfully managed interplay of highlight and shadow.

Collage This word derives from the French verb *coller* which means 'to stick'. Collage is a technique of creating an image or composition by glueing down scraps of paper, fabric or other materials. It is often used in conjunction with drawing and painting techniques to extend the range of color or texture in the work.

Complementary colors There are three basic pairs of complementary colors, each consisting of one primary and one secondary color. These are opposite colors in that the primary is not used in mixing the secondary, thus blue and orange (red mixed with yellow) are complementary. On an extended color sphere, a warm red-orange is opposite green-blue.

Composition The arrangement of various elements in a drawing or painting, for example, tone, contour, color etc.

Conte crayon A drawing stick like a hard, square-sectioned pastel, available in black, white, gray, red and brown.

Cross hatching A technique of laying an area of tone by building up a mass of criss-cross strokes, rather than with a method of solid shading.

Dry brush A means of applying watercolor with a soft, feathery texture by working lightly over the surface with a brush merely dampened with color. The hairs of the brush may be spread between finger and thumb.

Earth colors A range of pigments derived from inert metal oxides, for example, ochers, siennas and umbers.

Figurative This term is used in referring to drawings and paintings in which there is a representational approach to a particular subject, as distinct from abstract art.

Fixative A thin varnish sprayed onto drawings in pencil, charcoal, pastel or chalk. It forms a protective film on the work to prevent the surface from being blurred or smudged.

Foreshortening The effect of perspective in a single object or figure, in which a form appears considerably altered from its normal proportions as it recedes from the artist's viewpoint.

Fugitive color Certain pigments are inherently impermanent or the color may fade due to the action of natural elements, especially sunlight. A color which is short-lived in its original intensity is known as fugitive.

Gouache A water-based paint made opaque by mixing white with the pigments. Gouache can be used to lay thin washes of color but because of its opacity it is possible to work light colors over dark and apply the paint thickly to emphasize highlights or textural qualities.

Grain The texture of a support for painting or drawing. Paper may have a fine or coarse grain depending upon the methods used in its manufacture. Heavy handmade or machine made papers often have a pronounced grain which can modify the tones in a drawing.

Graphite A form of carbon which is compressed with fine clay to form the substance commonly known as 'lead' in pencils. The proportions of clay and graphite in the mixture determine the quality of the pencil, whether it is hard or soft and the density of the line produced. Thick sticks of graphite are available without a wooden pencil casing.

Ground The surface preparation of a support on which a drawing or painting is executed. A tinted ground may be laid on white paper to tone down its brilliance, for example in pastel or chalk drawing.

Gum arabic A water soluble gum made from the sap of acacia trees. It is used as the binder for soft pastels and watercolor paint.

Half tones A range of tones which an artist can identify between extremes of light and dark. These are often represented in drawing by techniques of hatching or stippling.

Hatching A technique of creating areas of tone in a drawing with fine, parallel strokes following one direction.

Hue This term is used for a pure color found on a scale ranging through the spectrum, that is red, orange, yellow, green, blue, indigo and violet.

Indian ink A dense black drawing ink, made from carbon, which may be diluted with water but is waterproof when dry. It is also called Chinese ink.

Local color The inherent color of an object or surface, that is its intrinsic hue unmodified by light, atmospheric conditions or colors surrounding it. For

example, a red dress, a gray wall.

Masking The use of adhesive tape or masking fluid to protect an area of a drawing while paint is applied to another area. For example, the outline of a shape can be masked while a wash of watercolor is applied around the edge. The mask is peeled or rubbed away when the paint is dry. This practice gives the artist more freedom to develop separate parts of an image.

Medium This term is used in two distinct contexts in art. It may refer to the actual material with which a drawing or painting is executed, for example, pastel, pencil or watercolor. It also refers to liquids used to extend or alter the viscosity of paint, such as gum or oil.

Modeling In drawing and painting, modeling is the employment of tone or color to achieve an impression of three-dimensional form by depicting areas of light and shade on an object or figure.

Monochrome A term describing a drawing or painting executed in black, white and gray only or one color mixed with black and white.

Not A finish in high quality papers which falls between the smooth surface of hot pressed and the heavy texture of rough paper.

Ochers Earth colors in a range from yellow to red-orange, the pigments being derived from oxide of iron.

Palette A tray or dish on which an artist lays out paint for thinning or mixing. The term also refers to the range of colors used in making a particular image or a color scheme characteristic of work by one artist.

Pastel A drawing medium made by binding powder

pigment with a little gum and rolling the mixture into stick form. Pastels make marks of opaque, powdery color. Color mixtures are achieved by overlaying layers of pastel strokes or by gently blending colors with a brush or the fingers. Oil pastels have a waxy quality and less tendency to crumble but the effects are not so subtle.

Perspective Systems of representation in drawing and painting which create an impression of depth, solidity and spatial recession on a flat surface. Linear perspective is based on a principle that receding parallel lines appear to converge at a point on the horizon line. Aerial perspective represents the grading of tones and colors to suggest distance which may be observed as natural modifications caused by atmospheric effects.

Picture plane The vertical surface area of a drawing or painting on which the artist plots the composition and arranges pictorial elements which may suggest an illusion of three-dimensional reality and a recession in space.

Pigment A substance which provides color and may be mixed with a binder to produce paint or a drawing material. Pigments are generally described as organic (earth colors) or inorganic (mineral and chemical pigments).

Primary colors In pigment the primary colors are red, blue and yellow. They cannot be formed by mixtures of any other colors, but in theory can be used in varying proportions to create all other hues. This is not necessarily true in practice as pigments used in painting and drawing materials are not likely to be sufficiently pure.

Resist This is a method of combining drawing and watercolor painting. A wash of water-based paint laid over marks drawn with wax crayon or oil pastel cannot settle in the

drawing and the marks remain visible in their original color while areas of bare paper accept the wash.

Sanguine A red chalk used for drawing.

Secondary colors These are the three colors formed by mixing pairs of primary colors; orange (red and yellow), green (yellow and blue) and purple (blue and red).

Sepia A brown pigment, originally extracted from cuttlefish, used principally in ink wash drawings.

Silverpoint A method of drawing using a silver-tipped instrument on a ground specially prepared, such as gesso. This delicate medium was extensively used by Renaissance artists but is relatively uncommon today.

Spattering A technique of spreading ink or paint in a mottled texture by drawing the thumb across the bristles of a stiff brush, loaded with wet color, to flick it onto the surface of the support.

Stippling The technique of applying color or tone as a mass of small dots, made with a drawing instrument or the point of a fine brush.

Study A drawing or painting, often made as preparation for a larger work, which is intended to record particular aspects of a subject, such as color, contour, the effects of light etc.

Support The term applied to the material which provides the surface on which a drawing or painting is executed, for example, board, paper or canvas.

Tone In painting and drawing, tone is the measure of light and dark as on a scale of gradations between black and white. Every color has an inherent tone, for example, yellow is light while Prussian blue is dark, but a colored

object or surface is also modified by the light falling upon it and an assessment of the variation in tonal values may be crucial to the artist's ability to indicate the three-dimensional form of an object.

Tooth A degree of texture or coarseness in a surface which allows a drawing or painting material to adhere to the support.

Torchon A stump made of tightly rolled paper, pointed at one end, which is used for spreading or blending a drawing material such as pastel, charcoal or chalk. It may also be called a tortillon.

Transfer paper Paper coated with a powdery tint used in transferring a drawing from one surface to another.

Transparency The quality of a painting medium which means that it stains or modifies the surface on which it is laid, rather than obliterating it. Ink and watercolor are transparent media and successive washes are used to build an intensity of tone and color through a gradual layering process.

Underdrawing The initial stages of a drawing or painting in which forms are loosely sketched or blocked in before elaboration with color or washes of tone.

Value The character of color or tone assessed on a scale from dark to light.

Wash An application of paint or ink considerably diluted with water to make the color spread quickly and thinly. Washes may be used to add color or broad areas of tone to a drawing in a linear medium. This is known as line and wash technique.

Watermark The symbol or name of the manufacturer incorporated in sheets of good quality paper. The watermark is visible when the paper is held up to the light.

INDEX

A

Aerial perspective *see Atmospheric perspective*
Anatomy, human 60-1
 basic structure of the skeleton 60-1, *60*
 male and female body shapes *61*
 muscles *60, 61*
 understanding of proportion *60*
Animals *see Still life*
Architecture *see Urban architecture*
Atmospheric (aerial) perspective 66, 67, *67*
 Bewick 66, *67*
 Breughel 67
 Ingres 67
 Ruskin's *Market Place, Abbeville 67*
 Turner 67
 Van Gogh 66, *67*
Auerbach:
 use of charcoal 11

B

Ball tip pen *34*
Ballpoint pen *34*
Bamboo pen *34*
Bewick, Thomas:
 atmospheric perspective in engravings 66, *67*
Birds *see Still life and natural history*
'Blind contour' pencil drawing *94*
Boards 39
Botticelli:
 Abundance of Autumn (pen and ink) *31*
Breughel, Pieter:
 atmospheric perspective *67*
Buildings *see Urban architecture*
Burnishers 36-7

C

Canaletto:
 perspective 64
 perspective – *The North East Corner of Piazza San Marco 62*

Caricatures 116-19
 band playing *116*
 doctor and patient *119*
 figure of a giant *117*
 Grosz's *Face of a Man 30*
 passengers waiting at airway terminal *119*
 Steadman *118*
 three witches *117*
 two heads in profile *116*
Cartoonists:
 use of pen and ink 13
Cartridge pen 33
Center line of vision 65
Chalk 26, 29
 masters of 29
Chalk drawings:
 Kollwitz's *Death holding a girl in his lap 29*
 Michelangelo's *Archers shooting at a mark 28*
 Rembrandt – *elephant 28*
 Seurat – figure 29
Charcoal 11, 19, 22, 25
 exponents of 25
 expressionists' use of (Auerbach) 11
 fixative 19
 forms available *22*
 making corrections 25
 paper 11, 22, 38
 pencils 19, 22
 range of marks possible 11
 variety of techniques shown *22, 22, 25*
Charcoal drawings:
 Bearded Man (still life) *150*
 Dürer's *Portrait of a Young Man 23*
 Girl in Jeans 90-1
 Girl with Long Hair 108
 Male Portrait (stages of work in progress and finished drawing) *110-11*
 Matisse's *Study for pink nude 23*
 Van Gogh's *The Gleaner 23*
 Whistler's *Maude reading 11*
Children (figure) 72-3, 96-9
 Baby and Child Asleep (pen and ink) *115*
 Boy in Dungarees (mixed media) *97*
 Boy in Red Boots (pastel) *96*
 Girl on Fire Box (mixed media) *98*
 Girl with Yellow Check Dress (mixed media) *98*

practical problem and answers 96, 98
 Seated Child (colored pencil) *99*
 techniques 98
Children (portrait) 112-13
 babies' heads 112
 Baby Girl (ballpoint pen) *112-13*
 Girl with Plaits (pencil) *113*
 problem of pose 113
 Young Child (pencil) *112*
Cold-pressed paper 38
Color (*see also Pastel, etc*) 13, 15, 17
 mixed media work 15
 use of acrylic paints 15
Colored ink 15, 33
Colored pencil drawings:
 Rhubarb 151
 Seated Child 99
Colored pencils 34, 35-6
 Hockney's use of 15
 some effects shown *36*
 uses 35-6
 water soluble 34, 36
Composition 54-5
 before you start 54
 Golden Section 54, 55
 mathematical approach 54, 55
 Piero della Francesca 54, 55
 scale 54
 thumbnail sketches as aid 54, *54*
 Turner 54, 55
 use of 'viewfinder' 54
Cone of vision 65
Constable, John:
 View of Wivenhoe Park (pencil) *20*
Correction (*see also Erasers*):
 charcoal work 25
 pen and ink work 35

D

Daumier, Honoré 13
Degas, Edgar 29
 Apres le bain (pastel over charcoal) *24*
 Dancer adjusting her slipper (pencil) *21*
 use of charcoal 25
 use of pastel *24*
Dip pen 29, 32
 some effects shown *33*

Dürer, Albrecht:
 grid system 57
 Portrait of a Young Man (charcoal) *23*
 proportions of human figure 57, *58*

E

Eakins, Thomas 13
Effects *see Pencil, etc*
El Greco 56
Equipment *see Materials and equipment*
Erasers 36-7, *37*
 art *37*
 bread 37, *37*
 burnishers 36-7
 electric *37*
 fibrasor *37*
 ink *37*
 pencils and cores *37*
 plastic *37*
 putty or kneaded 37, *37*
 soft *37*
Exhibiting 168-9
 gallery lighting and backgrounds 168
 photographic records of work *169*
 portfolio 168
 presenting work to potential exhibitors *168*

F

Felt tip pen 34, 36
 some effects shown *36*
Female figure 78-91
 approaches to nude studies 78, 83
 clothing 83-4, 86, 88
 Degas' *Apres le bain* (pastel over charcoal) *24*
 Degas' *Dancer adjusting her slipper* (pencil) *21*
 flowing long dress 83-4
 Girl in Dungarees (pencil) *78*
 Girl in Jeans (charcoal pencil) *90-1*
 Girl in Striped Jumper 1, 2 (mixed media) *80*
 Girl in White Dress (ink line and wash) *88*
 Girl with Long Hair (pencil) *86*

hats and other accessories 86, 88
Matisse's *Study for pink nude* (charcoal) 23
Nude bending over (pen, brush and ink) 83
Nude from behind (pen, brush and ink) 89
Nude leaning on Bed (mixed media) 81
Nude Posing (pen, brush and ink) 82
Old Woman Sleeping (pen and ink) 86-7
Pascin's *Redhead in a Blue Slip* (pen and ink) 14
posing clothed model 84
Reflective Woman (pencil) 80
Seated Nude (mixed media) 88
trousers 84, 86
type of cloth worn 86
Woman in Hat bending (pencil) 91
Woman with Hat (pencil) 83
Woman with Red Sash (mixed media) 79
Woman with Turban 1 (pencil) 84
Woman with Turban 2 (pencil) 84, 85
Young Nude (mixed media) 78
Female portrait 108-9
Girl in Sun Dress (pencil) 109
Girl with Long Hair (charcoal) 108
Girl with Scarf (pencil) 108
John's *Dorelia in a Straw Hat* (pencil) 10
Manet's *Madame Manet* (pastel) 12-13
Old Woman (rapidograph pen) 108
Rembrandt – wife (pen and ink) 30
Smith – informal portrait of girl 102-3
Whistler's *Maude reading* (charcoal) 11
Fibre tip pen 34
Field of vision, establishing 65
Figure *(see also Light and tone and Sketchbook)* 72-101
children 72-3, 96-9
female 78-91
groups 100-1
male 92-5

Figure, analysis of 74-7
axes and directional lines 75-6
geometric approach 74-5
hands 76
limbs 76
posing a model 77
three diagrams showing basic geometric structure 74-5
Figure, perspective in 63
avoiding optical distortions 63
foreshortening 63
measuring 63
Figure, proportions of 56-9
basic measuring 57
distortion 56-7
dividing into sections – use of grid 58, 59
Dürer 57, 58
historical systems 57-8
Leonardo da Vinci 56-7, 56, 57-8
measuring with pencil and outstretched arm 58
Michelangelo 56-7, 57
Fixative 19, 27, 37
Flowers 156-9
Chrysanthemum (pencil), stages of work in progress and finished drawing 156-7
Cyclamen (watercolor), states of work in progress and finished drawing 158-9
Foreshortening in figures 63
Fountain pen 32
Framing 164-7
alternative method of securing miter 166
assembling frame, step-by-step 166
cutting a miter, step-by-step 166
parts of modern frame 165
parts of molding 165
parts of traditional frame 165
range of moldings shown 164-5
ready made kits 167
tools 164

G
Ghirlandio:
technique (silverpoint) 8
Giacometti 29, 56

Gibson, Charles Dana 13
Glossary 170-1
Golden Section 54
to find 55
Turner's use of 54, 55
Goya 29
use of brush and ink 13
Graphos pen 32
Grosz, George:
Face of a Man (pen and ink) 30
Ground plane 64-5
Groups (figure) 100-1
Botticelli's *Abundance of Autumn* (pen and ink) 31
Kollwitz's *Death holding a girl in his lap* (chalk) 29
Michelangelo's *Archers shooting at a mark* (chalk) 28
People in Tunnel (pencil) 100
Reclining Nudes (pencil) 101
Women in Garden (pencil) 100
Groups (portrait) 114-15
Baby and Child Asleep 115
Children and Dog (pen and ink) 114
composition 114
Girls in Café (ballpoint pen) 115

H
History and development 8-15
charcoal 11
color 13, 15
drawing tradition 8, 11
Old Masters' sketches 8, 11
pen and ink 11, 13
Punch artists, 19th century 8, 11
Hockney, David:
Beach umbrella (pencil) 20
Nick and Henry on board, Nice to Calvi (pen and ink) 15
use of colored pencils 15
Hogarth, Paul 18
Calle Marco Polo, Tangiers (mixed media) 35
Holbein 29
Horizon line, placing of 54, 65
Hot-pressed paper 38
Human figure; human anatomy *see Figure; Anatomy*

I
Ingres, Jean August Dominique:
atmospheric perspective 67
pencil drawings 19
study of a young man (pencil) 20
Inks:
artists' drawing 32
colored 33
non-waterproof 32
range available 32

J
John, Augustus:
Dorelia in a Straw Hat (pencil) 10

K
Keane, Charles 13
Kennington, Eric 38
Kollwitz, Käthe 29
Death holding a girl in his lap (chalk) 29

L
Landscape *(see also Urban architecture)* 120-9
Abstract Landscape (pen, brush and ink) 128
aerial or atmospheric perspective 66, 67, 67
approaches to 124
color in 128-9
Constable's *View of Wivenhoe Park* (pencil) 20
Farm Outhouse (pen and ink) 129
Garden Scene (pencil) stages of work in progress and finished drawing 124-5
Leonardo – sketch of rock formation 8
location and studio work 132
media 132, 134
moods 124, 128
perspective in 134, 137
placing horizon line 54
practical tips on location work 140

Rubens' *A Path Bordered by Trees* 6-7
Smith (mixed media) *120-1*
some guidelines 129
some interesting effects *140-1*
some possibilities – after rain, etc 134
Trees in Pen and Ink (stages of work in progress and finished drawing) *126-7*
Van Gogh's *View of Arles* (pen and ink) 66
Wallis's *St Ives Harbour* 62
Landscape analysis 122-3
boathouses and trees – preliminary sketches and final choice of composition 122
composition 122
different viewpoints *123*
light 122
same view with different lighting effects *123*
Leonardo da Vinci –
Antique Warrior (silver-point) 9, 19
Perspective Study 52-3
proportions of human figure 56-7, 57-8
sketch of rock formation 8
Study of Human Proportions 56
use of pen and ink 11, 13
Light and tone 68-71, *144*
double figure study 69
figure study on tinted paper 70
figures in deck chairs 70
reflected light 71
richly textured tonal image 68
shadows 71
useful method of analyzing tonal values 68, 71
Light in the studio 40
Linear perspective 64

M

Male figure 92-5
Man in Uniform (ballpoint pen) 94
Man Sitting on Chair (pencil) 92
Mandolin Player (pencil) 94-5

Old Man and Papers (cartridge pen) 93
Seurat (chalk) 29
Study of Nude Man (pencil) 92
Van Gogh's *The Gleaner* (charcoal) 23
Wounded Man (pencil – 'blind contour' technique) 94
Male portrait 110-11
Dürer's *Portrait of a Young Man* (charcoal) 23
Hockney's *Nick and Henry on board* (pen and ink) 15
Ingres – study of a young man (pencil) 20
Leonardo's *Antique Warrior* (silverpoint) 9
Male Portrait (charcoal), stages of work in progress and finished drawing 110-11
Manet, Edouard:
Madam Manet (pastel) *12-13*
Mapping pen 33
Marker pen 34
Materials and equipment 16-51
check list of indoor and outdoor materials *41*
erasers 36-7, 37
for framing *164*
for mounting *162*
paper 38-9
pencils and other drawing media 18-37
sketchbook 42-51
some useful items 37
where you work (indoors and outdoors) 40-1
Matisse, Henri 8
nude pencil drawings 19
Study for pink nude (charcoal) 23
use of charcoal 25
May, Phil 13
Media *see Pencil, etc*
Michelangelo:
Archers shooting at a mark (chalk) 28
figure analysis – statue of David and drawing of Adam 76
proportions of human figure 56-7
study for the creation of Adam 57
use of chalk (Sistine Chapel studies) 29

use of pen and ink 11, 13
Mixed media 15
Degas' use of 24
use of oil pastel 26
Mixed media drawings:
Boy in Dungarees 97
Brighton Pier 138
Cat 155
Chimpanzee 154
Degas' *Apres le bain* 24
Duncan Street Development, London 140-1
Girl in Striped Jumper 1, 2 80
Girl on Fire Box 98
Girl with Yellow Check Dress 98
Hogarth's *Calle Marco Polo, Tangiers* 35
Leopard 154
Lioness 155
Nude leaning on Bed 81
Seated Nude 88
Smith – agricultural landscape *120-1*
Smith – portrait *102-3*
Venetian Scene 130-1
View of Church 133
Woman with Red Sash 79
Young Nude 78
Model, posing 77, 84
Modigliani
Molding, parts of *165*
Moldings, range illustrated *164-5*
Mounting 160-3
beveled edges 162, *167*
cutting glass, step-by-step 163
drawing lines around mount 162, *167*
drawing placed asymmetrically *160-1*
dry mounting with iron, step-by-step 163
equipment *162*
glass cover *162*
window mounting, step-by-step *162*
with rubber gum, step-by-step *163*

N

Natural history *see Still life and natural history*
Nibs 34
for dip pen *32*

use of pen and ink 11, 13
for fountain pen *32*
for graphos pen *32*
for stylo tip pen *32*
Not paper 38

O

Oil pastel 26, 26
in mixed media works 26
laying wash 27
uses of 26
with watercolor 27
Old Masters' sketches 8, 11
One-point perspective 64, 65
Outdoor work 40
check list of materials and clothes *41*

P

Paper 38-9
charcoal 11, 22, 38
hand-made 38
hot-pressed 38
machine-made 38
not (cold-pressed) 38
pastel 25-6, 38
pen and ink 34-5
rice 38
right side of 38, 38
rough 38
some examples shown 39
some recommended types 38-9
specialist types 38-9
stretching procedure 38, 39
weight 38
Pascin, Jules:
Redhead in a Blue Slip (pen and ink) 14
Pastel 25-6
adding detail with charcoal 27
adding detail with pastel pencil 27
highlighting 27
laying area of tone 27
laying oil pastel wash 27
lifting with brush 27
oil 26, 26
oil with watercolor 27
preparing surface yourself 26
sharpening 26
spraying fixative 27
support (paper 25-6, 38
types and accessories 26

variety of effects shown 27
variety of techniques shown 25
with watercolor 27
Pastel drawings
 Boy in Red Boots 96
 Degas' Apres le bain 24
 Galloping Horse 142-3
 Manet's Madame Manet 12-13
 Power Station (stages of work in progress and finished drawing) 134-5
 Study of Bottle and Glass 146-7
 Urban Scene 139
Pen/Pen and ink drawings:
 Abstract Landscape 128
 Baby and Child Asleep 115
 Baby Girl 112-13
 Black and White Drawing of Fish (stages of work in progress and finished drawing) 148-9
 Botticelli's Abundance of Autumn 31
 Children and Dog 114
 Eagle 152-3
 Farm Outhouse 129
 Girl in White Dress 88
 Girls in Café 115
 Grosz's Face of a Man
 Hockney's Nick and Henry on board, Nice to Calvi 15
 Nude bending over 83
 Nude from behind 89
 Nude posing 82
 Man in Uniform 94
 Old Man and Papers 93
 Old Woman 108
 Old Woman Sleeping 86-7
 Pascin's Redhead in a Blue Slip 14
 Rackham illustration 30
 Rembrandt – study of wife 30
 Rubens' A Path Bordered by Trees 6-7
 Skull 150
 St Pancras Station, London 136
 Van Gogh's View of Arles 66
Pen and ink 29, 33
 bamboo pen 34
 cartridge pen 33
 choosing a pen 33-4
 colored ink 33
 dip pen 29, 32
 fountain pen 32

graphos pen 32
making corrections 35
mapping pen 33
nibs 34
range of inks available 32
reed pen 33-4
reservoir pen 32
stylo tip pen 32
supports 34-5
types of pen 32
variety of effects shown (stylo tip and dip pen) 33
Pen and ink, history and development 11, 13
 Daumier's use of 13
 Eakins's use of 13
 Gibson's use of 13
 Goya's use of 13
 Leonardo's use of 11, 13
 May's use of 13
 Michelangelo's use of 11, 13
 Picasso's use of 13
 Rembrandt's use of 13
 use by cartoonists (Keane) 13
Pencil 18-19
 development of 18
 grades (H and B systems) 18, 18
 masters of 19
 sharpening 18-19
 variety of effects shown 19
Pencil drawings:
 Black-throated Diver 152
 Chrysanthemum (stages of work in progress and finished drawing) 156-7
 Constable's View of Wivenhoe Park 20
 Degas' Dancer adjusting her slipper 21
 Garden Scene 124-5
 Girl in Dungarees 78
 Girl in Sun Dress 109
 Girl with Long Hair 86
 Girl with Plaits 113
 Girlf with Scarf 108
 Hockney's Beach umbrella 20
 House in Charleston, USA 137
 Ingres – study of a young man 20
 John's Dorelia in a Straw Hat 10
 Man Sitting on Chair 92
 Mandolin Player 94-5
 People in Tunnel 100
 Reclining Nudes 101

Reflective Woman 80
Study of Nude Man 92
Terraced Houses 132
Woman in Hat bending 91
Woman with Hat 83
Woman with Turban 1 84
Woman with Turban 2 84, 85
Women in Garden 100
Wounded Man ('blind contour' technique) 94
Young Child 112
Pencil sharpeners 37
Pens (see also Pen and ink):
 ballpoint 34
 felt tip 34, 36
 fibre tip 34
 fine ball tip 34
 marker 34
Perspective 62-7
 aerial or atmospheric 66, 67, 67
 basic principles 64-5, 67
 Caneletto – The North East Corner of Piazza San Marco 62
 center line of vision 65
 Chinese painting 62, 62
 cone of vision 65
 conventional western (linear) system 64
 Early Christian religious works 62, 64
 establishing field of vision 65
 establishing horizon line 65
 figure 63
 ground plane 64-5
 Leonardo's Perspective Study 52-3
 one-point 64, 65
 three-point 65
 two-point 64
 Wallis's St Ives Harbour 62
Picasso, Pablo:
 use of charcoal 25
 use of pen and ink 13
Piero della Francesca:
 mathematical structure of work 54, 55
Portfolio 168
Portrait 102-19
 caricatures 116-19
 children 112-13
 female 108-9
 groups 114-15
 male 110-11
 sketches 49
Portrait analysis 104-7
 adult's skull 106

back, side and front views of head showing geometric forms 104-5
child's skull and features 106, 106
eyes 105, 106-7
facial structures of the sexes 106
head shapes – geometric forms 104, 106
lower jaw 107
mouth 105, 107
neck 107
nose 105, 107
old person's skull 106
scowl or frown 107
smile 107
Posing a model 77, 84
Punch artists, 19th century 8, 11, 13

R

Rackham, Arthur:
 pen and ink illustration 30
Record of work, photographic 169
Reed pen 33-4
Reflected light 71
Rembrandt:
 elephant (chalk) 28
 study of wife (pen and ink) 30
 use of brush and ink 13
Reservoir pen 32
Rice paper 38
Richter 58
Rodin 19
Rough paper 38
Rubbers see Erasers
Rubens:
 A Path Bordered by Trees (pen and ink) 6-7
Ruskin:
 perspective – Market Place, Abbeville 67

S

Sarto, Andrea del 29
Seurat, Georges:
 seated figure (chalk) 29
 use of chalk 29
Silverpoint 19
 Ghirlandio's use of 8
 Leonardo's Antique Warrior 9, 19

Sketchbook 42-51
addition of local color 47
basis for portrait 49
calligraphic representation of nude 50
catching fleeting ray of light 44
choice of medium 42, 42
course in figure drawing 44, 49
detailed botanical study 50
detailed view of old mine 51
pencil sketch of bent figure 50
range of types and sizes 42
rapid ballpoint sketch 50
trying out alternatives for painting 43
two approaches to figure 51
using colored pencils 47
Smith, Stan:
informal portrait of girl (mixed media) 102-3
Smith, Tony R.:
agricultural landscape (mixed media) 120-1
Steadman, Ralph:
some caricatures 118
Still life and natural history 143-59
aspects of composition 146
Bearded Man (charcoal) 150
Black and White Drawing of Fish (pen, ink and wash), stages of work in progress and finished drawing 148-9
Black-throated Diver (pastel) 152
Cat (mixed media) 155

Chimpanzee (mixed media) 154
Eagle (pen and ink) 152-3
elephant – Rembrandt (chalk) 28
flowers 156-9
Leopard (mixed media) 154
Lioness (mixed media) 155
media 152
practicing drawing from dead bird or animal 148, 152
Rhubarb (colored pencil) 151
Skull (ballpoint pen) 150
Study of Bottle and Glass (pastel), stages of work in progress and finished drawing 146-7
technical problems 148
Winer – galloping horse (pastel) 142-3
Still life analysis 144-5
arranging a still life 144
choice of subjects 145
light and tone 144
light sources 144
Stretching paper 38, 39
Studio equipment and organization 40, 41
check list of materials 41
size of work 40
work surfaces 40, 41
Studio light 40
artificial 40
location of easel 40
Stumps 37
Stylo tip pen 33
some effects shown 33
Supports see Papers, Boards

T
Techniques see Charcoal, etc
Three-point perspective 65
Thumbnail sketches as compositional aid 54, 54
Tone see Light and tone
Tools for framing 164
Torchons (tortillons) 37
Toulouse-Lautrec 29
Townscapes see Urban architecture
Turner, J.M.W.
atmospheric perspective 67
use of Golden Section 54, 55
Two-point perspective 64

U
Uccello 64
Urban architecture 130-41
Brighton Pier (mixed media) 138
Canaletto's The North East Corner of Piazza San Marco 62
Duncan Street Development, London (mixed media) 140-1
Hogarth's Calle Marco Polo, Tangiers (mixed media) 35
House in Charleston USA (pencil) 137
Power Station (pastel), stages of work in progress and finished drawing 134-5

practical tips on location work 140
Ruskin's Market Place, Abbeville 67
St Pancras Station, London (pen and ink) 136
Terraced Houses (pencil) 132
Urban Scene (oil pastel) 139
Venetian Scene (mixed media) 130-1
View of Church (mixed media) 133

V
Van Gogh, Vincent:
atmospheric perspective 66, 67
The Gleaner (charcoal) 23
View of Arles (pen and ink) 66

W
Wallis, Alfred:
perspective – St Ives Harbour 62
Watercolor 'drawing':
Cyclamen (stages of work in progress and finished drawing) 158-9
Watteau 29
Whistler, James McNeill:
Maude reading (charcoal) 11
Window mounting, step-by-step 162
Winer, Marc:
galloping horse 142-3

CREDITS